RAAC

W9-DJQ-307

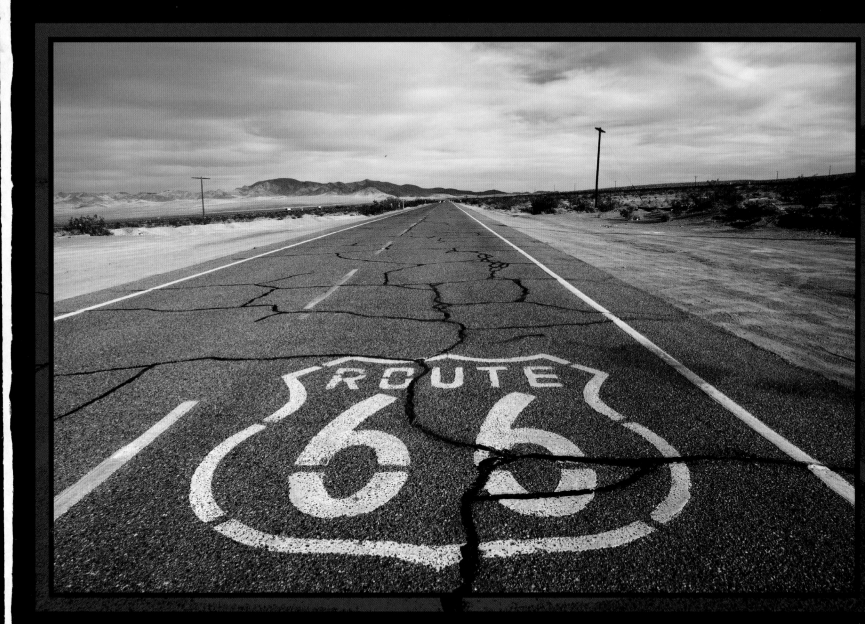

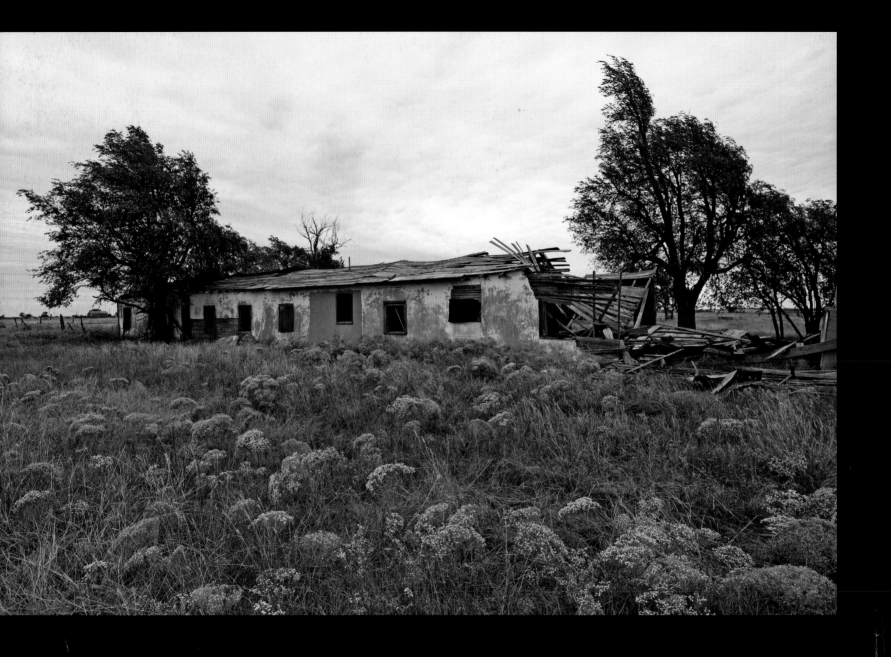

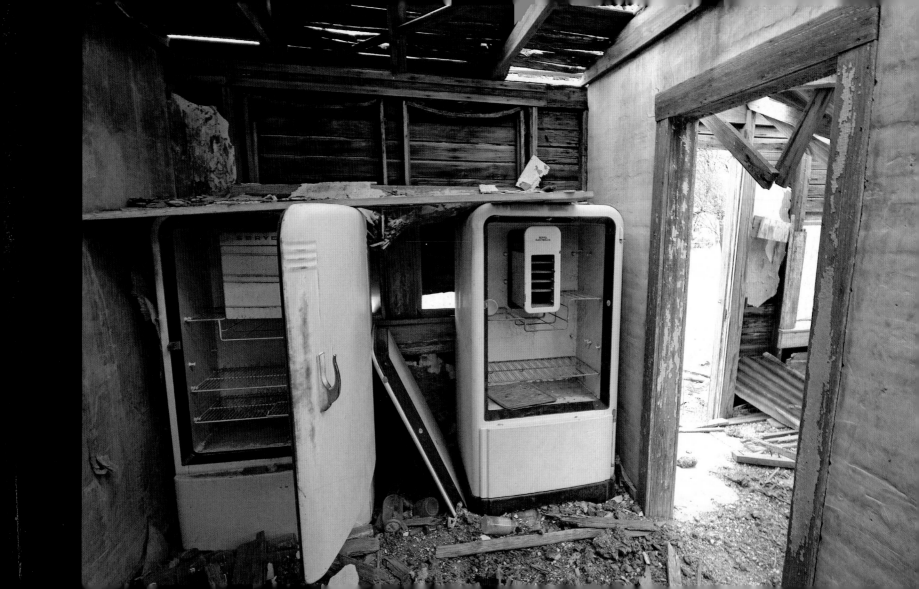

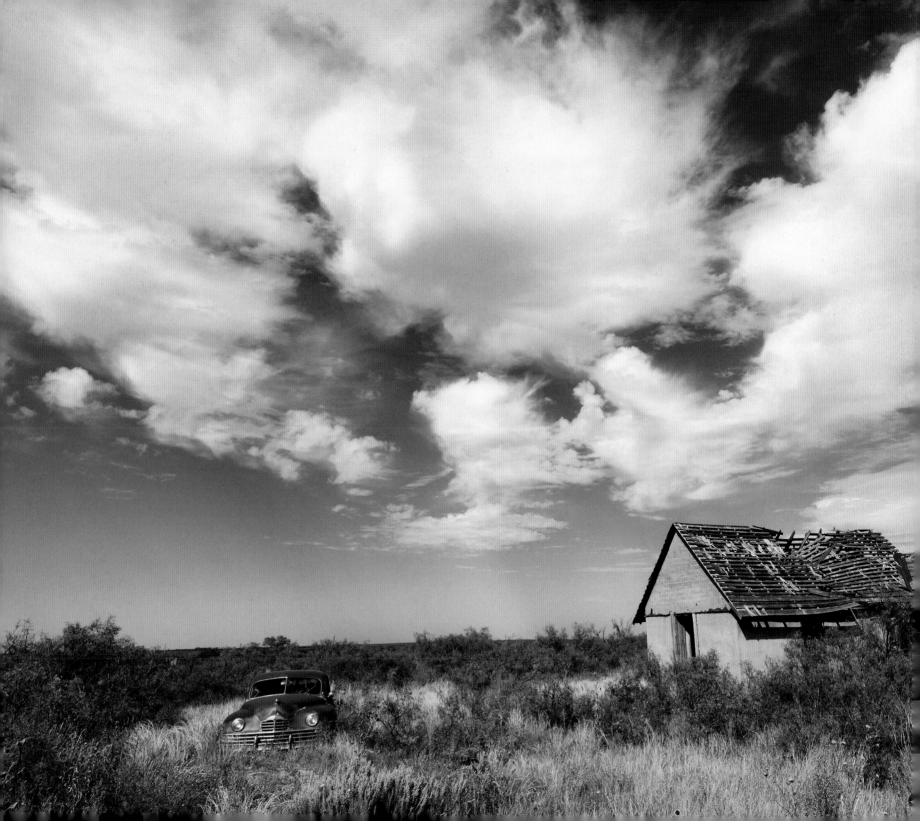

GHOST TOWNS of ROUTE 66

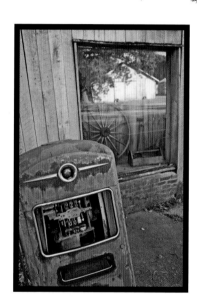

Text by Jim Hinckley

Photography by Kerrick James

VOYAGEUR
PRESS

Page 1: Route 66 in Ludlow, California.
Page 2: Ruins in Jericho, Texas.
Page 3: Windswept clouds over a vintage Packard in Endee, New Mexico.
Page 4: A gas pump in Funks Grove, Illinois.
Opposite: A vintage car parked at Hackberry General Store in Arizona.
Page 11: Faded memories and faded signs are the silent monuments in Newkirk, New Mexico.

Quarto is the authority on a wide range of topics.

Quarto educates, entertains and enriches the lives of our readers—enthusiasts and lovers of hands-on living.

www.quartoknows.com

Text copyright © 2011 by Jim Hinckley
Photography copyright © 2011 by Kerrick James

First published in 2011 by Voyageur Press, an imprint of Quarto Publishing Group USA Inc., 400 First Avenue North, Suite 400, Minneapolis, MN 55401 USA. This edition published 2016. Telephone: (612) 344-8100 Fax: (612) 344-8692

quartoknows.com
Visit our blogs at quartoknows.com

All rights reserved. No part of this book may be reproduced in any form without written permission of the copyright owners. All images in this book have been reproduced with the knowledge and prior consent of the artists concerned, and no responsibility is accepted by producer, publisher, or printer for any infringement of copyright or otherwise, arising from the contents of this publication. Every effort has been made to ensure that credits accurately comply with information supplied. We apologize for any inaccuracies that may have occurred and will resolve inaccurate or missing information in a subsequent reprinting of the book.

Voyageur Press titles are also available at discounts in bulk quantity for industrial or sales-promotional use. For details contact the Special Sales Manager at Quarto Publishing Group USA Inc., 400 First Avenue North, Suite 400, Minneapolis, MN 55401 USA.

Library of Congress Cataloging-in-Publication Data

Hinckley, James, 1958-
 Ghost towns of Route 66 / text by Jim Hinckley ; photography by Kerrick James.
 p. cm.
 Includes bibliographical references and index.
 ISBN 978-0-7603-3843-8 (plc)
 1. West (U.S.)—Description and travel. 2. United States Highway 66—Description and travel. 3. Ghost towns—West (U.S.) 4. Ghost towns—West (U.S.)—Pictorial works. 5. West (U.S.)—History, Local. 6. West (U.S.)—History, Local—Pictorial works. I. James, Kerrick. II. Title.
 F595.3.H55 2011
 978—dc22
 2010037770

Edited by Danielle Ibister
Design Manager: Katie Sonmor
Designed by Isolde Maher/4 Eyes Design
Cover designed by John Barnett/4 Eyes Design

Printed in China

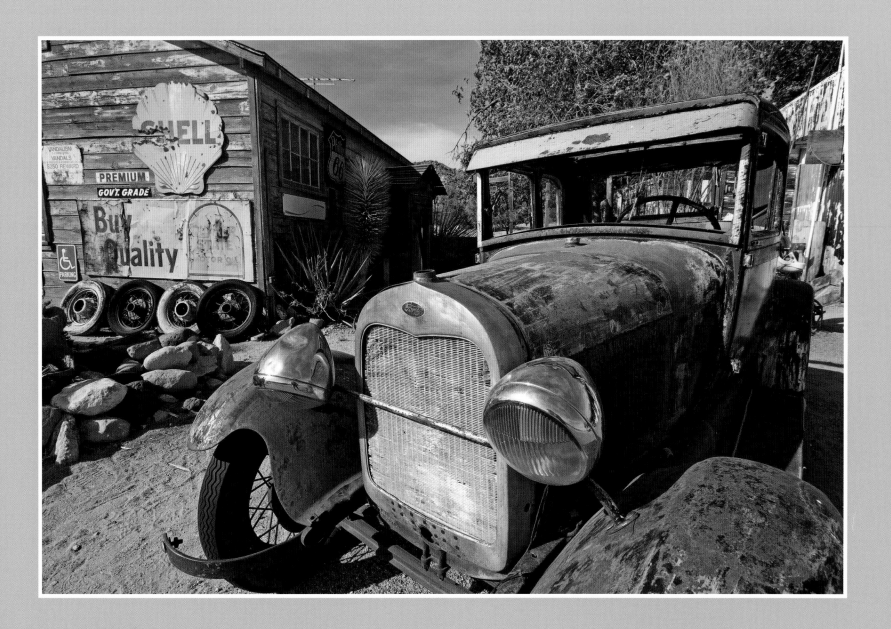

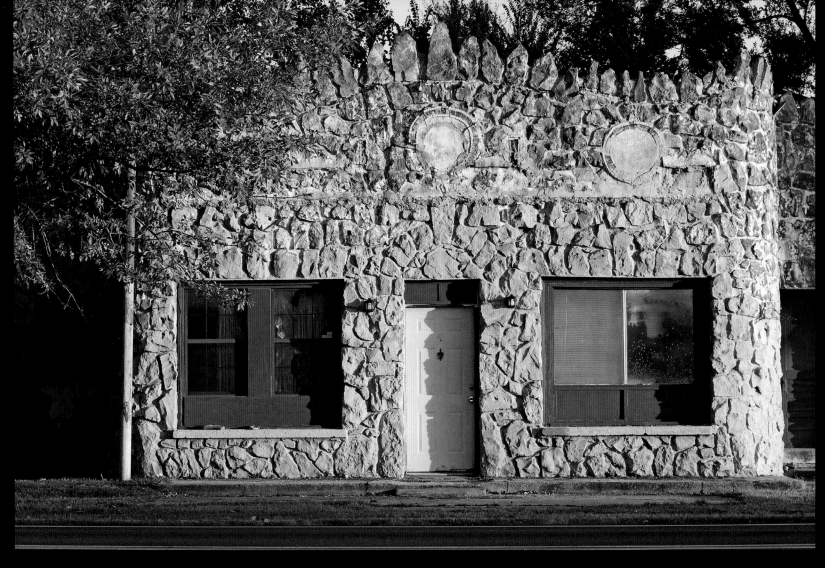

Sun lights the front of a stone building in Afton, Oklahoma.

To the one who has been my source of encouragement and
inspiration for more than two decades, my dearest friend, my wife.
—J. H.

To Julie Ann Quarry, who made the miles less lonely and the route
traveled never far from her heart and smile.
—K. J.

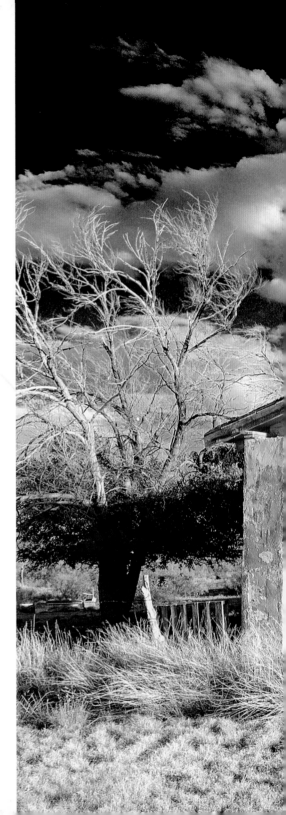

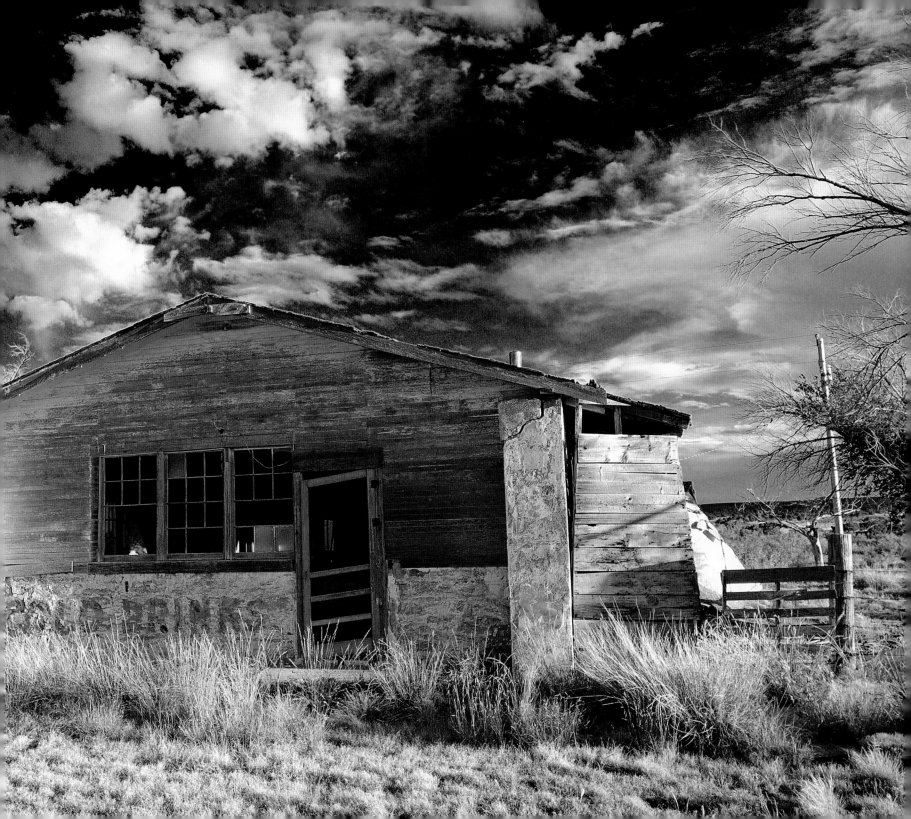

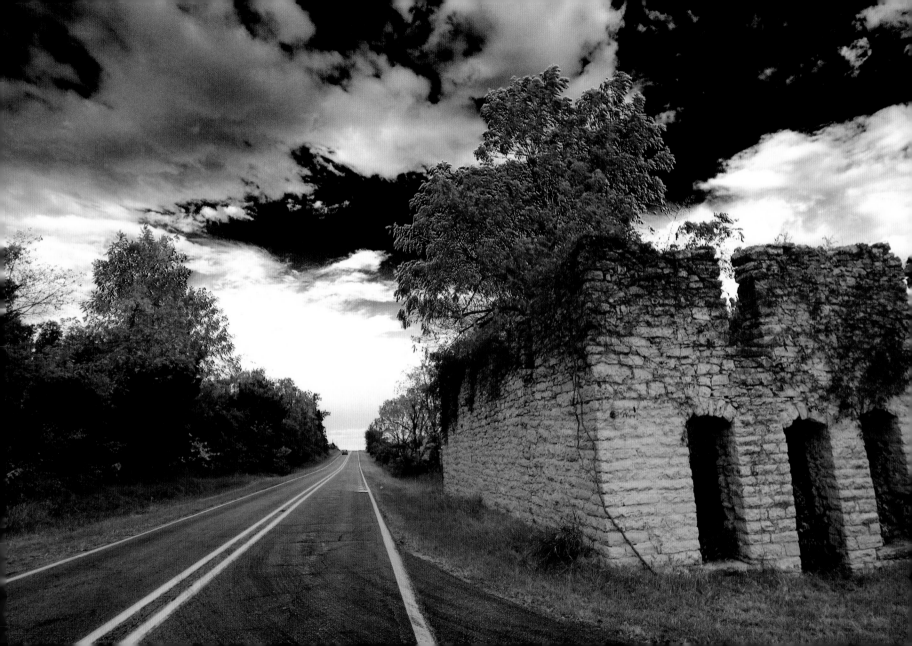

INTRODUCTION

ICONIC ROUTE 66 is more than a mere highway that connects a metropolis on the shore of Lake Michigan with a metropolis on the Pacific coast. It is the stuff of dreams. It is an icon of epic proportions that lures travelers from throughout the world to come experience American life as it once was and to seek the roadside ghosts from an era when Studebakers still rolled from the factory in South Bend.

The old highway is more than a 2,291-mile (according to a 1936 map) ribbon of asphalt lined with dusty remnants, ghostly vestiges, and polished gems manifesting more than eighty years of American societal evolution. Along Route 66, from Chicago to the shores of the Pacific Ocean at Santa Monica in California, whispering breezes carry the voices of ghosts from the Civil War that blend with those of French explorers, Native Americans, Spanish conquistadors, and pioneers fulfilling a young nation's Manifest Destiny.

To drive Route 66 is to follow the path of a new nation on its journey of westward expansion. The signs bearing the double six mark the path of an American highway that is but a modern incarnation of the Pontiac Trail, the Osage Trail, and the old Federal Wire Road; the Beale Wagon Road and the El Camino Real; the National Old Trails Highway; and the Santa Fe Trail.

This long and colorful history makes the ghost towns along Route 66 unique because they are ghosts of the modern era with roots that reach to the nation's earliest history.

There are territorial-era mining towns where men who came West on horseback cheered Barney Oldfield and Louis Chevrolet as they roared through town. There are quiet farming villages that once played center stage in the bloody conflict of the Civil War and dusty, wide spots in the road where centuries-old churches cast shadows over the ruts of the Santa Fe Trail as well as the broken asphalt of Route 66.

In the ghost towns of Route 66, the old road will forever be America's Main Street. In the empty places along America's most famous highway, the ghosts whisper on every breeze, and the swirling sands of time blur the line between past and present.

GHOST TOWNS

OF ROUTE 66

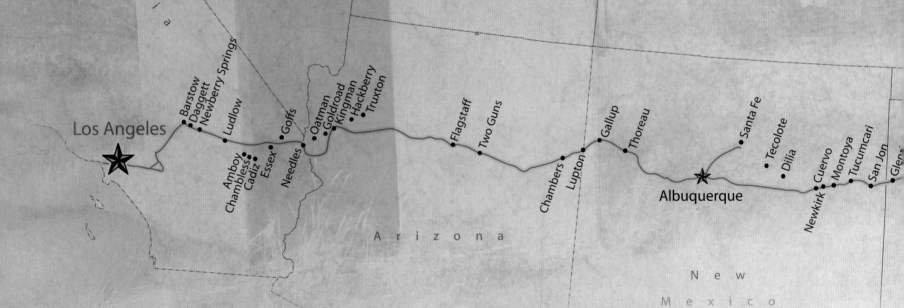

Los Angeles

Barstow
Daggett
Newberry Springs
Ludlow
Goffs
Oatman
Goldroad
Kingman
Hackberry
Truxton

Amboy
Chambless
Cadiz
Essex
Needles

Flagstaff
Two Guns

Gallup
Thoreau

Chambers
Lupton

Santa Fe

Albuquerque

Tecolote
Dilia
Newkirk
Cuervo
Montoya
Tucumcari
San Jon
Glenri

California

Arizona

New
Mexico

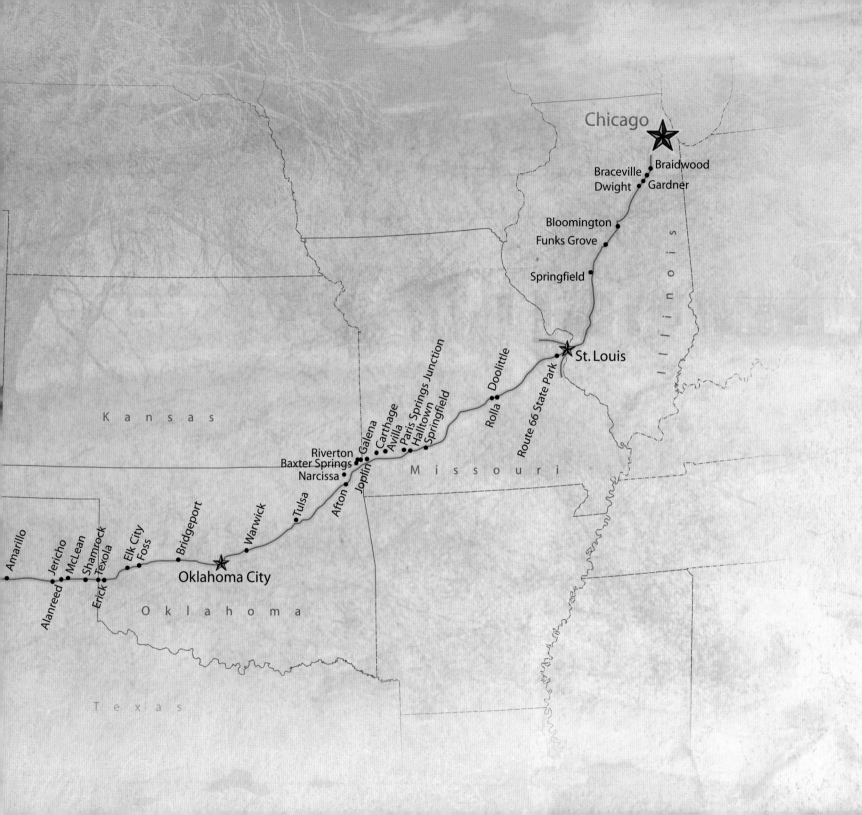

Chicago

Braceville • Braidwood
Dwight • Gardner

Bloomington
Funks Grove

Springfield

Illinois

St. Louis

Doolittle
Rolla
Route 66 State Park

Paris Springs Junction
Carthage
Galena • Halltown
Riverton • Avilla • Springfield
Baxter Springs
Narcissa
Joplin

Kansas

Missouri

Afton

Tulsa

Warwick

Bridgeport

Elk City
Foss

Oklahoma City

Amarillo
Jericho
McLean
Shamrock
Alanreed • Texola
Erick

Oklahoma

Texas

ILLINOIS

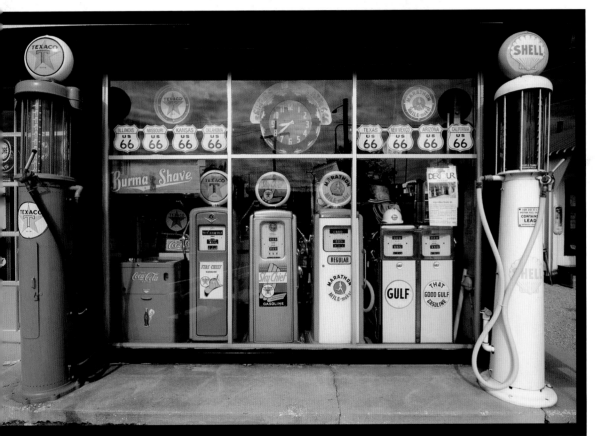

At Shea's in Springfield, Bill Shea has created a shrine to the gas station, the oil company, and the American love affair with the road trip.

ROADSIDE GHOSTS and roadside time capsules abound in Illinois, but ghost towns are a rarity and are of a different nature than those found farther west on the plains and desert sands. The rising tide of urban sprawl that spawned the interstate highway and that swept Route 66 from center stage during the last half of the twentieth century began here with the transformation of the venerable two-lane into a four-lane super slab.

As a result, the ghost towns that survive along Route 66 in Illinois do so as dots on a map, made manifest in a service station, transformed into a home or a quiet café, shadowed by centuries-old trees. In most of those that remain, the darkened neon and façades that seemed modern and chic during the era of the Edsel and tail fin often obscure vestiges from the town's long history that predates the automobile by decades.

THE TOWNS THAT COAL BUILT

MINING GAVE RISE to a small cluster of towns between Dwight and Wilmington. Of these, only Braidwood and Gardner have survived into the modern era with relative prosperity. The others—Godley, Braceville, and Mazonia—are a string of tarnished gems along old Route 66 with but the faintest of hints that they were once more than dusty, wide spots in the road.

Jack Rittenhouse, in his 1946 classic, *A Guide Book to Highway 66*, writes that Godley was "Once a booming mining community. Now only a few homes remain. South of the town are more slag heaps." Of Braceville, he says, "Like Godley, this town is but a remnant of a once thriving coal town. As you leave town, the typical slag heaps still blot the countryside." Mazonia did not warrant mention, and even less remains today.

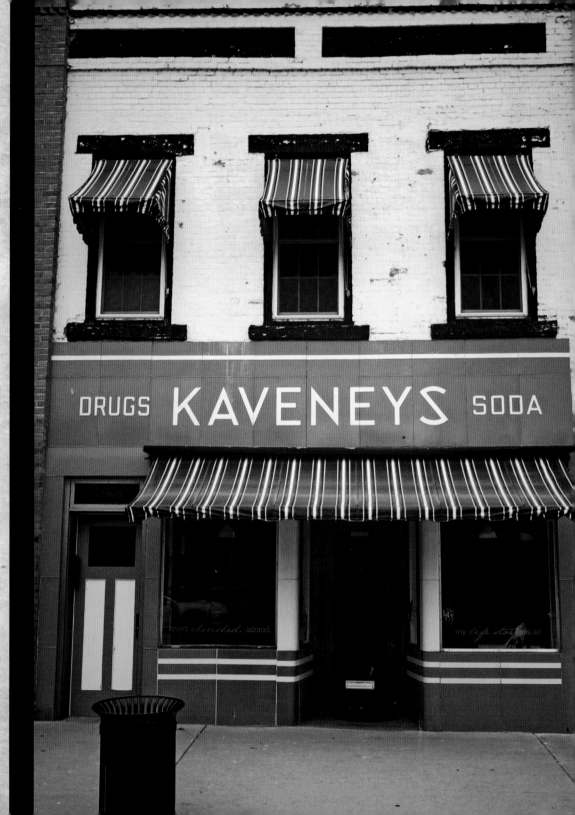

Kaveneys drugstore, now an antique shop, is just one of the many jewels found in the heart of historic Wilmington.

Wilmington, with a population of more than 5,600, may not be a ghost town per se, but ghostly remnants from an earlier time abound.

When You Go

From Wilmington, drive west on State Highway 53 approximately eight miles. Braidwood is north of the tracks on Highway 113. Godley, Braceville, and the site of Mazonia are on Highway 53.

In Wilmington, the Dé-Ja-Vu store sign encapsulates the essence of a drive on the iconic highway.

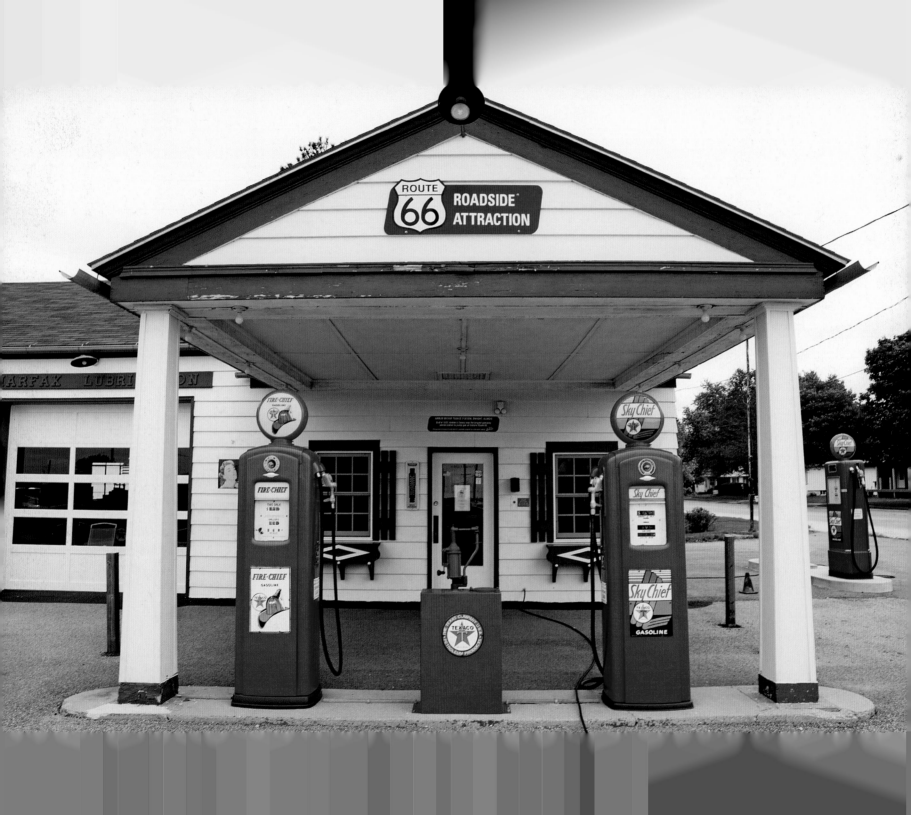

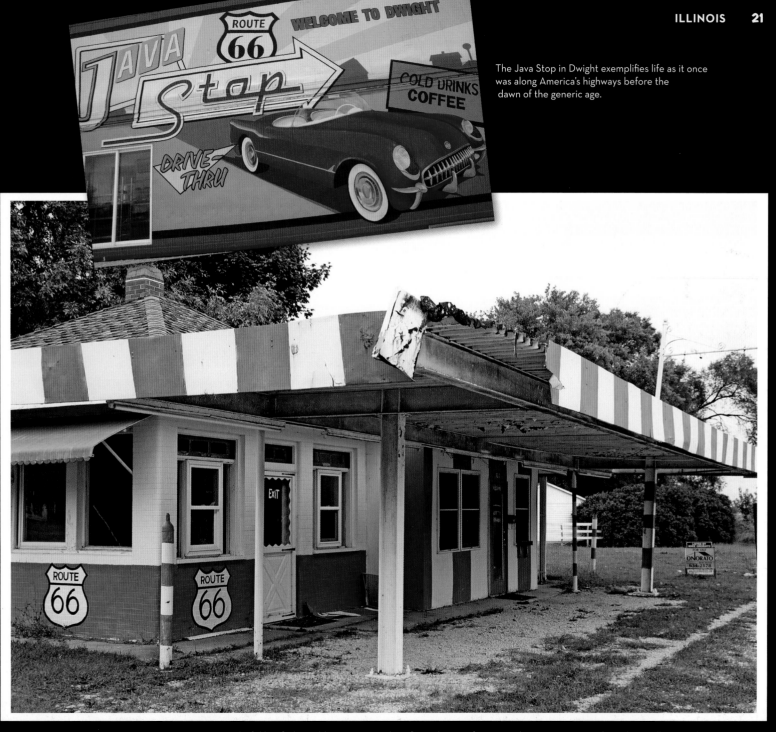

The Java Stop in Dwight exemplifies life as it once was along America's highways before the dawn of the generic age.

A colorful but forlorn old eatery in Dwight reflects the transformation the interstate wrought in the small towns along Route 66.

Jack Rittenhouse and His Classic Route 66 Guidebook

The 1946 Route 66 guidebook that author Jack Rittenhouse envisioned as the modern-day equivalent to *The Great West* (written by Edward H. Hall in 1866 and instrumental in fueling westward immigration) only sold a dismal three thousand copies. However, with the resurgent interest in Route 66 that began in the 1980s, Rittenhouse's *A Guide Book to Highway 66* was reprinted, is now sold at gift shops all along the highway, and provides an invaluable snapshot of Route 66 as it was in the immediate postwar period.

An interesting footnote to the guide and the expedition that led to its creation is the vehicle Rittenhouse selected for the roundtrip journey: a 1939 American Bantam coupe. These diminutive cars with seventy-five-inch wheelbases and twenty-two-horsepower engines were very fuel efficient, but they were also quite spartan and anemic, especially for a trip that included climbs to elevations exceeding seven thousand feet.

In his preface to the 1989 edition, Rittenhouse notes that his car had "no trunk, no trip odometer, no radio." He also notes the car had a 1,200-pound curb weight and would often deliver almost fifty miles to a gallon of gasoline.

66

Braceville, originally Braysville, was large enough to warrant a post office by 1855, but it was the discovery of coal in the early 1860s that transformed this community and its bucolic neighbors into rough-and-tumble boomtowns.

A flood of immigrant Scotch, Irish, and Welch miners numbering in the thousands poured into the area. They settled in Godley, Braceville, and Mazonia, giving these communities a boisterous, vibrant atmosphere. By the late 1880s, twenty-one coal mines were operating in the area. The population of Braceville soared to 3,500, and in Braidwood it surpassed 8,000. In Braceville alone, there were six general stores, two banks, a hotel, restaurants, and more than a dozen other businesses.

Whimsy, a large part of the Route 66 experience, manifests itself at the Polk-a-Dot Drive In as a delightful vintage timepiece.

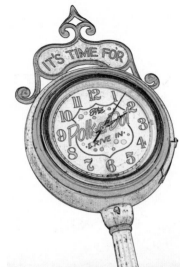

Dating to 1956, the Polk-a-Dot Drive In started as a bus in Braidwood painted with rainbow-colored polka dots and has morphed into a pre-franchise-era time capsule.

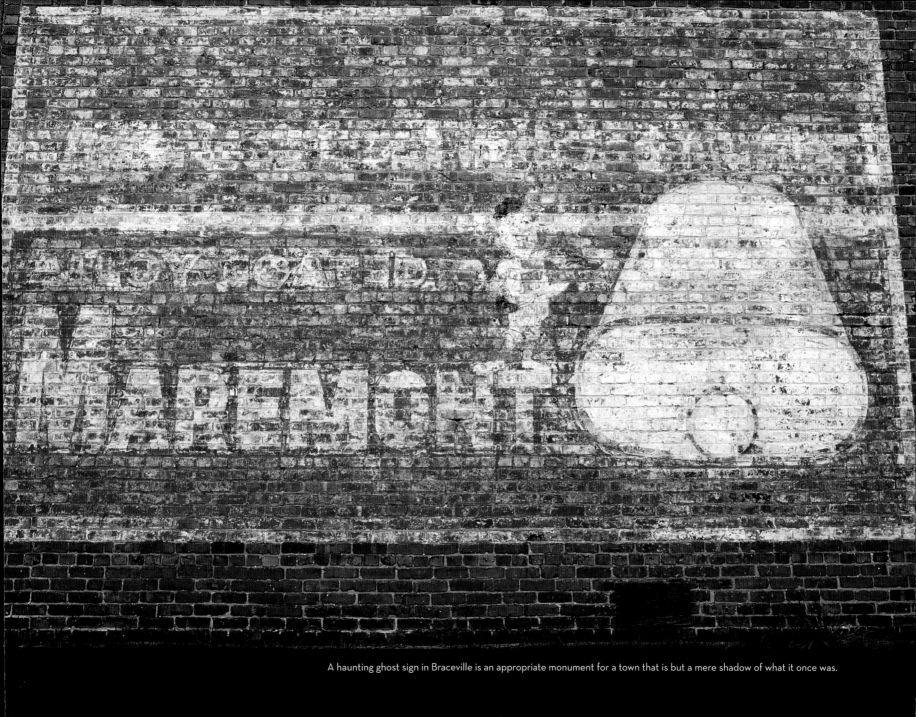

A haunting ghost sign in Braceville is an appropriate monument for a town that is but a mere shadow of what it once was.

A series of problems at the mines—a cave-in, a fire, a flooding, a string of labor disputes, and ultimately the exhaustion of profitable ore seams—resulted in a near complete closure of the mines by 1910. The dismantling of many of the buildings in Godley, Braceville, and Mazonia quickly followed. It was an inglorious end to towns that had once been at the center of an investment frenzy attracting syndicates from as far away as Boston, New York, and London.

Most, but not all, of the vestiges of past glory date to the era of Route 66. These include Braidwood's Polk-a-Dot Drive In, dating to 1956.

In Wilmington, as in almost every community along legendary Route 66, windows to the past are found in abundance.

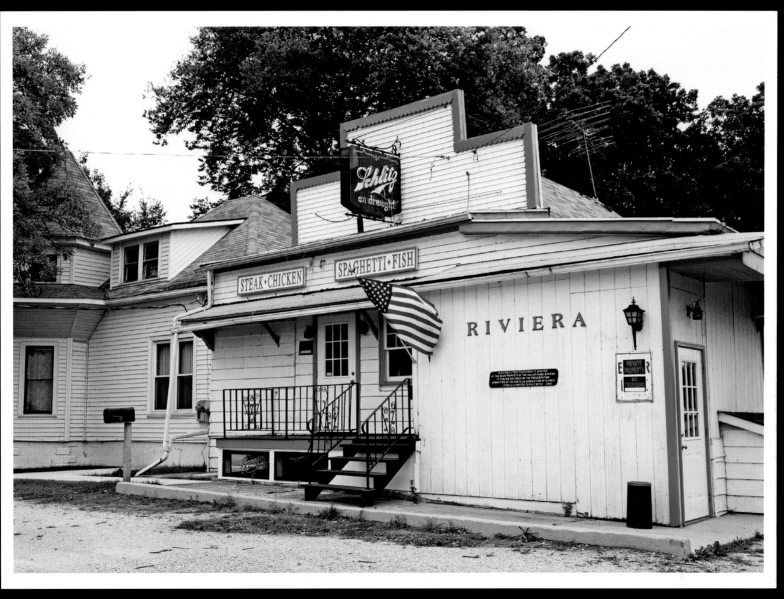

The unimposing Riviera, south of Braceville, had a long and colorful association with Route 66 before a fire destroyed the structure in 2010.

A streetcar diner in Gardner has received a new lease on life; plans are underway for its restoration.

INTO THE LAND OF LINCOLN

FROM GARDNER TO SPRINGFIELD, villages and towns amply sprinkled with refurbished pearls of roadside Americana nestle along shade-dappled Route 66, but only a few qualify as ghost towns. Still, many are mere shadows of what once was. These time capsules have a history that predates the highway by decades and illustrates why Illinois is known as the "Land of Lincoln."

Now vanished from the map is the little village of Cayuga, located south of Odell. Rittenhouse tells us that, in 1946, Cayuga consisted of "a grain elevator, a small school, one store, and a dozen homes."

This village was surveyed and platted April 10, 1855, and in *The History of Livingstone County Illinois* (1878), it is noted:

As a general thing, while towns established at a distance of ten or twelve miles apart have flourished, those lying between have been almost invariably less successful. Certainly, no other reason can be given why Cayuga should not have developed equally with other towns along the road. There is no more pleasant situation for a prosperous village on the road. Though the village compares but poorly with many other towns of the county, the business done here is, by no means, inconsiderable as will be seen by the following items, as given by the obliging agent of the Chicago, Alton & St. Louis Railroad, Edwin Chapman.

Apparently many were puzzled by the town's stagnation, a situation that neither the railroad nor Route 66 could alleviate. Route 66 enthusiasts today know this "town" for its Meramec Caverns barn. Once as common as the painted barns that proclaimed "See Rock City," this recently refurbished barn sign is one of two that remain in the state of Illinois.

Another village now vanished from modern maps is Ocoya, which a 1929 Rand McNally atlas shows six miles southwest of Pontiac. Rittenhouse describes Ocoya as "another dwindling community with the ever present grain elevator, a score of homes, two small stores, and a gas station, [lying] just off U.S. 66."

The post office opened here in 1860. Over the next forty years, it would open and close numerous times, depending on the ebb and flow of the population.

Shirley, just south of Bloomington, was a railroad town, but its proximity to Bloomington hindered its growth. In *The History of McLean County Illinois* (1879), it is noted that Shirley was "situated on the Chicago, Alton & St. Louis Railroad, six miles southwest of Bloomington. . . . The surrounding country is fertile and the farming community seems in easy circumstances, but the little village of Shirley does not grow rapidly."

Funks Grove, fifteen miles south of Bloomington, was never really a town. Yet

When You Go

From Gardner, continue west on State Highway 53 (Route 66).

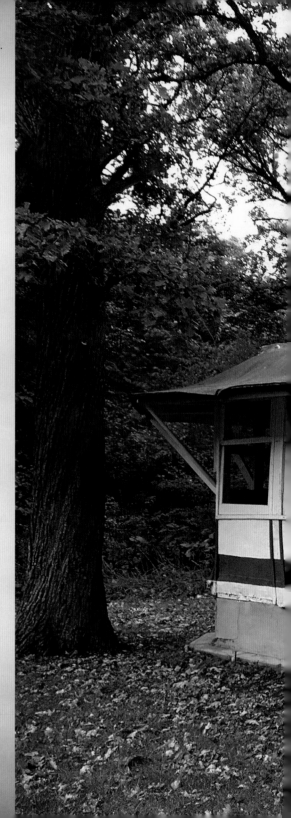

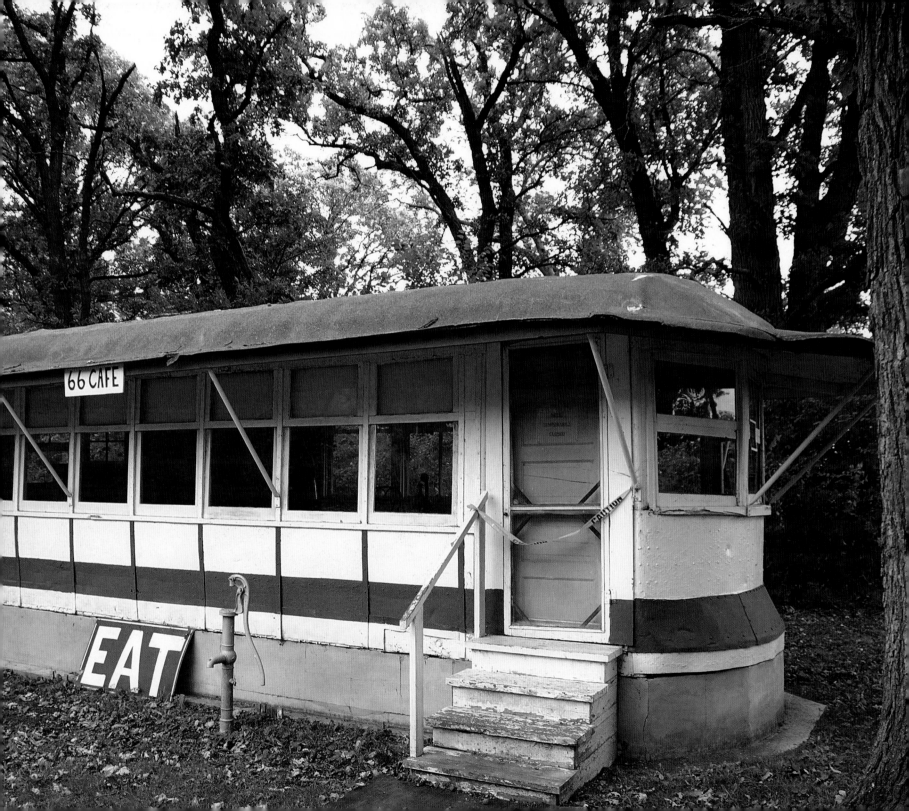

COTTON HILL

ONE OF THE MORE INTRIGUING and enigmatic ghost towns found along Route 66 is Cotton Hill, located near Springfield.

The quaint little farming village was large enough to warrant a post office by 1862, but its proximity to Springfield seems to have stunted its growth. By the turn of the century, the town was in decline, and in 1907, the post office closed.

Still, Cotton Hill clung to life by serving as a stop on the Illinois Central Railroad and, after the establishment of Route 66, by offering services to motorists scurrying between Chicago and St. Louis. With the creation of Lake Springfield and realignment of Route 66, Cotton Hill was razed.

Today, the site—and the second alignment of Route 66, Cotton Hill Road—is under the lake. Adventuresome explorers can still follow the old highway through the brush to the water's edge and, when water levels are low, get their kicks by splashing along old Route 66.

Old U.S. 66 leads to the shore of Lake Springfield, under which lies the site of Cotton Hill.

it is more than hallowed ground for fans of the old double six; it is an institution with roots as a family business that reach back to Issac Funk's homesteading on the site in 1824. Amazingly, the maple sirup (a spelling that designates purity) sold by the Funk family has never been sold anywhere but here. For more than eighty years, they have relied on Route 66 for customers.

The church at Funks Grove dates to 1845. The general store and depot, relocated from another site, are faithful recreations that enhance the sense of timelessness. The gas station and café that Rittenhouse mentions in his guidebook are now closed and provide favorite photo opportunities for travelers on Route 66.

When Rittenhouse drove through Lawndale in 1946, he described it as "not really a town at all, since it consists of a couple of red railroad shacks, a few homes, and a pair of grain elevators." This was not always the case. In *The History of Logan County Illinois* (1911), the entry for Lawndale indicates that, in June 1857, it was platted and surveyed "the next year after the Alton & Sangamon (now Chicago & Alton) railroad was completed to that point." The town originally contained twelve blocks, but "Ewing's addition in 1864 added seventeen blocks more. . . . The village has never been incorporated. It is located in East Lincoln Township and has a population of about 200."

Little has changed in Lawndale since the days of the Rittenhouse expedition. Even in the most popular modern travel guides, such as *EZ 66 Guide for Travelers* by Jerry McClanahan, the community warrants little more than a dot on a map.

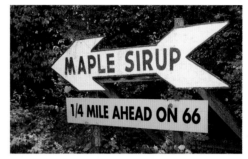

From the inception of Route 66, a sign like this has pointed the way to Funks Grove.

DON'T MISS

The Route 66 walking tour in Towanda provides a great opportunity to stretch the legs. Titled "Historic Route 66: A Geographic Journey," the trail utilizes an abandoned section of the highway and features interpretive displays from all eight states as well as Burma Shave signs.

In 1946, Jack Rittenhouse found a gas station and a café in Funks Grove, but these businesses survive today only as photo ops.

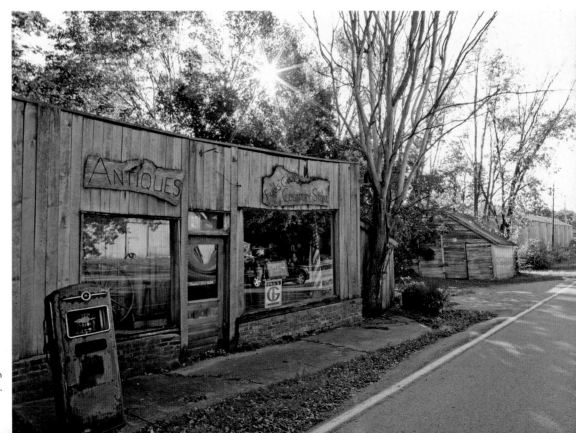

For more than a century, the Funks Grove sign has been synonymous with maple sirup.

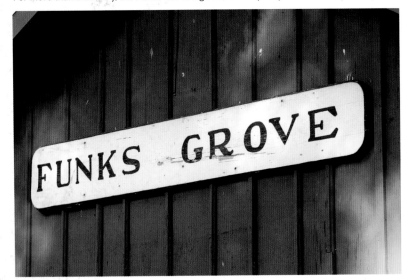

An old brick wall serves as the backdrop for a sign proudly proclaiming Gardner's place on historic Route 66.

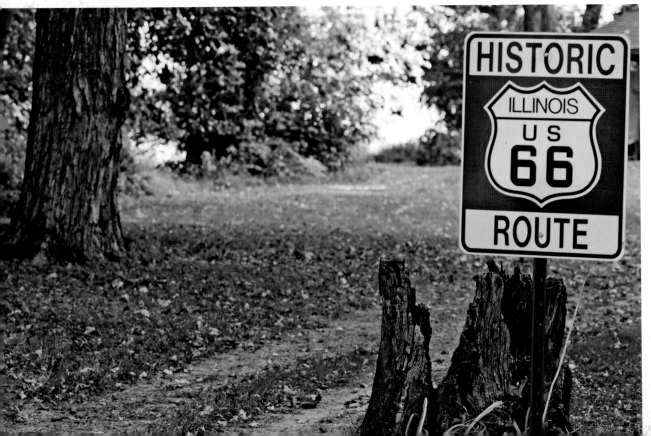

As this sign near Funks Grove indicates, the state of Illinois has done an excellent job of identifying the various alignments of historic Route 66.

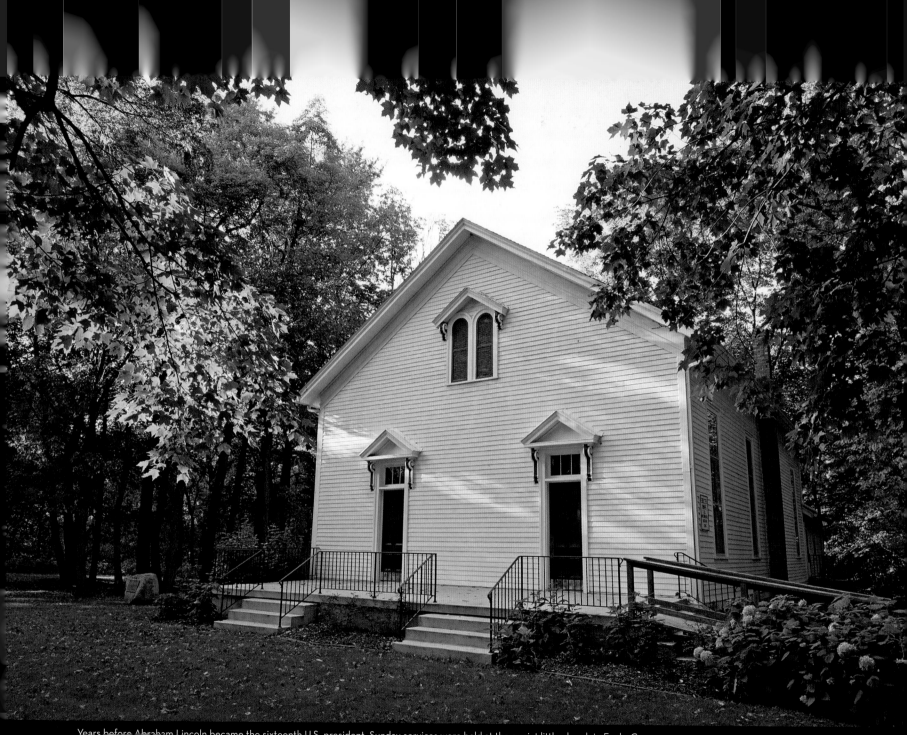

Years before Abraham Lincoln became the sixteenth U.S. president, Sunday services were held at the quaint little church in Funks Grove.

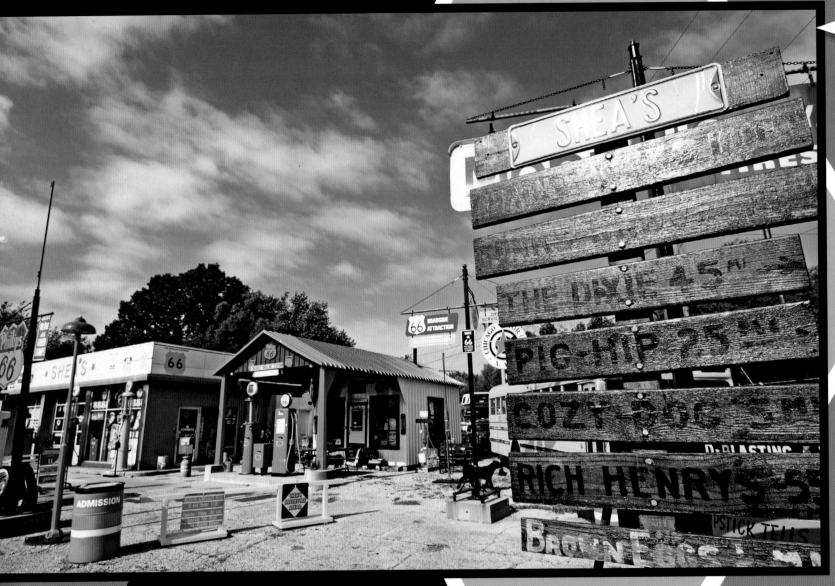

Both photos: Shea's Gas Station Museum in Springfield presents a three-dimensional history of the American service station encapsulated in a former fuel center and vintage station relocated to the site.

The Realignment of Route 66

FROM SPRINGFIELD SOUTH TO GRANITE CITY, there are two distinct versions of Route 66. There is the 1926–1930 alignment that was originally Illinois State 4 and the 1930–1977 alignment that is now generally Interstate 55 with Route 66 serving as a frontage road.

As with the section of Route 66 that lies east of Springfield, the alignments to the west are dotted with small, picturesque communities that have lengthy, colorful histories and an abundance of refurbished ghosts. Counted among the must-see ghosts are Art's Motel in Farmersville. In Litchfield, there is the SkyView Drive-In Theatre and the Ariston Café, the oldest continuously operated, one-family-owned café on Route 66, dating to 1931. Other stops of note include Soulsby Station in Mt. Olive, which dates to 1926, and the Luna Café, circa 1924, in Mitchell.

MISSOURI

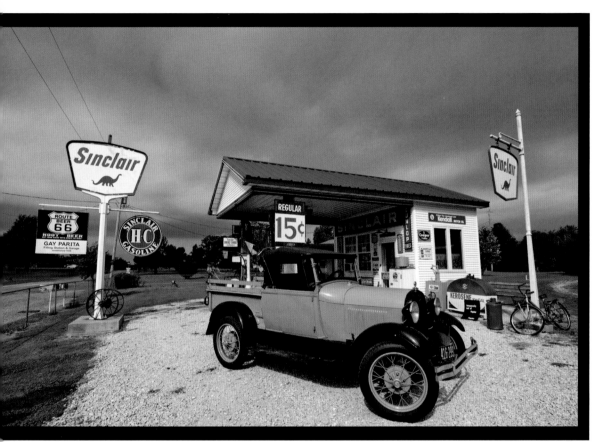

Gary Turner's re-creation of Gay Parita Garage and Sinclair station in Paris Springs Junction shows remarkable attention to detail.

IN THE SHOW-ME STATE, much of Route 66 follows the old Wire Road, a vital communications and transportation road that was at center stage in some of the bloodiest fighting of the Civil War. Many of the weathered headstones and monuments in shade-dappled cemeteries perched on ridges above the old road stand in silent testimony to these dark times.

In stark contrast is the colorful glow of neon, refurbished or remembered, that sheaths many towns along the double six in Missouri. This garish façade harks back to the glory days of Route 66.

Not all ghost towns in the shadow of the Ozark Mountains are tinged dark by the tumult of the Civil War, nor are they all memorialized with neon monuments. At least one began with the promise of good times before becoming a victim of the modern industrial era and environmental degradation.

IN AN ODD TWIST OF FATE, the idyllic Route 66 State Park on the Meramec River mirrors the vision of those who established a small resort community on this site seventeen miles west of St. Louis in 1925. It also masks the tragedy that claimed the community of Times Beach.

GHOST OF THE MODERN ERA: TIMES BEACH

After acquiring a 480-acre site on a flood plain utilized for farming, the owners of the *St. Louis Star Times* initiated an unusual promotional campaign to increase the newspaper's circulation. For $67.50, a customer could purchase a 20x100-foot lot and receive a six-month subscription to the newspaper. There was a slight catch: to utilize the property and build a house required the purchase of a second adjoining lot.

Since this was largely a summer resort, and the area was prone to flooding, stilts were foundational elements of the cottages built. By 1930, residents were building more substantial homes, a reflection of the move from resort to community. This and a growing business district gave the town an atmosphere of stability.

The shift from resort to town marked a new chapter in the history of Times Beach. The next chapter began with World War II, gas rationing, and the postwar housing shortage that again transformed the character of "The Beach," as residents called it.

By 1970, some 1,240 people called Times Beach home, and the town was slowly moving beyond its postwar image as a low-income community of mobile homes and cracker-box houses.

The most notable manifestation of this change was the decision to address the town's 16.3 miles of dusty, unpaved streets. With a budget insufficient to meet the projected cost of paving, city administrators instead turned to oiling the roads to control the dust. Contracted for this endeavor was Russell Bliss, owner of a small company that hauled waste oils and other materials.

What city management did not know was that Bliss was also hauling waste for the Northeastern Pharmaceutical and Chemical Company of Verona, Missouri, a major producer of Agent Orange during the Vietnam War. As a result, for several years, Bliss sprayed the streets of Times Beach with material laden with deadly dioxins.

In the fall of 1982, an investigative reporter turned his attention to Times Beach after establishing a link between Russell Bliss and the death of dozens of horses at stables he had sprayed with waste oil. This investigation was quickly followed by one initiated by the Environmental Protection Agency.

On December 5 of that year, the worst flooding in the town's history forced an almost complete evacuation. Eighteen days later, the EPA notified residents and the community's administration, "If you are in town it is advisable for you to leave and if you are out of town do not return."

In an instant, the obscure little community of Times Beach dominated international headlines and became synonymous with deadly environmental degradation, the bane of the modern era. By 1985, the mandatory evacuation was complete, negotiated buyouts were underway, and the town site was quarantined.

In 1996 and 1997, the final chapter in Times Beach history began to unfold.

The banner headlines proclaiming the opening of Times Beach marked the beginning of one of the most unusual promotional campaigns in newspaper history. *Missouri Department of Transportation*

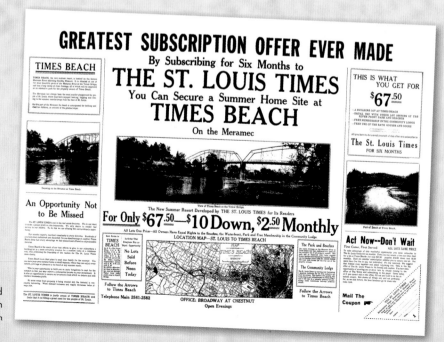

An incinerator built on the site at a cost of $110 million burned 265,000 tons of contaminated soil and materials. Upon completion of the project and certification that the site was clean, the property reverted to the state of Missouri, which, in turn, reopened it as Route 66 State Park in 1999.

There are but two remnants of the little town on the banks of the Meramec River: one a monument to Times Beach, the other to Route 66. Steiny's Inn, a 1935 roadhouse, now serves as the park's visitor center, and a beautiful steel truss bridge, closed in 2009, stands in mute testimony to the forgotten town's ties to legendary Route 66.

Route 66 State Park, on the former site of Times Beach, is now a haven for wildlife, waterfowl, and those seeking a respite from the rush of the modern era.

When You Go

Route 66 State Park, the site of Times Beach, is accessed from exit 266 on Interstate 44 east of Eureka.

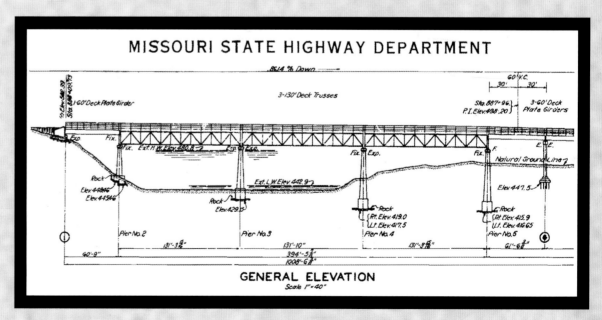

MISSOURI STATE HIGHWAY DEPARTMENT

GENERAL ELEVATION
Scale 1"=40"

These plans may soon be all that remains of Times Beach's Meramec River Bridge, closed in 2009.
Missouri Department of Transportation

The overgrown ruins of a former casket company are among the last remnants of Plano.

THE GHOST TOWN TRAIL OF MISSOURI

ON THE SECTION OF OLD U.S. 66 between Springfield and Carthage, only the traffic keeps you anchored to the modern era. Here, the line between past and present is blurred. The ghost towns, ruins, and vintage bridges that frame timeless, bucolic scenes enhance the illusion that it is possible to step back in time.

The first hint that this drive will be special is the shade-dappled Yeakley Cemetery, established in 1852. Still used for services is the chapel that dates to 1887.

Plano, a few miles west, may have once been a prosperous little farming community or even a bustling service center meeting the needs of Route 66 travelers, but today only two hints of better times remain. One is the overgrown stone ruins that were once a mortuary and casket factory; the other is the former service station and garage that now serve as a residence.

If a town's post office illustrates its lifeline, the glory days in Plano were short. The post office opened its doors in 1895 and closed them in 1903.

The next stop is Halltown, home of the White Hall antique store housed in the former Whitehall Mercantile, which has cast its false-fronted shadow across the road for more than a century. In 1926, the year Route 66 debuted on the world stage, Halltown supported almost two dozen businesses, including the mercantile, several grocery stores, a blacksmith shop, and a drugstore.

As of the spring of 2010, the future of White Hall Antiques is unknown; the proprietor who opened the store in 1985 and co-founded the Route 66 Association of Missouri in 1990, Thelma White, passed away at the age of eighty-three.

The river of traffic that flowed east and west on Route 66 transformed towns all along the route by igniting the creative, entrepreneurial spirit of the common man. In Halltown after 1930, weary travelers could find rest at the Las Vegas Hotel. The name may have seemed out of place to those passing through, but locals knew that proprietor Charlie Dammer paid for the construction with silver dollars won in a lucky streak in Las Vegas, Nevada.

On his 1946 odyssey, Jack Rittenhouse notes that Halltown, population 168, consisted of "15 or 20 establishments that line

When You Go

Join State Highway 266 at exit 72 on Interstate 44 west of Springfield. Continue west to Spencer and the junction with State Highway 96. Highway 96 continues to Avilla.

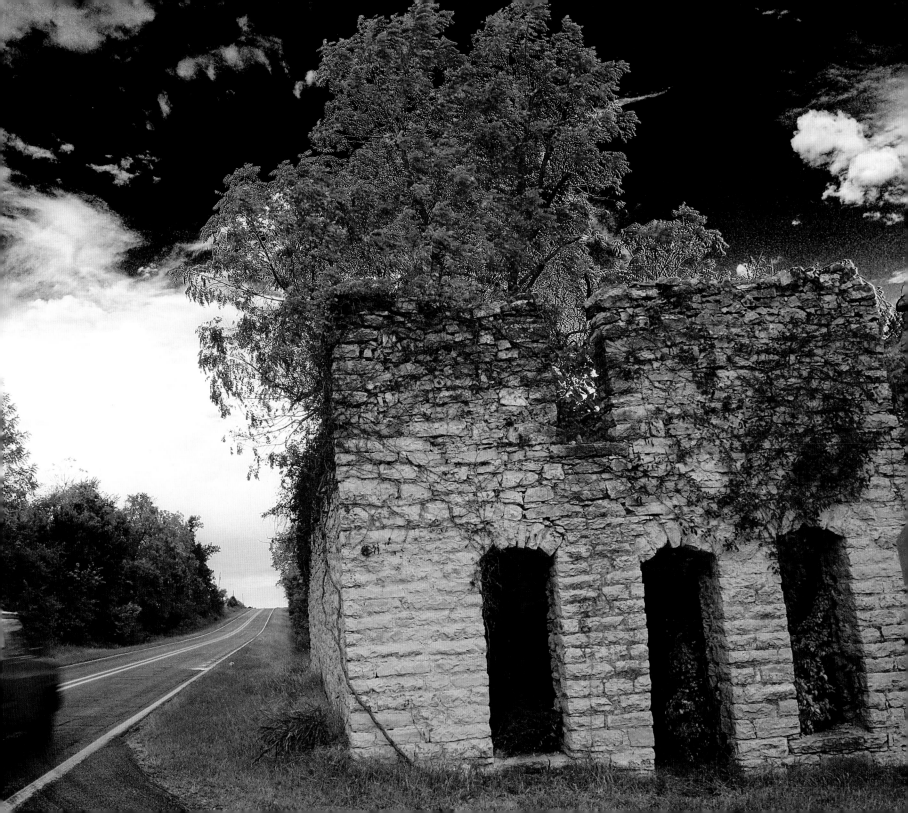

The Whitehall Mercantile, now an antiques shop, has cast a shadow across the road for more than a century.

both sides of the highway here: gas stations, cafes, antique shops, stores." Today, traffic still flows through town on State Highway 266 but not in volume enough to support the businesses noted by Rittenhouse. Even with the resurgent interest in Route 66, Halltown slumbers.

The stunning time capsule that is the refurbished Gay Parita Garage and Sinclair station dominates Paris Springs Junction. Many modern maps inadvertently list this as Paris Springs even though the site of the town founded in 1870 that lent its name to the junction is actually a half mile north of this intersection.

Name changes and confusion over them are merely part of the colorful history of the site. The first settlement, called Chalybeate

DON'T MISS

The Halltown Cemetery, also known as the Rock Prairie Cemetery, is a somber place that invites reflection amid the monuments under ancient trees. The cemetery dates to about 1840 and, during the Civil War, was used by both Confederate and Union forces.

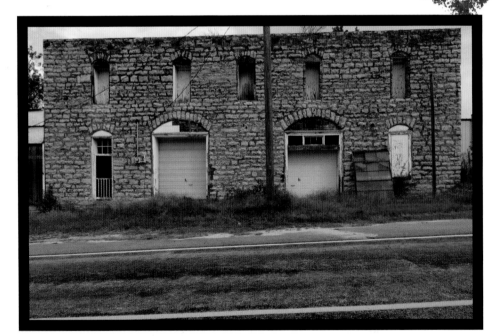

The remnants from Halltown's glory days, such as this stone duplex, stand in silent testimony to more prosperous times.

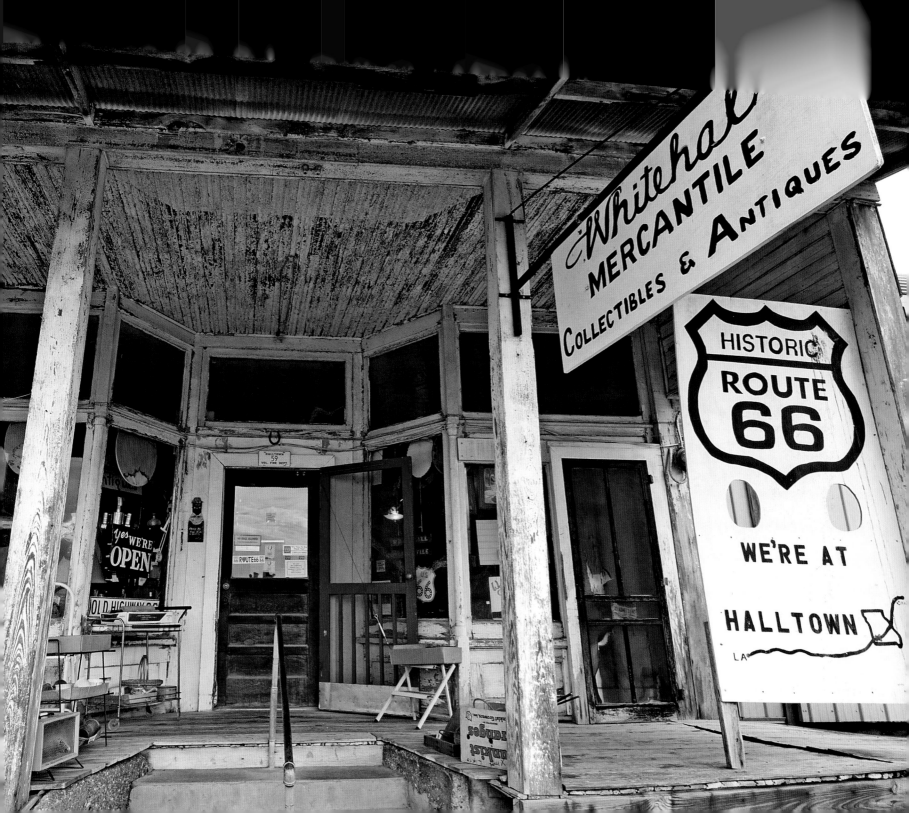

Springs, became Johnson Mills after O. P. Johnson of Cherry & Johnson established a mill to grind flour and cornmeal, as well as a chair factory, a sawmill, and a wool mill on Clover Creek.

By 1872, when Eli Paris opened a spa and hotel to capitalize on the purported healing powers of the mineral-rich springs, the town also sported a wagon manufacturing enterprise and a profitable blacksmith shop. The spa led to the next and final name change.

When the newly built Route 66 bypassed the fading little community by half a mile, a number of entrepreneurial-minded citizens opened businesses at the junction—and Paris Springs Junction was born. This proved to be the death knell for Paris Springs, and today, very little remains to mark the site.

One of the first buildings raised at the intersection was a cobblestone-faced garage, followed four years later by a Sinclair station. Business was brisk at the Gay Parita Garage, and in the years that followed, owners Gay and Fred Mason added a small café and several cabins. But all good things must end, and for the Masons and Paris Springs Junction, the beginning of the end came in 1953 with the death of Gay and, two years later, the destruction of the Sinclair station by fire.

The decommissioning of Route 66 and the bypass by Interstate 44 completed the first chapter of the building's history. Unlike many properties along the old double six, however, the Gay Parita Garage and even the old Sinclair station received a new lease on life with the acquisition of the property by Gary and Lena Turner.

Doolittle

West of Rolla, at the intersection of County Road T, is a well-worn wide spot in the road designated by a sign as Doolittle. Jack Rittenhouse notes in his 1946 guidebook that Doolittle is "a community loosely strung along about two miles of highway."

Counted among the services strung along the road was Ramsey's Garage. The 1946 edition of the AAA *Service Station Directory* lists this as the only recommended repair facility.

Originally called Centerville, the community found itself in the international spotlight for but a moment on October 10, 1946. That was the day Medal of Honor recipient General Jimmy Doolittle landed his plane on the eastbound lane of U.S. 66 to attend the ceremony in which the town was renamed in his honor.

Under the Turners' careful stewardship, the store and café are now a residence, with the front façade appearing as it did during the 1930s. The garage and resurrected Sinclair station are carefully replicated time capsules providing a rare opportunity to step back into the world of Route 66 motoring, circa 1930.

The last vestiges of empty little Spencer—the next town to the west that was bypassed by the realignment of 1961—are carefully preserved in a state of arrested decay by the current owners, the Ryans, who have plans of refurbishing the property. The emptiness of Spencer is both comforting and haunting, feelings enhanced by lush landscapes framed by the 1923 steel pony bridge over Turnback Creek and the 1926 truss bridge over Johnson Creek.

The ghostly buildings that cast shadows over Route 66 date to the teens and early twenties, including the former café, barbershop, garage, and service station built by

The attention to detail in the Paris Springs Junction station re-creation results in an almost flawless time capsule from when legendary 66 was the Main Street of America.

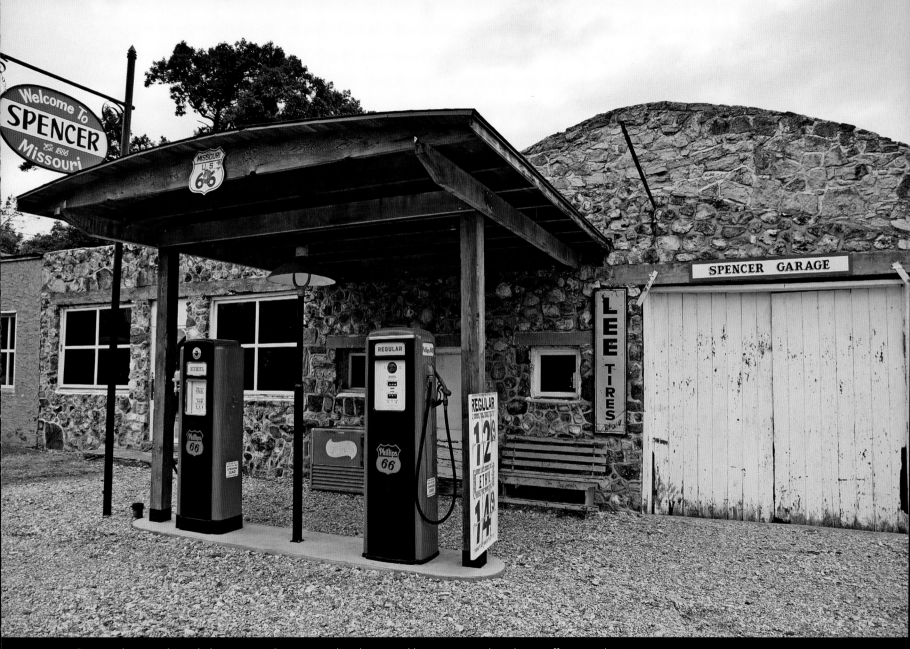

Dating to the 1920s, the roadside remnants in Spencer are relatively recent additions in a town where the post office opened in 1868.

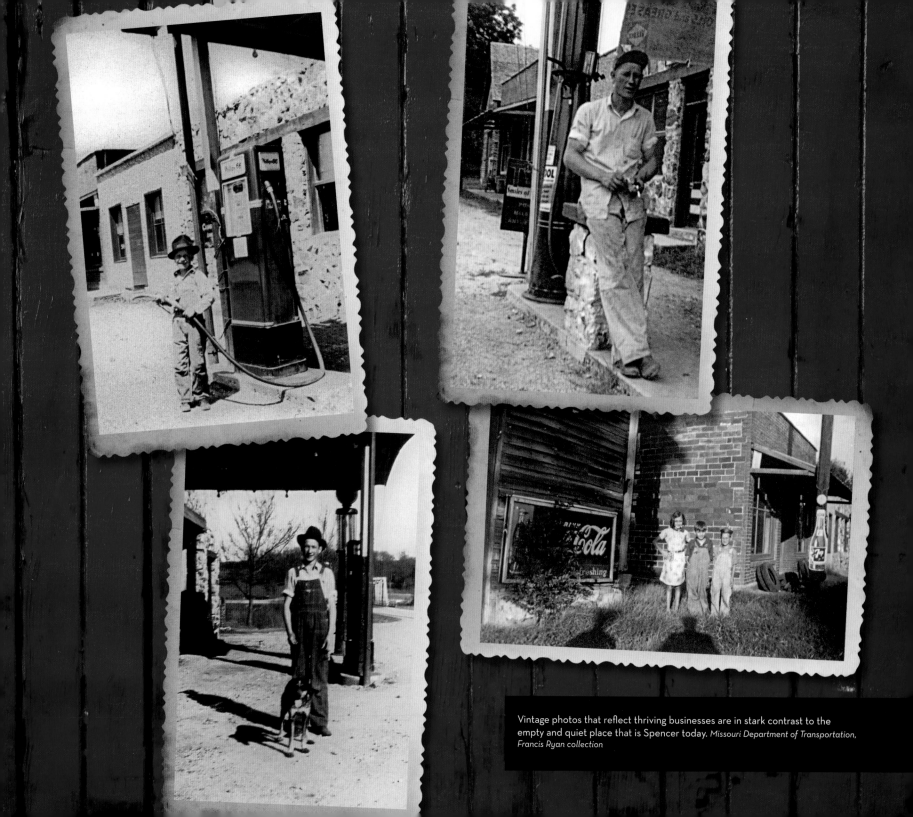

Vintage photos that reflect thriving businesses are in stark contrast to the empty and quiet place that is Spencer today. *Missouri Department of Transportation, Francis Ryan collection*

Sidney Casey in 1925 and 1926. However, the town itself predates the remaining structures by decades, with the first post office opening in 1868.

Heatonville also dates to 1868 and the platting of a town site by Daniel Heaton. Albatross, established the same year Route 66 was designated (1926), began as a bus stop for the Albatross Bus Lines. By the 1950s, it had morphed into a service hub with six gas stations.

Phelps, named for Colonel Bill Phelps, an attorney for the MoPac Railroad, predates the Civil War with a post office that opened in 1857. During the infancy of Route 66, travelers could avail themselves of a wide array of services, including a café, a barbershop, a boardinghouse, a service station, a restaurant, and cabins.

Mr. and Mrs. Roy Rogers (no relation to the famous cowboy duet, who had a ranch along Route 66 near Victorville, California) put Rescue on the map for Route 66 motorists in the 1920s with a lodge, cabins, and a service station. This facility was later known as Reed's Cabin Court and today survives in part as a private residence.

Officially, Plew dates to 1893, but settlement in the area began at least fifty years earlier. Today, it is not much larger than the dot on the map that represents it.

These small villages are now even less than the wide spots in the road they once were. Rittenhouse notes in his 1946 travel guide that Heatonville offered the services of garages, groceries, gas stations, a general store, and Castle Rock Cabins. The business district in Albatross consisted of a garage, several gas stations, and Carter's Cabins. Phelps had gas stations, a café, a few houses, and "two very old store buildings." Rescue was "a small village" with Brown's Garage, Rescue Garage, and Reed's cabins.

From Springfield to Avilla, a wide array of remnants and ruins dot the roadside, standing in mute testimony to this history. This is Missouri's ghost town trail, where the vestiges of the modern era seem oddly out of place.

DON'T MISS

Missouri contains a veritable treasure-trove of roadside artifacts and towns that hover somewhere between resurrection and obscurity induced by abandonment. Amply sprinkled among these are true time capsules, such as the recently refurbished circa-1934 Wagon Wheel Motel in Cuba and Meramec Caverns, a classic roadside attraction.

To cruise Route 66 through Hooker Cut and over the 1923 Big Piney River Bridge at Devil's Elbow or grab a snack at the Circle Inn Malt Shop in Bourbon is to discover the very essence of the Route 66 experience. To cruise Route 66 from St. Louis to Joplin is an opportunity to experience a ghost highway where the past is never very far removed from the present.

The forest slowly reclaims businesses and homes alike, transforming the landscape into one not seen in Avilla since the Civil War.

AVILLA

INDICATIVE OF THE SLOW-MOTION slide to oblivion that marks Avilla's past century is a population that today numbers around 120, compared to the 500 who resided here in 1874. Nestled in a rich agricultural district, the town began as a business and trade center established on the western fringe of the Ozarks in 1856.

On October 28, 1861, Governor Jackson met with the Missouri General Assembly in Neosho and declared Missouri the twelfth state to join the Confederate States of America. Upon hearing the news in Avilla, a group of leading men gathered in the park to hoist the stars and stripes of the United States. To defend their homes and farms from Confederate raiders and guerillas, Dr. J. M. Stemmons organized a militia that consisted of men deemed too old to serve in the military. On March 8, 1862, the reserve of this stalwart group was put to the test when a group of Confederate raiders under the leadership of William T. "Bloody Bill" Anderson moved on Avilla.

Killed in the ensuing action were Dr. Stemmons, three of his sons, and at least two Avilla militiamen, but Avilla was spared the fate of Carthage, which was almost erased from the map in a skirmish. In the late summer of 1862, the Union Army took possession of the area, headquartered in Avilla in 1863, and authorized the local militia to patrol portions of Jasper and Lawrence counties.

Spared much of the destruction that neighboring communities experienced during the war, Avilla became a boomtown at the center of postwar reconstruction. By the early 1870s, the town supported boot stores and a cobbler, several dry goods stores, grocers, livery stables, a drugstore, doctors' offices, and several attorneys. The town also had a school, three churches, an Odd Fellows Lodge, and a Freemasons Lodge.

The railroad that connected Springfield with Carthage and Joplin bypassed Avilla, and the town began a slide only briefly interrupted by the flow of traffic on Route 66, which sparked a resurgent growth in new businesses. Rittenhouse notes that the population in 1946 was 178 and that the town consisted of "Gas, café, stores. The lumber yard and farm implement stores here indicates its importance as agricultural trading and supply center."

By the late 1970s, a decade after Interstate 44 replaced Route 66, Avilla was a ghost town. Just a few businesses remain in operation. Vacant lots now outnumber buildings, but the structures that remain are most interesting. The most notable is the bank building, built in 1915 and now serving as the post office, one block north of former U.S. 66.

When You Go

Avilla is located on State Highway 96 several miles west of Plew.

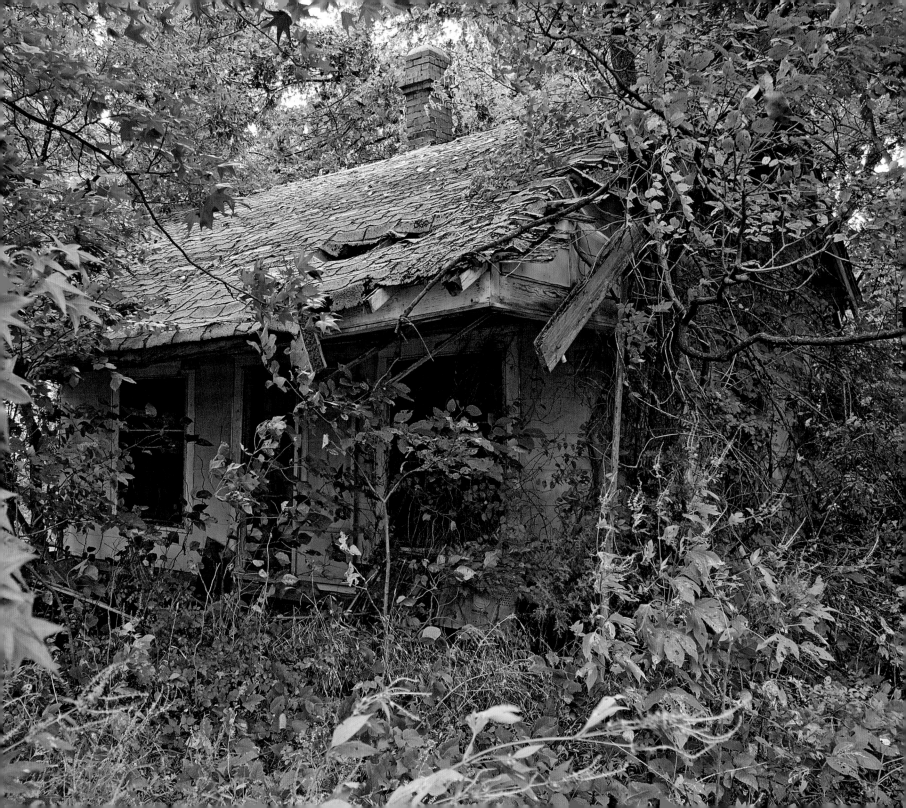

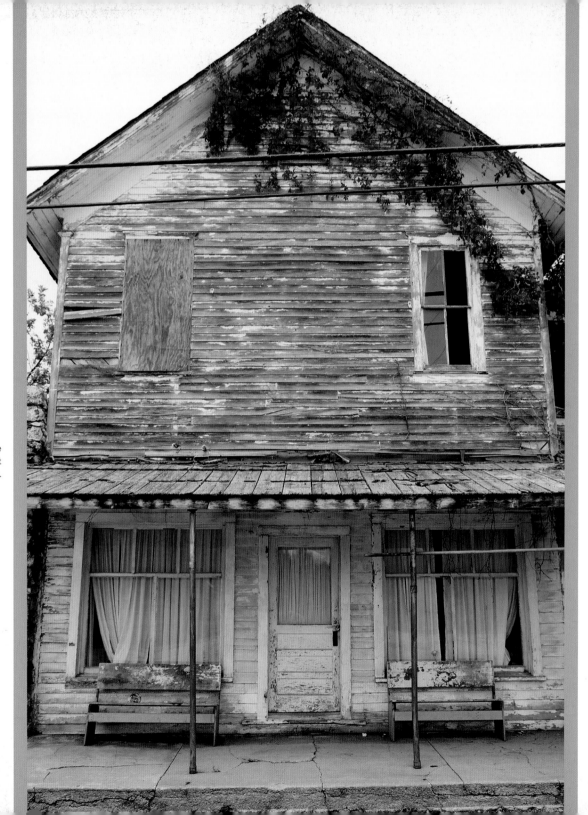

Hints of better times abound in the weathered façades and overgrown vacant lots of Avilla's business district.

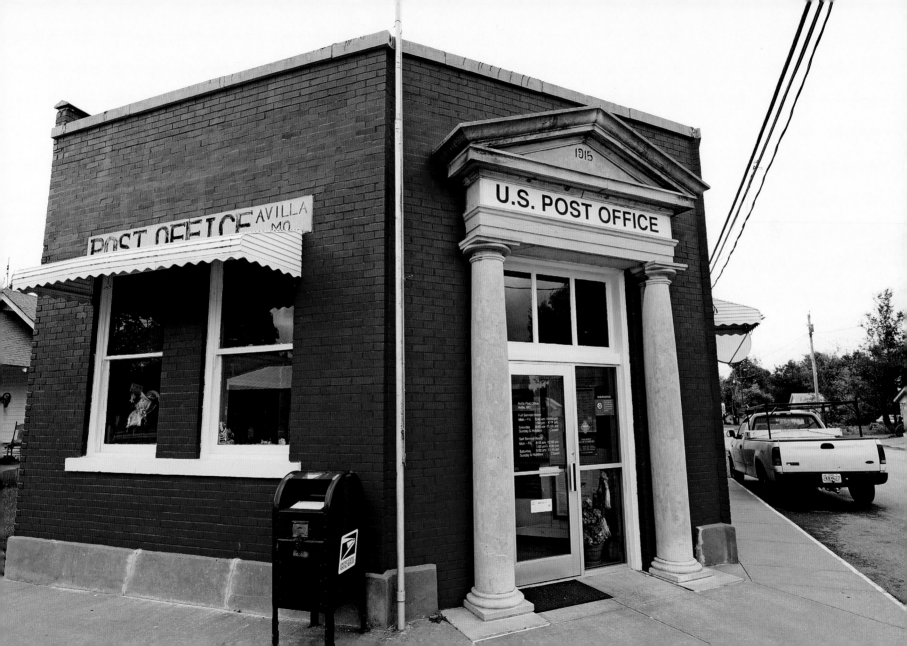

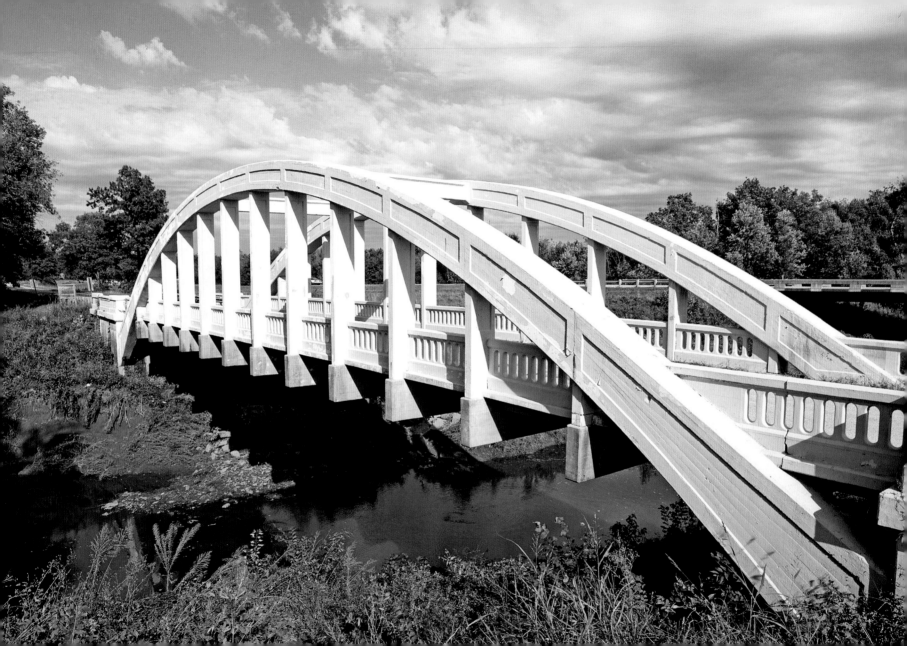

KANSAS

Kansas may lay claim to less than fourteen miles of Route 66, but there is pride in every mile of that association.

IT MIGHT SEEM ODD to include Kansas in a book about ghost towns found along Route 66. After all, less than fourteen miles of Route 66 run through this state. Though the three towns along this section of highway are quite historic, only two have sizable populations. Still, Galena (population 3,168), Baxter Springs (population 4,344), and Riverton (population 600) are key components in the story of Route 66. They are also shadows of the boomtowns that they once were.

Even a vintage Chevy truck seems oddly modern when viewed against the backdrop of century-old buildings with towering façades in downtown Galena.

JUST ONE MILE FROM the Missouri state line lies the site of the Eagle-Picher Smelter, once a leading producer of lead and the location of yet another bloody chapter in the history of U.S. 66. It was here in 1935 that a strike was led by John L. Lewis, the union boss of the United Mine Workers.

For a short period, striking miners blocked the highway. Cars that failed to heed their demand to stop were pelted with stones, rock salt, and even bullets. Targets of even more violent attacks were the carloads of "scabs" from Missouri who dared to run the gauntlet for employment during the hard times of the Great Depression.

Under order from Alf Landon, governor and presidential candidate in 1936, the National Guard arrived in Galena to quell the violence. The murder of nine men at the headquarters of the International Mine, Mill, and Smelter Workers Union office in Galena marked the culmination of this violent chapter on April 11, 1937.

At its peak, the estimated population of Galena was more than fifteen thousand. Remnants from its mining boomtown

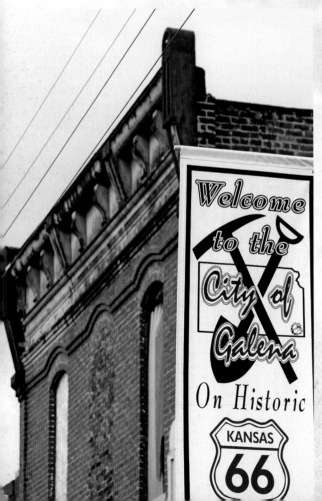

When You Go

From Galena, drive west on State Highway 66. At the junction with U.S. 69A, continue west on Beasley Road. Follow the well-marked route of U.S. 66, with a slight detour across the scenic and historic 1923 Marsh Rainbow Arch Bridge, south to Baxter Springs.

A colorful banner proclaiming Galena's rich heritage adds contrast to a weathered brick façade that predates the highway by decades.

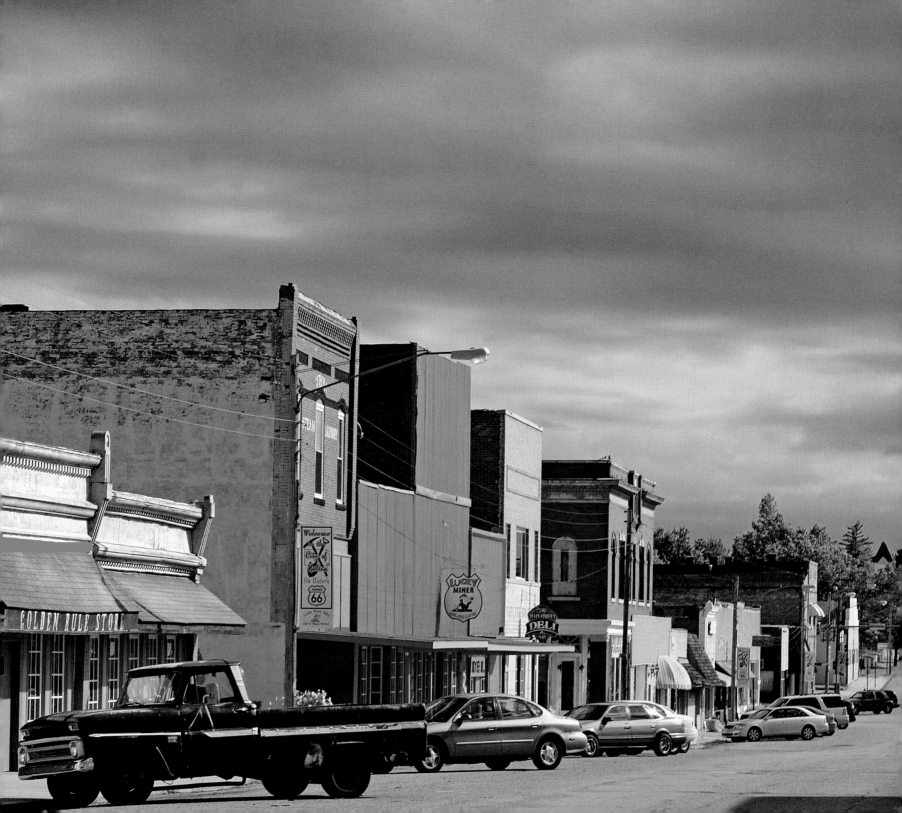

days—and the era when Route 66 served as the town's main street—abound.

For Route 66 enthusiasts, one of the crown jewels is 4 Women on the Route. This former Kan-O-Tex gas station has been lovingly restored and transformed into a snack bar and gift shop, where the essence of travel on Route 66 circa 1960 is preserved for future generations.

In his 1946 work, Jack Rittenhouse notes that Riverton, to the west of Galena, consisted of a gas station, "limited facilities, and Jayhawk Court." Today, it is the circa-1925 Eisler Brothers Grocery and Deli that ensures Riverton remains on the map. However, this store closed in 2010, and it is uncertain when and if it will reopen.

Baxter Springs contains numerous historic sites. Two of the gems found here are the Route 66 Visitor Center, housed in a restored 1930s-era Phillips 66 station, and Café on the Route and the Little Brick Inn, occupying a former bank robbed by Jesse James in 1876.

The history of Baxter Springs is a lengthy and colorful one. The modern era begins with the arrival of John Baxter and his family from Missouri, who established an inn and general store on the Military Road at a spring on Spring River in 1849.

The springs figured prominently in a heinous massacre in 1863. The Confederate Quantrill's Raiders, led by guerilla fighter William Quantrill, attacked a garrison of Union troops defending a small fortification at Baxter Springs. The raiders then turned their attention to a military convoy led by Major General Thomas Blunt. After a brief

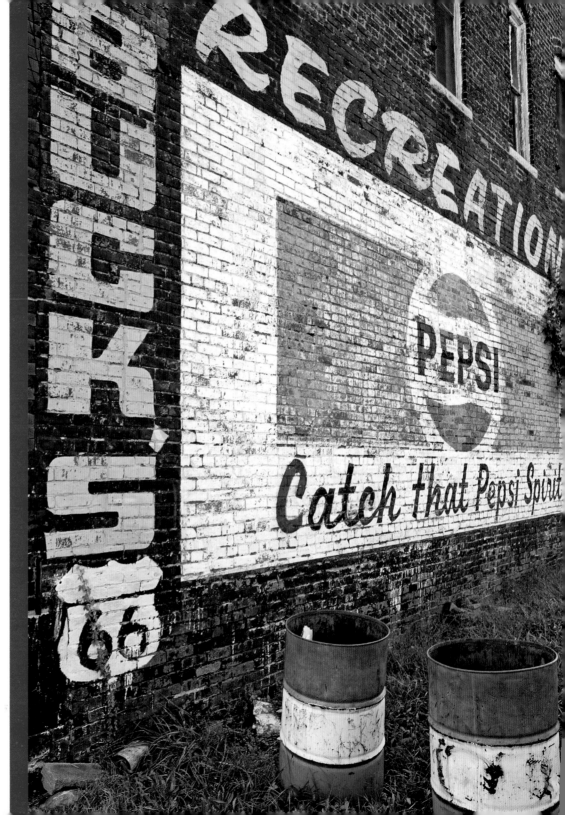

Ghost signs and future ghost signs add a timeless touch to the weathered brick walls in Galena.

skirmish, Quantrill called for the surrender of Blunt and his men. Upon compliance, the raiders fired upon and killed may of the unarmed men.

By 1868, the year Baxter's Place incorporated as Baxter Springs, the town was on the fast track to becoming a metropolis on the Western frontier. Growth was fueled by Texas cattlemen who drove their herds north along the Shawnee Trail to fulfill the demand for beef in northern markets. The completion of the Missouri River, Fort Scott & Gulf Railroad also made Baxter Springs a key shipping point.

Spared the decline that afflicted many cattle towns when beef prices collapsed, Baxter Springs morphed into a resort community built upon the reported curative

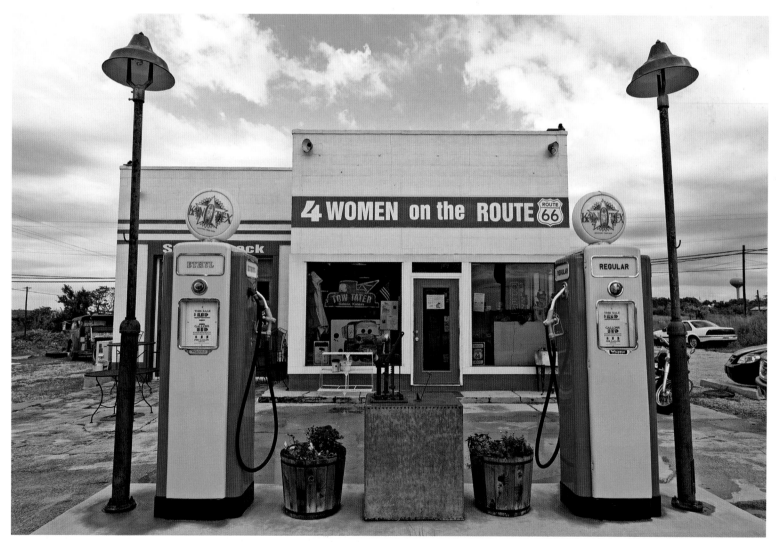

A carefully restored Kan-O-Tex service station in Galena is now home to 4 Women on the Route, a delightful combination gift shop and snack bar.

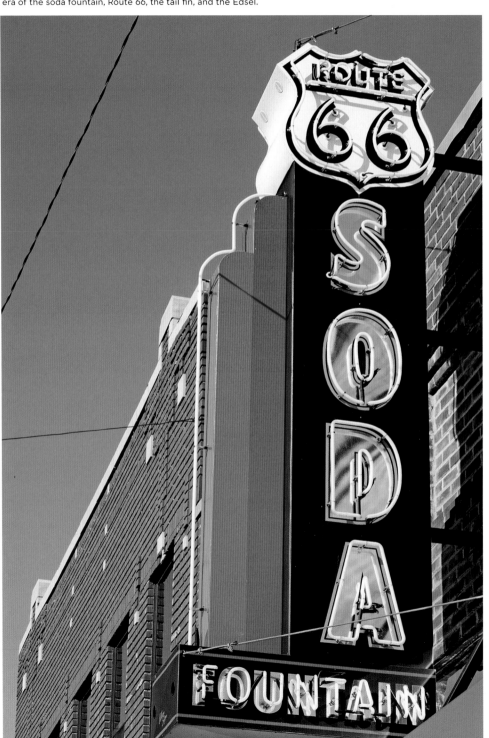

In Baxter Springs, re-created neon signage encapsulates the colorful era of the soda fountain, Route 66, the tail fin, and the Edsel.

powers of its namesake springs. The next transformation came with the discovery of rich deposits of lead and zinc in the immediate area as well as in nearby Oklahoma and Missouri.

The final boom came with the establishment of Route 66 and the transformation of Baxter Springs into a major service and transportation center. At one point during the late 1950s, five national trucking companies had yards here, and one major freight company established its eight-state maintenance yard and shipping point here.

Today, Baxter Springs is a large and busy ghost town, where the past haunts the present with dusty remnants of better times. It is also a faded snapshot of small-town America from the era when Mickey Mantle was the pride of the local team, the Baxter Springs Whiz Kids.

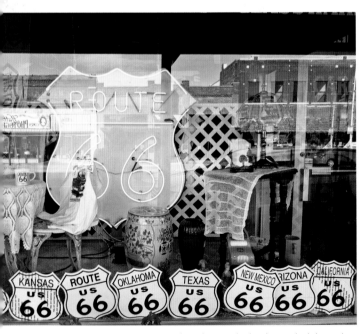

Can there be any doubt about which legendary highway this café fronts in historic Baxter Springs?

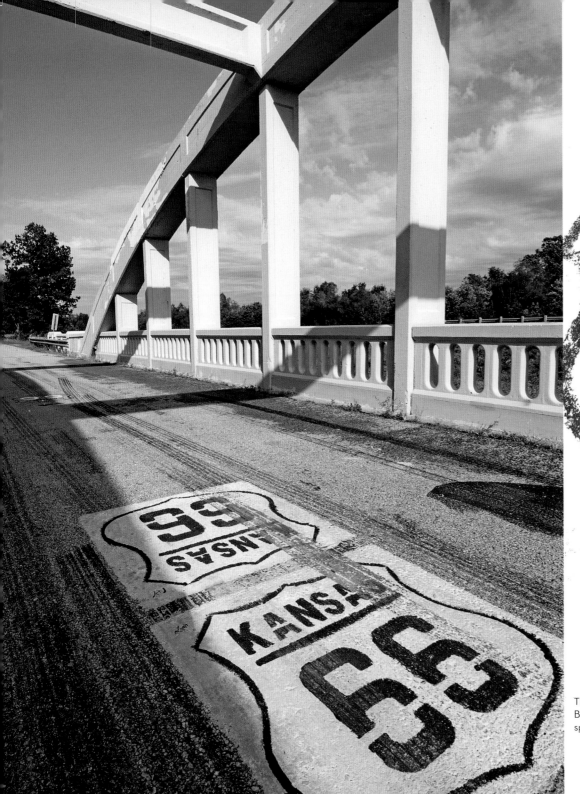

DON'T MISS

The scope of exhibits at the Galena Museum, housed in the old depot at 319 West 7th Street, is nothing short of extraordinary. A stop can easily consume an afternoon. In addition to massive displays that include a military tank, a switchyard engine, and a caboose, there is also an excellent display of ore samples as well as an extensive series of displays chronicling the town's rich history.

The lovely Rainbow Bridge over Brush Creek, between Galena and Baxter Springs, is the last of three Marsh Arch bridges that once spanned creeks on Route 66 in Kansas.

OKLAHOMA

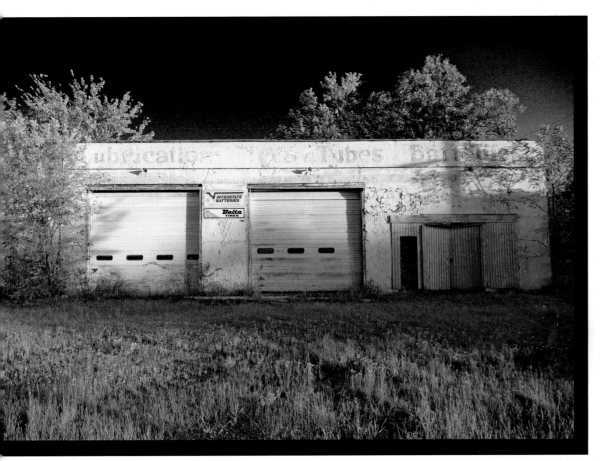

Vestiges of better times attest to the slow-motion slide toward abandonment that has been the story of Afton since Route 66 retired from its role as Main Street of America.

FROM THE KANSAS STATE LINE to Texola, Oklahoma, a cornucopia of dusty little towns line Route 66. All have surprising and colorful histories. A few hover at a point between being the busy centers of commerce they once were and becoming ghost towns, but only a few have withered to near complete emptiness.

In each of these towns, there is a common theme: With the arrival of Route 66, coffee shops and truck stops replaced the saloons and cattle yards of boisterous cow towns, and motels and service stations replaced the hotels and blacksmith shops of territorial-era farm towns. With the never-ceasing flow of traffic diverted from the main street to the super slab, businesses closed, and people moved on in search of opportunity. The elements, as well as vandals, then transformed homes and once-prosperous businesses into picturesque ruins that predate neon or the liberating contribution of Henry Ford and his Tin Lizzie.

AFTON AND NARCISSA

NARCISSA, A FORMER FARMING community named after Narcissa Walker in 1902, was the proverbial wide spot in the road when Jack Rittenhouse rolled through in 1946. He notes, "Only one establishment on US 66: a gas station with a grocery and small garage."

Even though Afton had a population of more 1,200, Rittenhouse does not have much more to say about this town than he does Narcissa: "Baker's Café, Northeast Garage, and Eagle Service Station garage; Acme Court." Afton is another one of those places on Route 66 that do not fit the general ideal of what a ghost town should be unless viewed in the context of what once was there—or with a slow drive through

town on Route 66. It teeters on the brink of revival and continued decline.

Bassett's Grocery, after serving the community for more than half a century, closed in 2009. The 1911 Palmer Hotel, its café, the old Pierce & Harvey Buggy Company, and the Avon Court and Rest Haven motels are now all empty.

Farming played an important role in the economy of Afton, but it was the railroad, and later Route 66, that gave it vitality. According to George Shirk, an Oklahoma historian, it was also the railroad that indirectly gave the town its name.

Shirk asserts the name was bestowed by Anton Aires, a Scottish railroad surveyor, as a monument to his daughter, Afton Aires. Moreover, the Afton River in Scotland was the inspiration for the naming of his daughter.

Growth in Afton was slow but steady. The post office opened in 1886, and by 1900, the population had surpassed six hundred. A decade later, the population had doubled; the Kansas City, Fort Scott & Memphis Railroad had constructed a second line through town; and Afton was on the fast track to a very promising future. This trend continued through the teens. By that time, the town supported a large waterworks, a brick and tile plant, a creamery, several mills and grain elevators, two banks, two hotels, and a newspaper.

For a town heavily dependent on the railroad and agriculture, the post–World War I collapse of wheat, corn, and beef prices was devastating. Between 1920 and 1930, the population dropped by almost 20 percent.

Association with Route 66 did not ensure prosperity for a community, as evidenced by Narcissa, a town that in 1946 consisted of a combination gas station/grocery store/garage, a school, a grain elevator, and a few dozen homes.

In 1926, a ray of hope, signed with a shield and two sixes, shone on Afton. Service-related industries—from motels and gas stations to garages and attractions, such as the once legendary Buffalo Ranch—infused the economy with a vitality that lasted for decades. Adding to this new era of prosperity was the completion of the Pensacola Dam in 1940, which created the Lake O' Cherokees.

With the suspension of railroad repair in Afton in the late 1930s and the completion of Interstate 44, which left the town isolated on a forgotten stretch of highway, hard times returned to the town. Demolition of the roundhouse and turntable, closure of motels and cafés—all were symptomatic of a town in decline. But it was closure of the iconic Buffalo Ranch in 1997 that provided the clearest indication that Route 66 had been the lifeblood of this historic community.

Route 66 seems infused with a power to transform those who drive its broken asphalt and truncated alignments. In Afton, this transformation led Laurel and David Kane to purchase a defunct DX service station and give it new life as Afton Station, a time capsule that houses a vast collection of memorabilia and a collection of vintage Packards.

Afton Station epitomizes the new era of Route 66. As testimony to the passion and hard work of the Kanes, the business was recognized in 2009 as the Route 66 business of the year.

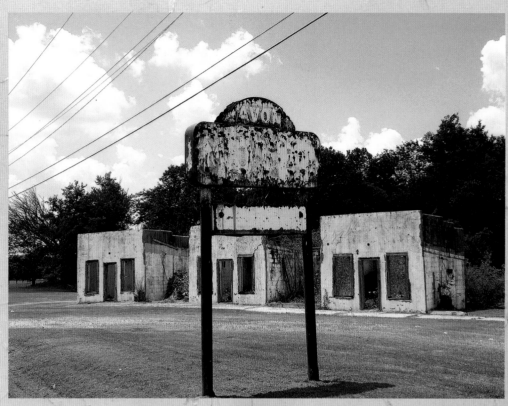

The empty cabins of the Avon Court Motel in Afton, Oklahoma, stand as silent monuments to the dream of John Foley, who established the facility in 1936. *Jim Hinckley*

When You Go

From Miami, drive south sixteen miles on U.S. Highway 69. For a one-of-a-kind Route 66 experience, inquire locally about the "Sidewalk Highway," an original section of Route 66 that was only nine feet wide! Narcissa has the distinction of being the only community on this unique alignment.

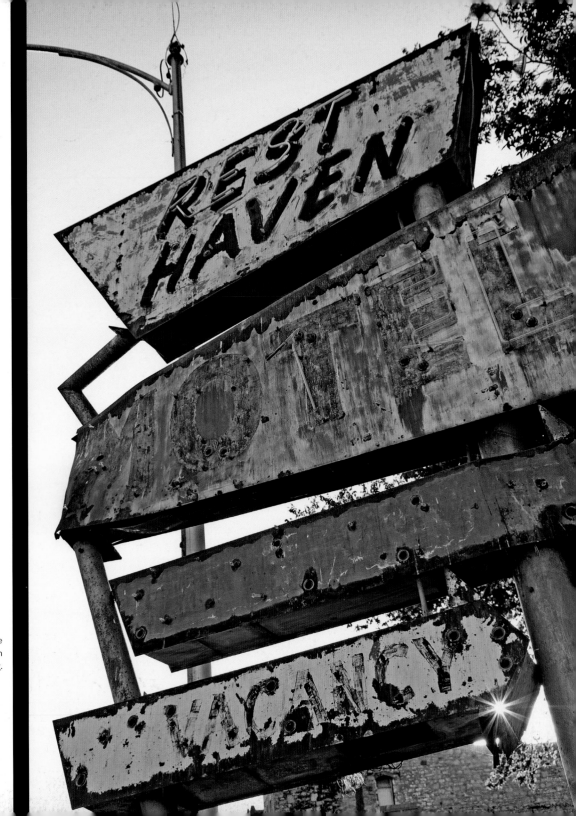

The faded glory of the Rest Haven Motel on the east end of Afton is reflected in its weathered sign stripped of its colorful neon tubing.

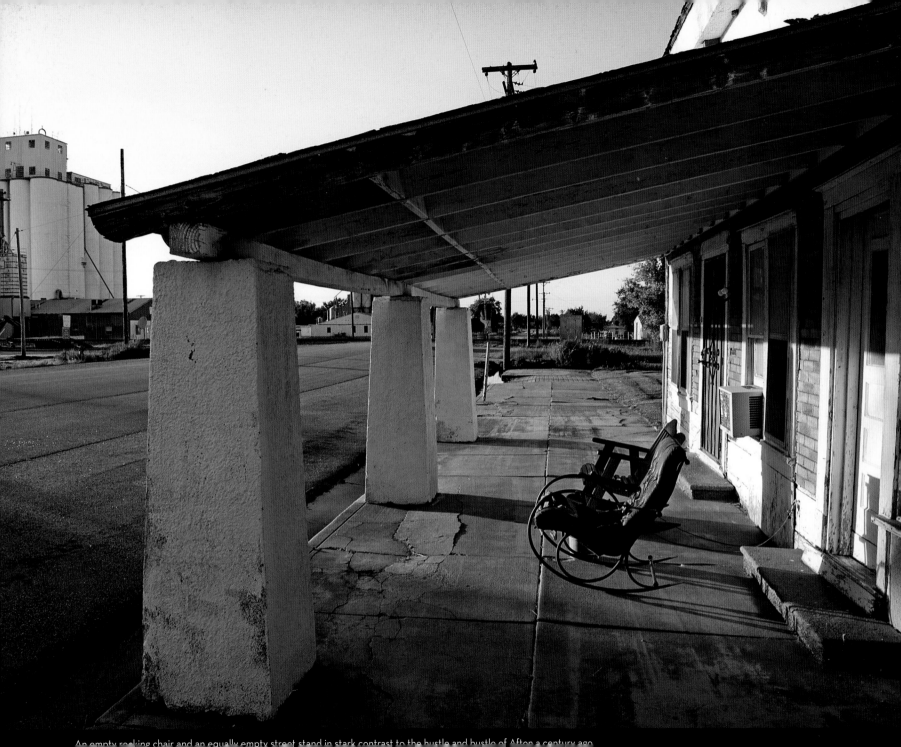

An empty rocking chair and an equally empty street stand in stark contrast to the hustle and bustle of Afton a century ago.

WARWICK

THE WELL-WATERED LANDS along Deep Fork River were what led David and Norah Hugh to homestead a farm, in 1891, on the site that would become Warwick. A collective of similar-minded farmers provided ample reason for the establishment of a post office in 1892.

In the early fall of 1896, the St. Louis & San Francisco Railroad purchased a right of way from Hugh. A second right of way was deeded, in 1903, to the Fort Smith & Western Railway Company, and in the same year a town site was platted and lots sold.

Indicative of the nature of the people who settled here, a solid, modern stone building, built in 1909, replaced the little log schoolhouse that had also served as a church. Reflecting the town's agricultural underpinnings, the business district during this period consisted of a blacksmith shop, a veterinarian, a general merchandise store, a sawmill, and a saloon.

From the late teens through the 1930s, meeting the needs of motorists enabled the small town to diversify its economic base. It can be said with a degree of certainty that the year 1940 was the best of times and the worst of times in Warwick. A new schoolhouse reflecting the town's optimism was built, the railroads that gave rise to the community went bust, and the Burlington Northern Railroad picked up the pieces but discontinued passenger service. Postwar, nearby Wellston began siphoning an increasing share of Route 66–related business. By 1968, the Warwick school was consolidated with the Wellston school.

In December 1972, the post office closed, and little Warwick was on the fast track to becoming a ghost town. Surprisingly, a few remnants survived into the modern era and, with the resurgent interest in Route 66, are now treasured souvenirs.

Topping the list is the historic Seaba Station, a former machine shop built in 1924 that expanded into providing other services, such as gasoline and automotive repair, after the certification of Route 66 in 1926. It is listed on the National Register of Historic Places, and in the summer of 2010, refurbishment to house an antique motorcycle museum was completed.

When You Go

Warwick is accessed from exit 157 on Interstate 44.

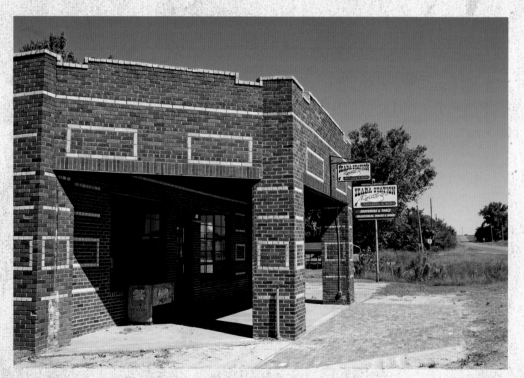

Built in 1921, the Seaba Station in Warwick now appears on the National Register of Historic Places and is being refurbished as a motorcycle museum.

As evidenced by this stately old home, the historic Seaba Station is not the only hint that Warwick was once a prosperous community with a promising future.

END OF THE ROAD

A BRIDGE GAVE RISE TO BRIDGEPORT, and a bridge led to its demise and abandonment. The town was born on the South Canadian River at the site of a stage crossing. The Rock Island Railroad established a work camp and built a bridge in 1891, and the site quickly morphed into a respectable little town.

On February 20, 1895, a post office established at Bridgeport gave the residents a sense of solidity and a promising future. The first decades of the new century did little to dampen that enthusiasm.

The postal road through Bridgeport became a primary roadway for early motorists traversing Oklahoma, and in 1917, this route was absorbed into the Ozark Trails network. Spearheading this important development were business owners in nearby Geary, who assembled their own road crew, improved the road to the river, and negotiated with George Key of the Postal Bridge Company in Oklahoma City for the construction of a permanent bridge at Bridgeport.

The resultant suspension bridge built a mile north of Bridgeport in 1921 furthered Bridgeport's prominence. The tolls charged were steep: one dollar for automobiles, a quarter for horse and rider, ten cents per head of livestock. Because this was the only dependable crossing in the area, the fees were paid, but not without complaint.

In 1926, the Key Bridge was incorporated into the U.S. highway system and became the Route 66 crossing of the South Canadian River. With the purchase of the

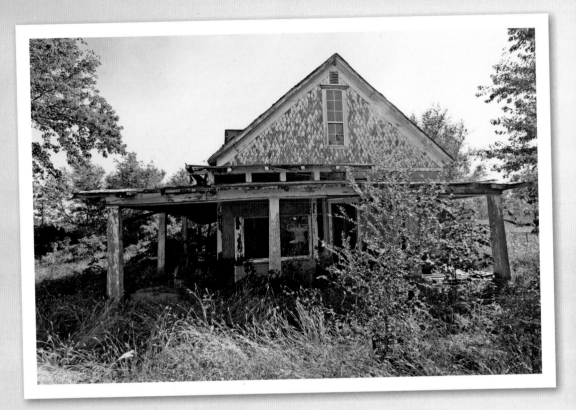

bridge by the state of Oklahoma in 1930, tolls were suspended.

The good times in Bridgeport ended in 1934 with the completion of a bridge on a realignment of the highway that eliminated the loop through Calumet, Geary, and Bridgeport. In an instant, Bridgeport became an isolated community severed from its primary source of revenue, traffic on Route 66.

The Key Bridge successfully met the needs of local traffic and survived for

another dozen years before a 1946 fire rendered it unusable. A salvage firm from Kansas City purchased the bridge and dismantled it in 1952.

Today, the last remnants from this often-overlooked chapter in the history of Route 66 are a scattering of abandoned homes and businesses and the rusty supports for the Key Bridge. However, Bridgeport is not a true ghost, since the town is still home to a handful of residents who value their privacy at the end of a lost highway.

When You Go

From Interstate 40, turn north on U.S. Highway 281 at exit 101 and turn west on old U.S. 66; the road is well marked. Continue west for a couple of miles, turn north on Market Street, and then turn right on Broadway to Main Street, where you turn left.

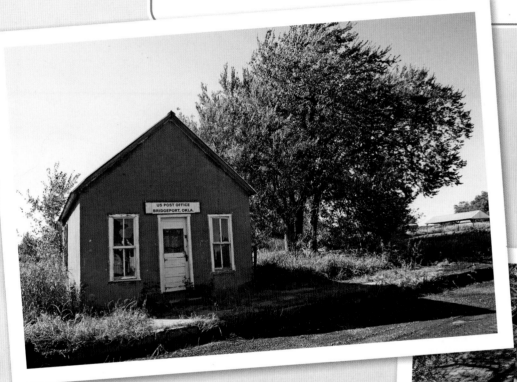

All three photos: The fast-vanishing links to Bridgeport's gilded age that dot the fields provide few hints it was once a town of importance.

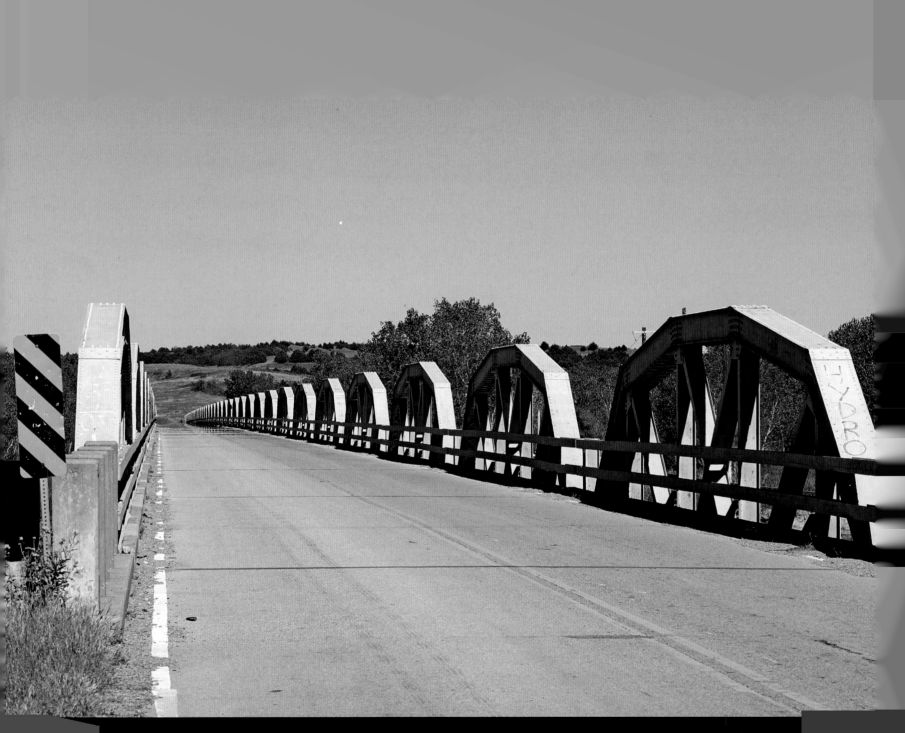

nadian River.

Engineering Time Capsule

The section of Route 66 between Hinton Junction and Weatherford is a perfect time capsule of Route 66 circa the mid-1930s. The concrete roadway is curbed here to divert rainwater that rolls across the hills, an antiquated highway engineering practice with few surviving remnants.

The thirty-eight span, 3,994-foot "pony" bridge across the South Canadian River that replaced the one at Bridgeport was a federal aid project that opened in 1934. At 3,944 feet, this was and is the longest bridge on Route 66 in Oklahoma.

Lucille Hamon's gas station and motel, just west of Hydro, is one of the most photographed sites on Route 66. Dating to 1941, the structure has changed little, and plans are in the works to refurbish the building in the near future.

Established in 1927, the property known today as Lucille's was operated by Lucille Hamon from 1941 to 2000. It is now listed on the National Register of Historic Places, and the original Hamon's Court sign is displayed at the Smithsonian Institute.

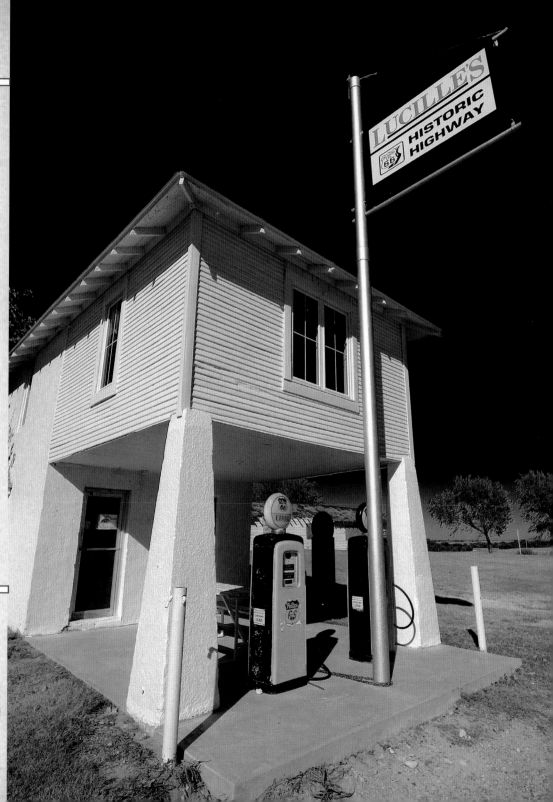

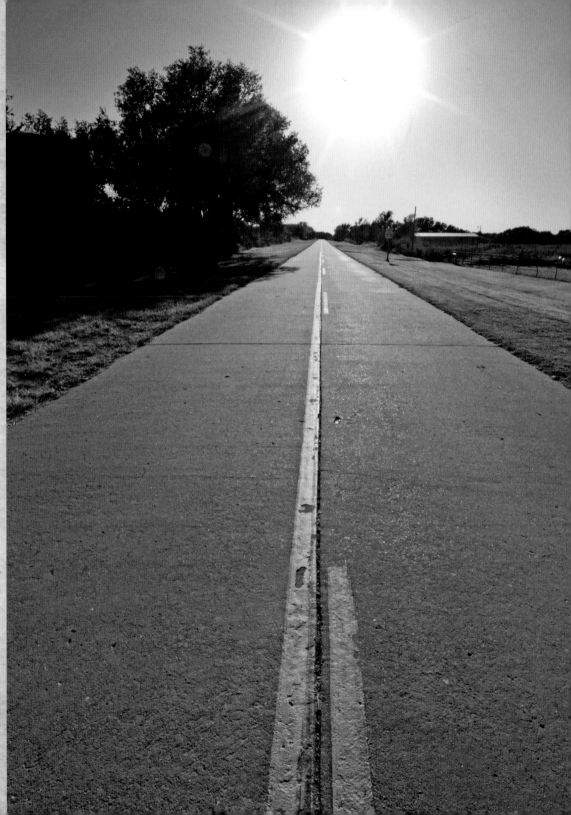

THE FIRST MANIFESTATION OF Foss—named after J. M. Foss, former postmaster in Cordell, Oklahoma, on Turkey Creek north of the present site—vanished with the flood of May 2, 1902. Relocating to higher ground, the residents rebuilt the town at the heart of a vast area of rich farmlands.

FOSS

By 1912, Foss was a prosperous and substantial community of stone buildings with a business district that included two banks, cotton gins, several general merchandise stores, a newspaper, a wagon works, a machine shop, drugstores, a bakery, a broom factory, and an opera house. At its peak, the population purportedly neared one thousand residents.

When You Go

At exit 53 on Interstate 40, turn north on State Highway 44.

Near Foss, Route 66 runs straight as an arrow to the horizon through a pastoral landscape unchanged in appearance since the town was a vital, thriving farming community.

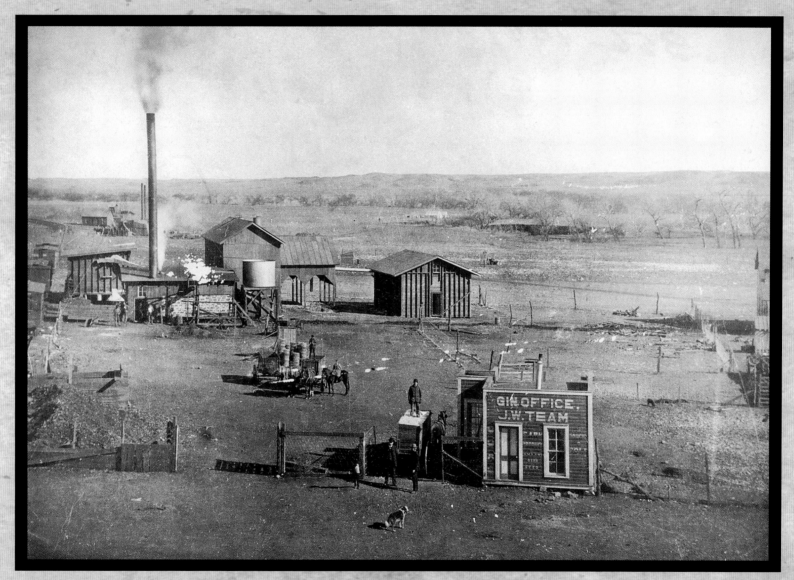

In 1900, the Foss cotton gin was one of the busiest enterprises in the area and an important component of the town economy.
Research Division of the Oklahoma Historical Society

A ghost sign on a weathered wall provides the faintest of hints as to what purpose an overgrown building once served in Foss.

The development of nearby Clinton and Elk City as rail and supply centers was the first blow to the town's economic stability. The population plummeted to 348 in 1920. Providing services to motorists on Route 66 partially stemmed the decline, but this was a short-lived reprieve, as collapsing agricultural prices and the drought that fueled the Dust Bowl spurred a second exodus.

For a brief moment in the early 1950s, with the establishment of an Air Force facility at nearby Burns Flat, it appeared Foss might experience a renaissance. But the closure of the base and the bypass of Route 66 by Interstate 40 sent the old town into a downward spiral. In 1977, the last bank closed for good.

Those who still reside in Foss adamantly deny the community is a ghost town. However, history, the ruins nestled in the brush, and broken sidewalks give credence to the descriptor. There are a few picturesque surviving structures of particular note, including a service station at the junction in a small grove of trees.

The old city meat market in Erick has found new life with the resurgent interest in Route 66 and is now the Sand Hills Curiosity Shop, owned by Harley and Annabelle Russell, better known as the Mediocre Music Makers.

SMALL TOWNS, BIG HISTORY

GHOSTS

that serve as tangible links to a time when this storied highway truly was the Main Street of America line Route 66 from Quapaw to Texola. Not as evident, however, is the rich history that was made along this route.

Lead and zinc in copious amounts may have been the most profitable exports from the Commerce area, but they were not the town's most famous contribution. That would be a baseball player with extraordinary talents by the name of Mickey Mantle.

Miami is home to the lovingly restored 1929 Coleman Theatre. The steel truss bridge spanning the Neosho River just west of town since 1937 was the last link in the paving of U.S. 66 in Oklahoma.

Vinita is the namesake of Vinne Ream, the sculptor who created the life-sized statue of the sixteenth president, Abraham Lincoln, that stands in the U.S. Capital building. This was also the first town in Oklahoma with electrical service.

Foyil was the hometown of Andy Payne, winner of the 1928 Bunion Derby, a transcontinental foot race from Los Angeles to New York that followed the entire length of Route 66.

Diminutive Kellyville was the site of the worst railroad disaster in Oklahoma history, a distinction earned when two trains collided west of town in 1917.

The town of Erick produced two legends of the American music scene: Roger Miller and Sheb Wooley. It is also the site of the 100th Meridian Museum, housed in an ornate bank building built long before the commissioning of U.S. 66.

Along Route 66 in Oklahoma, no town is too small to have a rich and colorful history. For the traveler, this means endless opportunities for discovery abound.

Stand quietly on the Texola pump island in a sea of grass, and on the breeze you can hear the clicking of the pump as it counts the gallons.

TEXOLA

TEXOLA, AS WITH GLENRIO ON THE WEST END of the Panhandle, suffers from a conflicted identity. Straddling the Texas/Oklahoma border, the tiny hamlet, founded in 1901, has been surveyed eight different times and, dependant on the survey, alternatively listed as being in Texas or Oklahoma. It is currently listed as an Oklahoma community one half mile east of the border.

The confliction of identity is also apparent in the various names it has had. At various times, maps show it as Texokla, Texoma, and Texola.

When You Go

Texola, accessed via exit 5 or exit 1, is south of Interstate 40.

The bright, colorful murals of Water Hole #2 in Texola seem out of place among the overgrown parking lots and weathered façades.

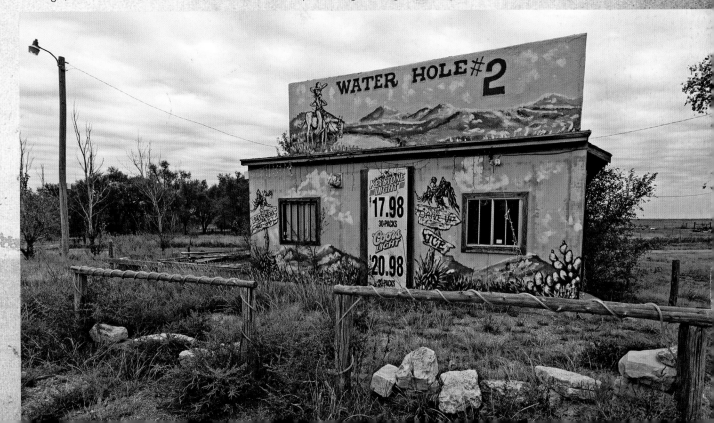

A humorous touch in empty Texola is the sign on the old roadhouse that says it all: "No Place Like Texola."

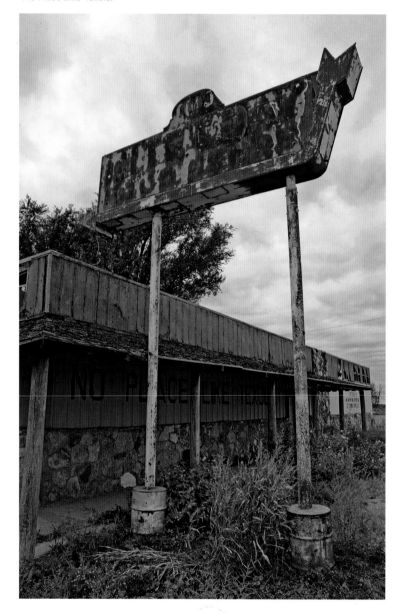

Change comes slow to the Western plains, and as late as the 1940s, the little village gave the appearance of being locked in a preterritorial time warp. Jack Rittenhouse notes this in his route guide: "gas, cafes; no courts; limited facilities. This sun baked small town has an old section of stores which truly savor of pioneer days. Notice them to your right on the town's one main cross street. They have sidewalk awnings of wood and metal, supported by posts."

Originally the lands here were ceded to the Choctaw tribe by treaty, but an 1896 Supreme Court ruling designated them a part of the territory of Oklahoma. Settlement in the area began in earnest in the 1880s. Establishment of the railroad at the turn of the century provided the accoutrements of civilization necessary for the establishment of towns on these plains.

Texola today is almost a pure ghost town, with a population counted in the single digits. This has kept the vandalism to a minimum, but the ravages of time are taking their toll, as evidenced by the shell of the WPA-era school nestled among the trees along Route 66.

Still, there is a wide array of remnants from better days, many of which bridge the gap between the days of the Western frontier and the glory days of Route 66. Counted among the former is the tiny stone territorial jail a few blocks north of Route 66 on the last street at the east end of town.

Sepia tones add an eerie, haunting quality to scenes of empty homes and shuttered businesses amid the prairie grass in Texola.

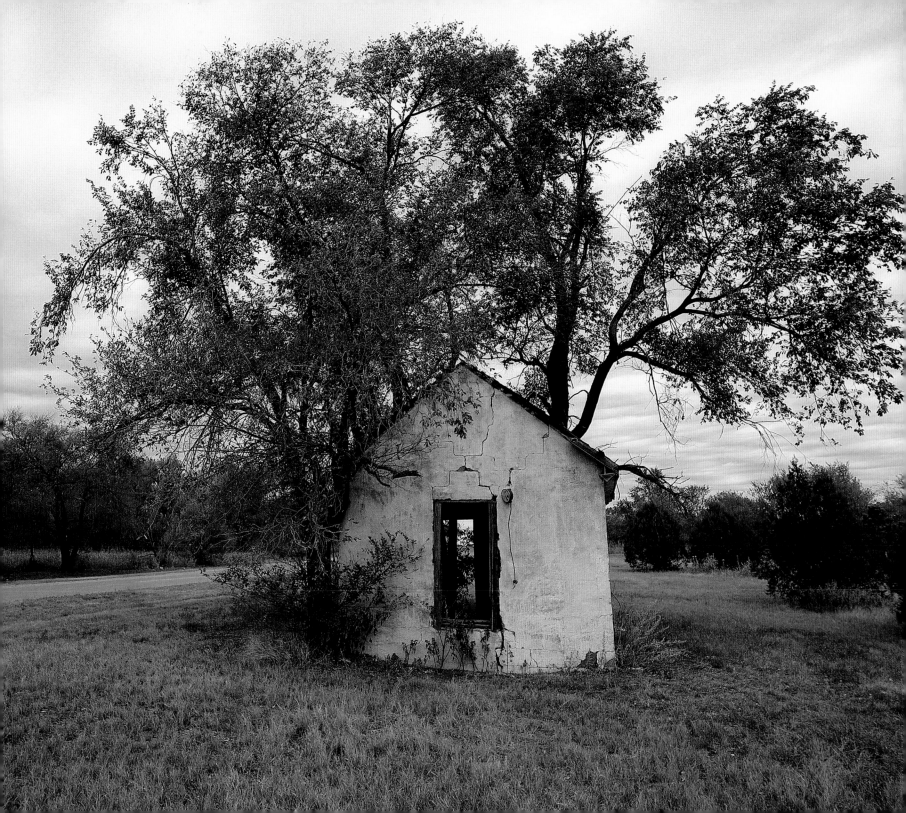

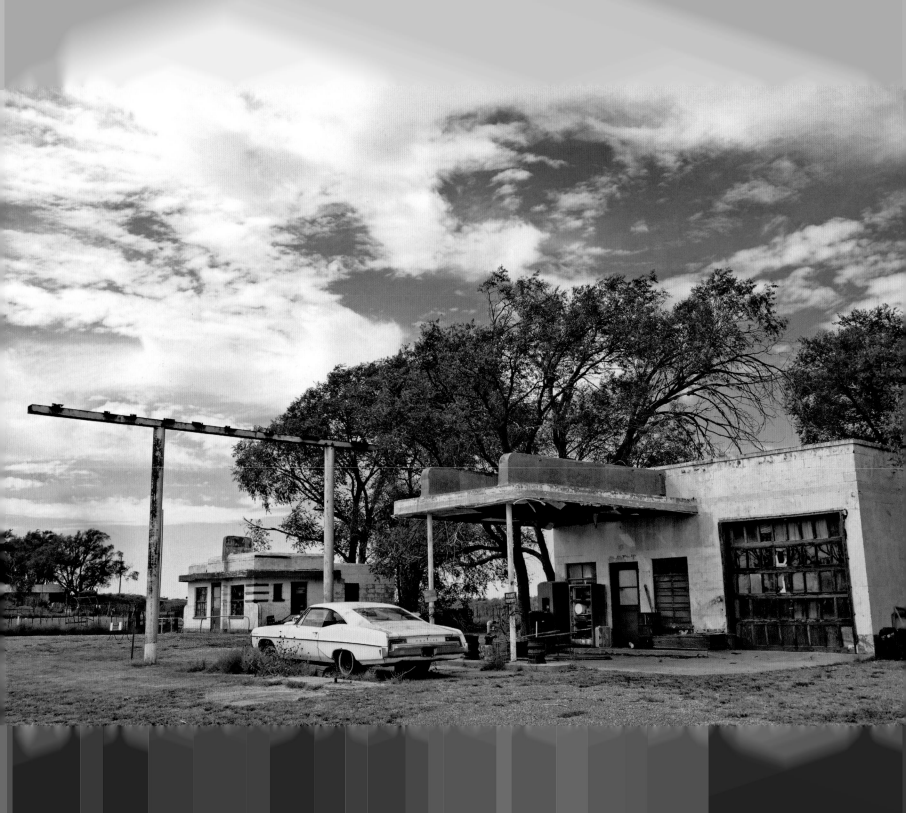

TEXAS

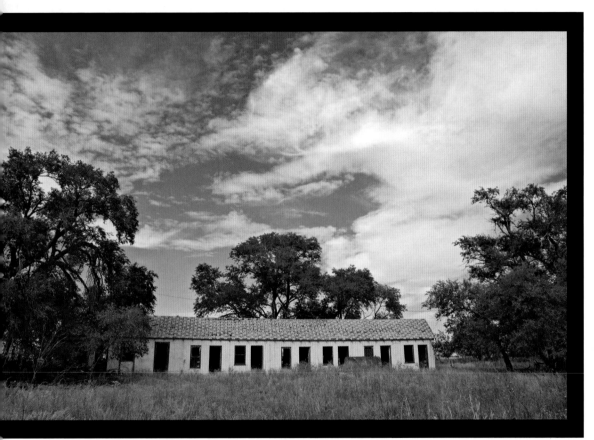

In Glenrio, only prairie critters find respite from the summer sun or the winter wind at an old motel that was once a restful haven for the road-weary.

IN THE PANHANDLE, the ghost towns of Route 66 are few, but the ghostly remnants of those towns that have faded to mere shadows are many.

Most towns in the Lone Star State along the old double six share the common foundational element of agriculture, but each followed a different path in its rise. For some, it was oil; for others, it was the railroad. In others, it was cattle and watermelons. In one, it was all of the above plus women's undergarments.

Ultimately, each weathered the hard times of the Great Depression, the Dust Bowl, World War II, and dying oil fields with a flow of traffic that ebbed and flowed as a tide on Route 66. In spite of their diversity, the decline of each also has a common denominator: the replacement of Route 66 with a four-lane superhighway that allowed motorists to zip past rather than wander through.

FROM THE GHOSTLY STREETS of Texola near the Oklahoma border to the modern metropolis on the high plains that is Amarillo, Route 66 travelers are seldom out of sight of the modern era manifested in the four lanes of Interstate 40. Perhaps this element is what gives the ghost towns and the empty places along this section of Route 66 such a surreal feeling.

TO AMARILLO

With a population hovering just under two thousand souls, Shamrock stretches the idea of *ghost town* a bit. However, when viewed in the context of the boomtown of nearly four thousand residents in 1930 that spawned the businesses and service stations that are now stark, skeletal ruins under a prairie sky, the term becomes an appropriate descriptor.

The town derives its name from the post office application submitted by Irish immigrant George Nickel in 1890. Interestingly, the post office never opened, since Nickel's home/post office burned that same year.

Therefore, the official beginning for the town is pegged to the year 1902, with the arrival of the Chicago, Rock Island & Gulf Railway and the selling of town lots that summer. When Frank Exum submitted an application for a post office, he wanted to name the town for himself, but the railroad designated the stop Shamrock in deference to the original post office application.

By 1911, Shamrock was an incorporated community with a promising future, two banks, the *Wheeler County Texan* newspaper, numerous businesses, and the Cotton Oil Mill. Amazingly, the prosperous little town depended on hauled water until

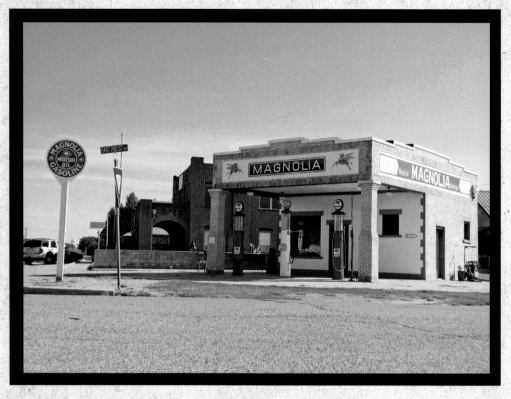

This lovingly restored Magnolia station in Shamrock seems to have been lifted from the pages of history and transported into the modern era. *Jim Hinckley*

completion of a water line from the J. M. Porter Ranch in 1923.

With the discovery of oil in the area in 1926 and the designation of Route 66 in the same year, Shamrock became a modern, bustling community. Jack Rittenhouse notes that, in 1946, the town hosted a hotel, numerous auto courts, garages, and a wide array of cafés.

AAA accommodations directories from the 1940s list three recommended motels and auto courts: the Sun 'n Sand Motel, the Village Motel, and Cross Roads Court. Surprisingly, these directories do not list recommended service facilities.

The decline of the oil industry and the completion of Interstate 40, which allowed travelers to bypass Shamrock, have resulted in a slow downward spiral. The population decreased from 3,113 in 1960 to 1,828 in 2006. Still, this little town takes great pride in its association with legendary Route 66, as evidenced by the restoration of the iconic U-Drop Inn, an art deco masterpiece built in 1936, and the restored Magnolia gas station downtown.

Lela, six miles west of Shamrock, was never much more than a wide spot in the road. Its peak population was 135 in 1980, although the town had shown great promise

Shamrock's U-Drop Inn, built in 1936, has become a Route 66 icon, as evidenced by its inclusion in the imaginary town Radiator Springs in the animated film *Cars*. *Joe Sonderman collection*

When You Go

From Texola, continue west on old U.S. 66, a later four-lane alignment that becomes the south Interstate 40 frontage road. At exit 146 on Interstate 40, cross the interstate and turn left on the north frontage road. Inquire in McLean about earlier alignments south of Interstate 40. To continue with the later portions of Route 66, follow Highway 273 south from McLean one mile, then turn right on County Road BB and continue to the junction with Highway 291. From Alanreed to Amarillo, Route 66 serves as the frontage road for Interstate 40.

in 1902 as a station on the Chicago, Rock Island & Gulf Railway.

Shamrock supplanted Lela as a trade center, and were it not for Route 66, the tiny town might have vanished from the map entirely. In 1946, Rittenhouse notes it was a "small settlement consisting of five gas stations, a café, and a post office."

McLean, fifteen miles west of Lela and the last Route 66 town bypassed in Texas, is another town that stretches the definition of the term *ghost town*, with a population numbered at 782 in 2006, almost half of the peak reached in 1950. Yet classic elements that fit the *ghost town* definition abound, including nearly empty main streets shadowed by a long-shuttered theater, a hotel, and stores.

The town's story begins with Alfred Rowe, master of RO Ranch's two hundred thousand acres and a multifaceted entrepreneur with a diverse background that included a Peruvian birth and an English education. Rowe believed in learning to run a business from the ground up, which meant that his introduction to Texas ranching came as a lowly cowboy employed by Charles Goodnight.

He was also a master at sensing opportunity, and that was what he saw in a well, a switchyard, and a section house built in 1901 by the Choctaw, Oklahoma & Texas Railroad Company (later the Rock Island Railroad). Rowe had the foresight to donate adjoining properties for a cattle-loading facility.

On December 3, 1902, a plat for the town of McLean—named for William Pinkney McLean, a hero of the war for Texas independence and the state's first railroad commissioner—was recorded in the Gray County Courthouse. Within two years, the town was a thriving hub of commerce with three general stores, livery stables, a bank, and even a newspaper.

During the early 1920s, the discovery of oil in the area and burgeoning Route 66 traffic kicked growth into high gear. By 1940, there were six churches, a population of more than 1,500, and more than fifty businesses. McLean was also an economically diverse community with petroleum,

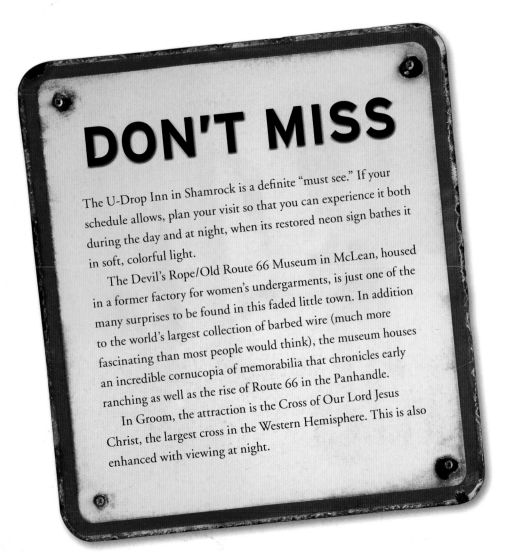

DON'T MISS

The U-Drop Inn in Shamrock is a definite "must see." If your schedule allows, plan your visit so that you can experience it both during the day and at night, when its restored neon sign bathes it in soft, colorful light.

The Devil's Rope/Old Route 66 Museum in McLean, housed in a former factory for women's undergarments, is just one of the many surprises to be found in this faded little town. In addition to the world's largest collection of barbed wire (much more fascinating than most people would think), the museum houses an incredible cornucopia of memorabilia that chronicles early ranching as well as the rise of Route 66 in the Panhandle.

In Groom, the attraction is the Cross of Our Lord Jesus Christ, the largest cross in the Western Hemisphere. This is also enhanced with viewing at night.

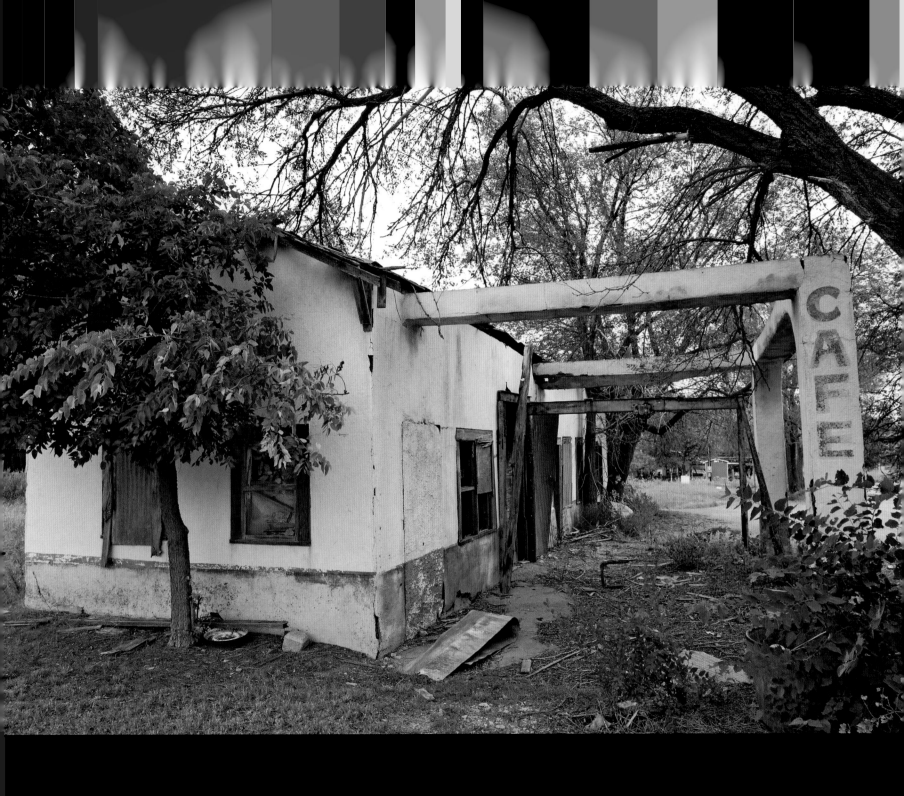

agriculture, and Route 66-oriented businesses, as well as a factory (now the Devil's Rope/Old Route 66 Museum) that produced ladies' undergarments.

During World War II, the economy received an additional boost from a military facility constructed north of town. The history of this facility, utilized as a POW camp for German mariners, is preserved at the Devil's Rope/Old Route 66 Museum.

Several factors sent McLean into the slow-motion downward spiral experienced by so many Route 66 communities: drought, the emergence of Pampa as the county's industrial center, the collapse of the oil industry, and, of course, the bypass of Route 66. Today, the resurgent interest in Route 66 has stemmed the decline and has served as a catalyst for the resurrection of McLean's

remaining roadside relics, including the recently refurbished Phillips 66 station that dates to 1930 and the Cactus Inn Motel.

Less than a dozen miles to the west lies the old town of Alanreed, another victim of changing times. As of 2001, the population hovered at fifty residents.

The town site in the basin of McClellan Creek six miles north of present-day Alanreed, selected in 1881, was centrally located on the busy stage and freight road that connected Mobeetie to Clarendon. Oddly enough, it would be three years before the Clarendon Land & Cattle Company began selling lots.

When surveys in 1900 made it apparent that the Choctaw, Oklahoma, & Texas Railroad would miss the little community, the platting of a new community commenced. The following year, the school

opened, and the year after this, the post office transferred to the new location.

By 1904, Alanreed was the largest community in Gray County, and by the mid-teens, all indications were that this town was a rising star. The community had a bank, a hotel, a depot, churches, saloons, grocery and hardware stores, and a livery stable and blacksmith shop.

In the early 1920s, oil replaced watermelons as the area's primary export, and for a brief moment, there was a booming surge that pushed the population to an estimated five hundred in 1927. As with most towns along Route 66 in the eastern half of the Texas Panhandle, the downward slide of Alanreed was a slow one.

In 1947, the population had slipped to three hundred people, and there were eleven businesses, mostly service related,

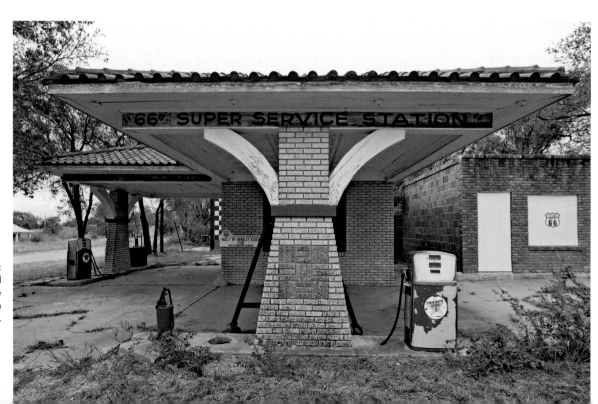

Maintained by the Texas Historic Route 66 Association, the restored Bradley Kiser 66 Super Service Station, circa 1930, is the crown jewel of Alanreed.

Alfred Rowe

ALFRED ROWE, founder of McLean and master of the RO Ranch, lived a life of amazingly diverse adventures. Born in Lima, Peru, and educated in England, he immigrated to the United States in 1878 after years spent in worldwide exploration.

Even though his secondary education centered on agricultural studies, Rowe chose to learn the art of American ranching in the Texas Panhandle from the ground up. A year after literally learning the ropes from legendary pioneer rancher Charles Goodnight, Rowe began purchasing trail herds, as well as complete outfits. He started his own ranch using an abandoned dugout as headquarters and drove his herds to Dodge City in Kansas.

By 1895, the RO Ranch encompassed more than two hundred thousand acres of owned and leased lands, and Rowe was one of the most successful ranchers on the Panhandle plains. This success fueled other endeavors on both sides of the Atlantic Ocean, and soon he was traveling, often with his family, to England at least twice a year.

With the establishment of rail lines to the north and south of the ranch, Rowe diversified his business enterprises and began selling small farms. Tying this and his ranching together was his donation of land, in 1902, for a cattle-loading facility on the Rock Island Railroad and the platting of an accompanying town site.

Rowe's star was still rising when, in 1912 on a return trip from England, he tragically became a victim of the sinking of the H.M.S. *Titanic*.

along Route 66. Thirty years later, there were an estimated sixty residents and no operating businesses.

The reawakening interest in Route 66 has kept the faintest spark of life glowing, however. Perhaps the most notable manifestation of this is the preservation of the 66 Super Service Station, dating to circa 1930.

Less than a dozen miles west of Alanreed are the forlorn remnants of Jericho, a small community with origins dating to 1902 and the establishment of a station for the Chicago, Rock Island & Gulf Railway. Ironically, traffic on Route 66 made the dark days of the Great Depression the glory days for Jericho.

At its peak during the early 1930s, the town boasted three stores, a grain elevator, a tourist court, a garage, and a filling station. But the realignment of the highway and the changing face of agriculture in the Panhandle fueled the town's demise. By 1955, the population no longer was sufficient to warrant a post office.

The original alignment of Route 66 from Jericho to Groom is notorious in the annals of the highway's history. This section, known as the Jericho Gap, was infamous for mud, ruts, and enterprising farmers ready to rescue motorists for a few dollars. The Texas Department of Transportation began work to close the gap with a paved bypass in 1928, and the project was completed in 1931.

Groom, forty-two miles east of Amarillo, appears to be another ghost along Route 66, with its empty auto courts and service stations, but in actuality the town has maintained a rather steady population: 800 in 1972 and 587 in 2000. Conway has a similar appearance, but its population has dropped from a high of 175 in 1969 to less than 20 today.

Amid the ruins of Jericho, the rusty bones of what was once
the pride of Detroit provide a link to the modern era.

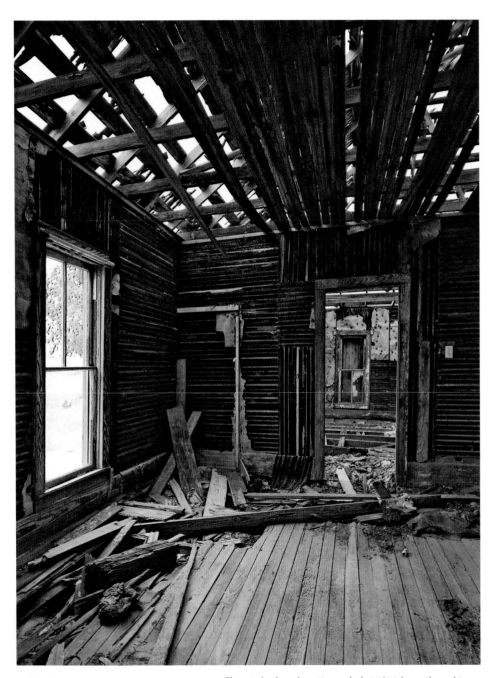

The winds play a haunting melody in Jericho as they whisper
through glassless windows and swirl dust on floors.

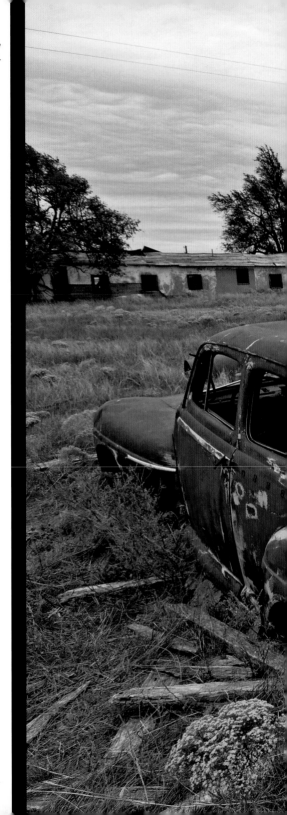

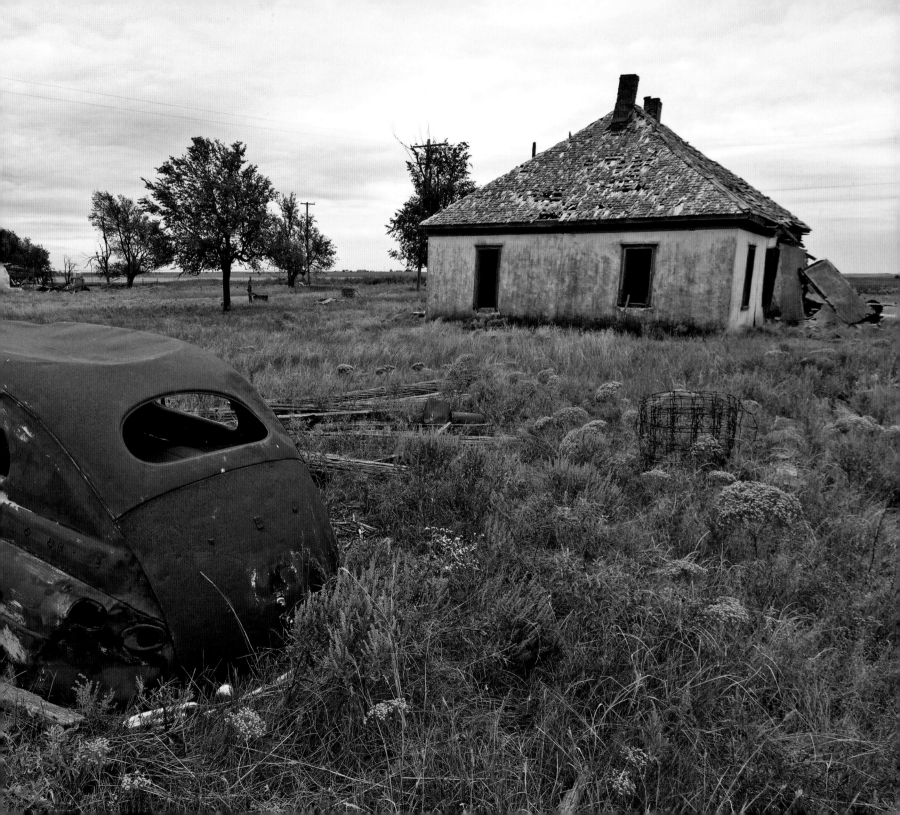

THE STAKED PLAINS

IN HIS SEMINAL WORK published in 1946, *A Guide Book to Highway 66*, author Jack Rittenhouse says about the road west of Amarillo: "Now you are on the 'STAKED PLAINS,' or 'Llano Estacdo' as the Spaniards called it. The origin of the name is disputed, but it is generally taken to be derived from the legend that early pioneers drove stakes along their trails for lack of natural landmarks to guide them."

Vestiges of the Route 66 glory days and the frontier era in which they were founded pepper the communities in the western half of the Panhandle, but few qualify as ghost towns. The exceptions are Boise (less than a site on an early alignment of the highway that is on private property), Wildorado, and Glenrio.

Depending on the date of the map you consult, Glenrio may be shown in New Mexico or Texas, but it is actually in the latter astride the border in northwestern Deaf Smith County. At least most of the town is in Texas; Jack Rittenhouse notes that, in 1946, the depot was on the west side of the state line, and the business district was on the east.

Some twenty years before the road through town was marked with a shield emblazoned with two sixes, Glenrio was a farming town on

When You Go

Glenrio is accessed from exit 0 on Interstate 40.

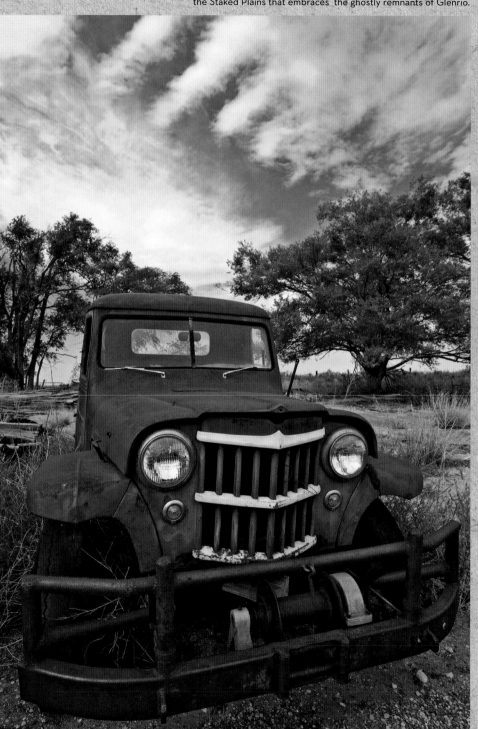

A vintage Jeep out to pasture seems an apt monument to the landscape of the Staked Plains that embraces the ghostly remnants of Glenrio.

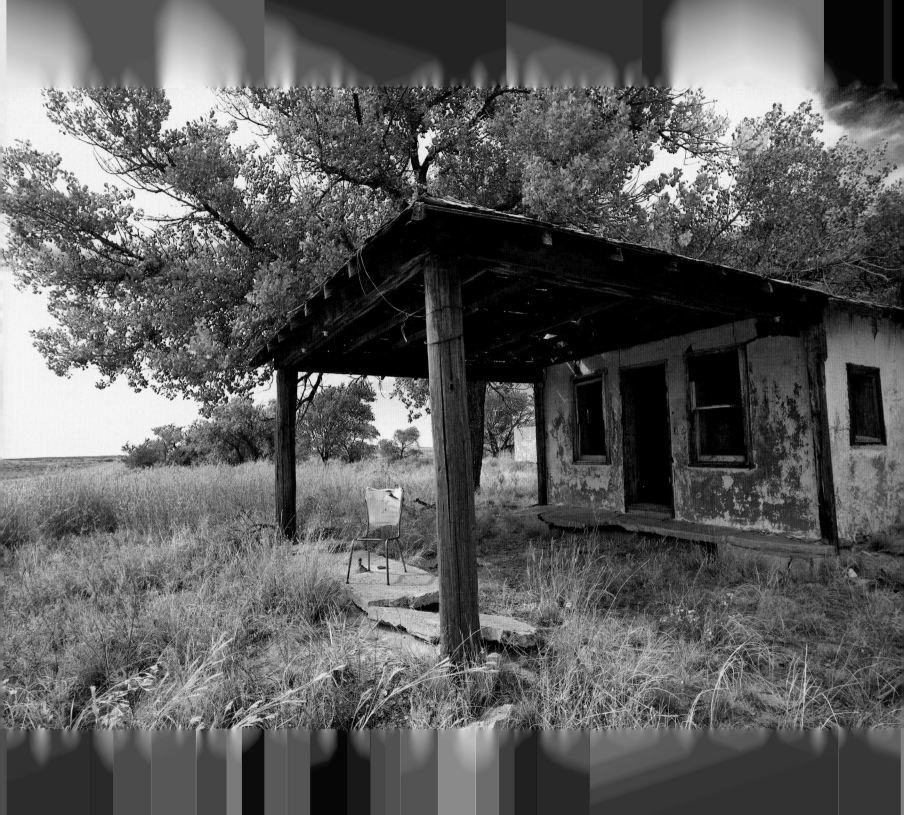

the Chicago, Rock Island & Gulf Railway. The depot and railyard were beehives of activity. Cattle and produce were loaded on outbound shipments, while freight and dry goods for the area's farms and ranches came inbound.

By the 1920s, the little town on the staked plains was a quiet but busy community with a hotel, a land office, a hardware store, a grocery store, and several cafés and service stations. It even had a newspaper, the *Glenrio Tribune*.

What it did not have were bars or liquor stores, since Deaf Smith County was dry. This posed no real hardship on residents, though, since libations were but a dusty five-mile

drive to the west in Endee, New Mexico.

With the closure of the depot in 1955, the asphalt lifeline that was Route 66 became the town's primary source of revenue. Upon completion of Interstate 40 in 1973 and the severance of this tenuous hold, Glenrio quickly succumbed to abandonment.

Today, Glenrio is a photographer's paradise, with its forlorn ruins casting long shadows over the empty asphalt of the old highway. Among the favored photo ops are the empty remnants of the Texas Longhorn Motel and Café, once promoted with a sign that read "First Stop in Texas" on one side and "Last Stop in Texas" on the other.

The Longhorn story begins with the opening of the State Line Bar on the New Mexico

side of the state line in 1934 by Homer and Margaret Ehresman. As an interesting historic curiosity, Margaret ran the post office from this location, and an early photo shows this building with "Post Office Glenrio N.M." over the door.

In 1946, rumors of a pending realignment led the Ehresmans to relocate their business five miles west to Endee, New Mexico. In 1950, they returned and opened the Longhorn.

The Longhorn and the Ehresmans' story encapsulates life along Route 66 in the pre-interstate era. For people like Homer and Margaret, Route 66 was more than a highway; it was an asphalt opportunity with possibilities only limited by the imagination and the amount of expended effort.

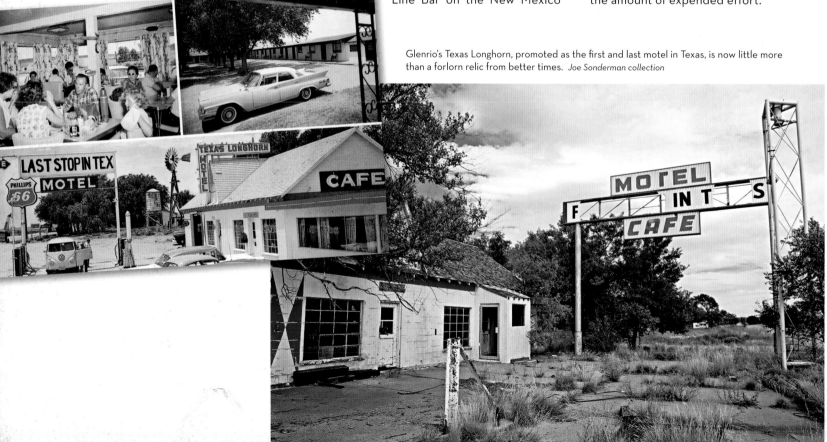

Glenrio's Texas Longhorn, promoted as the first and last motel in Texas, is now little more than a forlorn relic from better times. *Joe Sonderman collection*

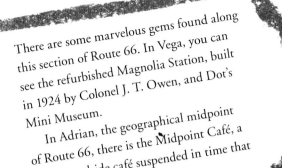

There are some marvelous gems found along this section of Route 66. In Vega, you can see the refurbished Magnolia Station, built in 1924 by Colonel J. T. Owen, and Dot's Mini Museum.

In Adrian, the geographical midpoint of Route 66, there is the Midpoint Café, a classic roadside café suspended in time that specializes in fresh pies.

Imagine the parade of travelers headed east and west who stopped at Glenrio's State Line Bar on the New Mexico side of the border to cool the radiator and top off the tank.
Joe Sonderman collection

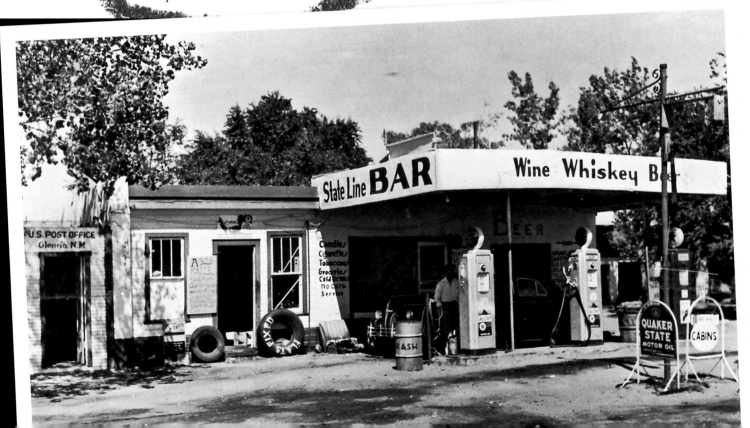

NEW MEXICO

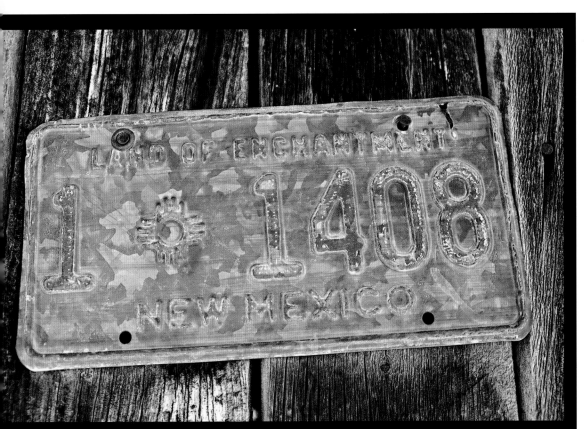

The blending of weathered wood and faded steel in San Jose encapsulates the timeless and diverse nature of New Mexico, the Land of Enchantment.

THE GHOST TOWNS OF ROUTE 66 in New Mexico are unique among those found along this historic highway. They are also some of the oldest.

In some, the ghostly remnants of Route 66, even those dating to the 1920s, seem oddly out of place and modern when seen against the backdrop of churches that date to the 1820s or stores that met the needs of travelers on the Santa Fe Trail. Amazingly, a few of these ghosts in the Land of Enchantment were prosperous, modern communities long before the thirteen colonies became the United States of America.

INTRODUCTION TO THE LAND OF ENCHANTMENT

THE ROUTE 66 OF THE 1950S parallels Interstate 40 on its westward course across the high plains and into the landscape dominated by buttes, mesas, and tortured stone edifices farther west. The first miles of Route 66 of the Okies, of the Bunion Derby, and of Jack Rittenhouse are now a gravel track across the rolling plains, through rolling hills, and over vintage bridges of wood.

Five miles west of Glenrio are the scattered ruins that mark the site of Endee, founded as a supply center for area ranches, including the sprawling ND Ranch that began operation in 1882. In 1946, Jack Rittenhouse notes that the town consisted of 110 people, a gas station, a garage, a grocery store, a school, and a "scant" handful of cabins.

Today, the tumbledown remnants nestled on a windswept knoll framed by vast Western landscapes offer a wide array of unique photographic opportunities. A touch of comedic relief is found in a building with "Modern Rest Rooms" emblazoned on the side.

Rittenhouse found Bard, a few miles to the west, had even less to offer the traveler: "Population 26; gas and garage. This 'Town' consists of a single building, but it includes a post office." Scattered ruins north of exit 361 on Interstate 40 are all that remain.

San Jon (pronounced *San Hone*) was founded in 1902 as a ranching and farming supply center fifteen miles west of Glenrio on the Tucumcari & Memphis Railroad. It was once the largest town on the eastern plains of New Mexico. Rittenhouse came across gas stations, garages, the San Jon Implement Company, two auto courts, several cafés, a hotel, and a variety of stores. "Main Street" (Route 66) was an endless stream of traffic every hour of the day, every day of the week.

The neon no longer lights the night at the Circle M Motel, Smith's Café, or the Western Motel. The Old Route 66 Truck and Auto Parts garage no longer serves as an oasis for the traveler who has an overheating car. Today, San Jon clings to life by a thread, its population hovering somewhere around the two hundred mark, and a multiservice truck stop near exit 356 serves as one of the last vestiges of a once vital business district.

Photo postcards like this one of a station in Endee are sought-after Route 66 artifacts because they were never produced in large quantities. *Joe Sonderman collection*

Adding a comedic tone to the ghostly atmosphere is a building signed "Modern Rest Rooms," one of the best-preserved structures in Endee.

When You Go

At the end of the pavement at the west end of Glenrio, continue across the concrete bridge and follow the graded gravel road eighteen miles to San Jon. If the road is muddy, use of exit 356 or 361 is suggested.

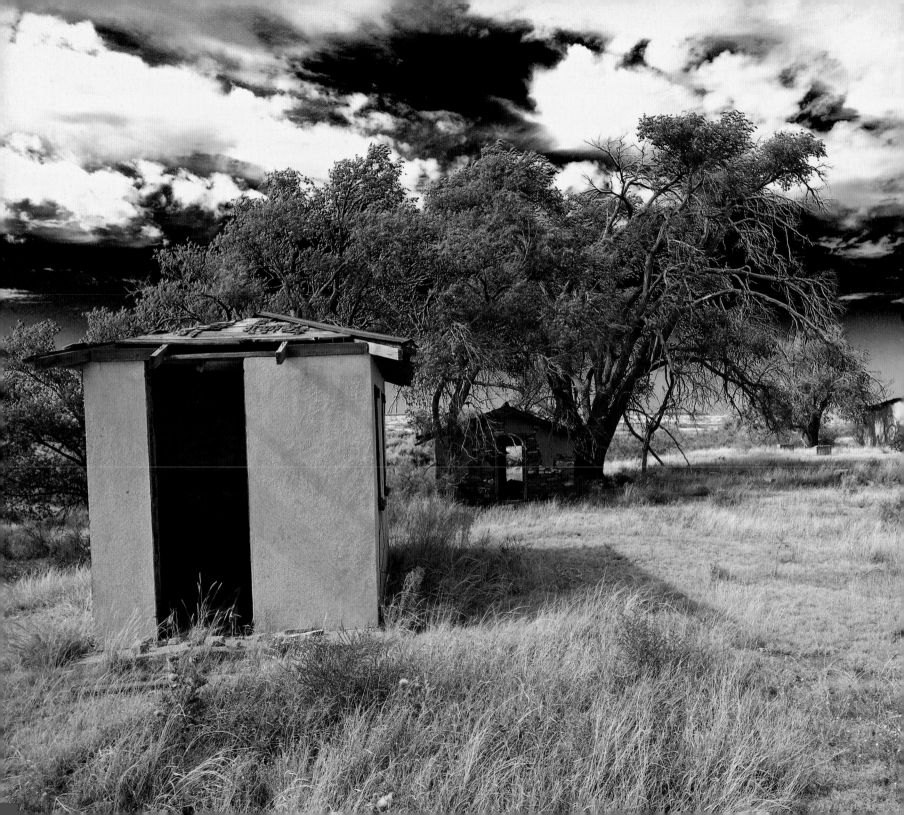

The ruins of Endee convey a charming serenity nestled among towering trees and meadows of prairie grass along an equally empty highway.

NEW MEXICO 97

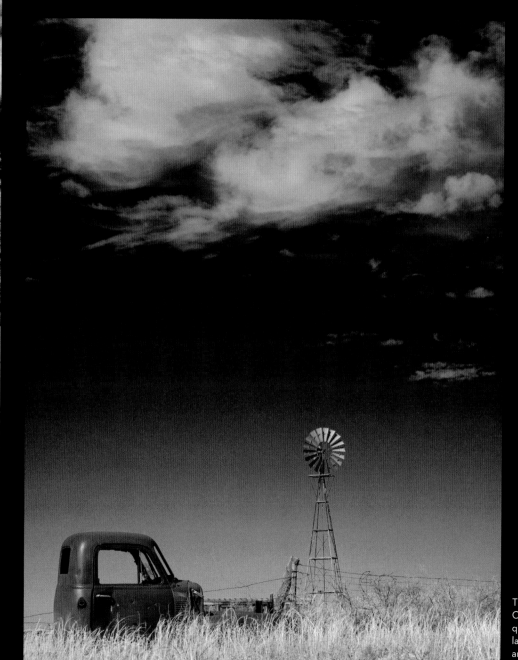

The cab of a vintage Chevy truck, framed by a quintessential prairie landscape, appears as an old workhorse out to

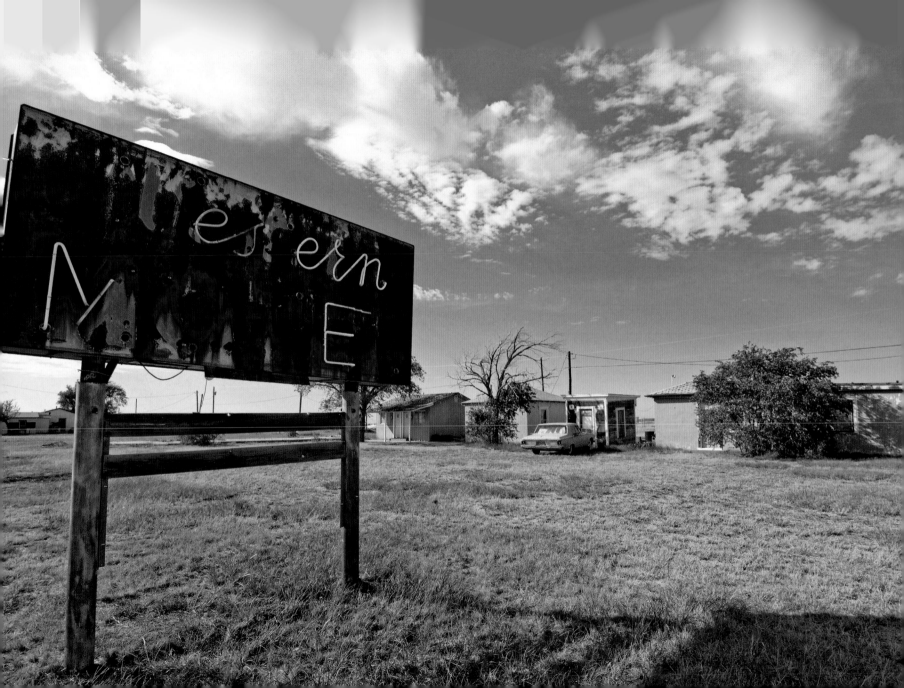

DON'T MISS

At exit 369 on Interstate 40, on the site of the second Texas Longhorn Motel and Café, is a new travel plaza and automobile museum that captures the essence of the old road. Appropriately, this full-service facility sits on the post-1954 alignment of Route 66.

GAS
50 MI.

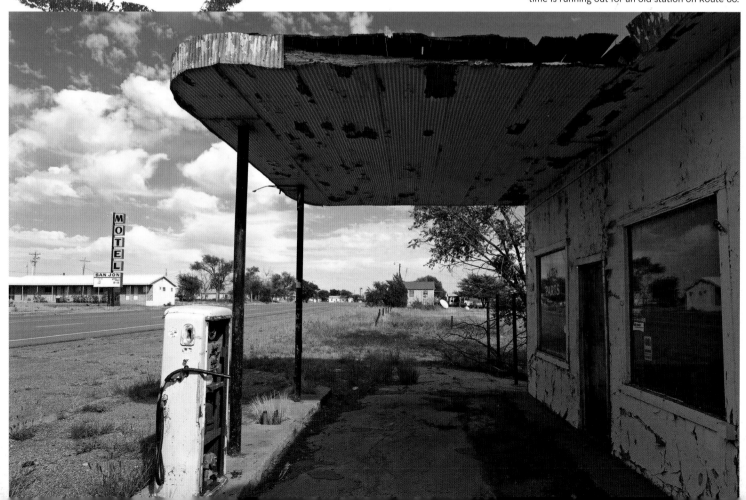

San Jon clings to life by the thinnest of threads, but time is running out for an old station on Route 66.

WEST OF TUCUMCARI, the landscape is more of the quintessential type associated with the desert southwest. The ghost towns on this stretch of old Route 66 are haunting, empty places that reflect the vast, lonely landscape that embraces them.

MONTOYA, NEWKIRK, CUERVO

The windswept cemetery in Montoya, founded as a loading point for the railroad in 1902, enhances the forlorn feeling that gives those unfamiliar with the empty places of the southwest an involuntary shudder. In this little town, the mesquite and juniper now crowd Richardson's Store. The mercantile added Sinclair gasoline at some point between the day it opened in 1925 and its closure in the mid-1970s, and it fades closer to oblivion with the passing of each year.

The towering Casa Alta, built of cut stone blocks, is often mistaken for an old store. Built shortly after the town's founding, the home of Sylvan and Maria Hendren is now succumbing to more than half a century of abandonment to the elements and vandals.

Newkirk, originally Conant, to the west of Montoya, also dates to the first years of the twentieth century. The town grew slowly in the years before the designation of Route 66, but the stream of money that resulted from that event flowed east and west in Fords and DeSotos, Packards and Studebakers. By the mid-1930s, there were four service stations, restaurants, De Baca's Trading Post, and a few cabins.

Cuervo, as a town, dates to the construction of a railroad siding here in 1901 and the establishment of a post office in 1902, but settlement predates this by several years. As with its neighbors to the east, the town never progressed much beyond being a supply center for area ranches and, after 1926, a stop for travelers on Route 66.

Rittenhouse notes that the 1940 census counted a town population of 128. When he drove through, there were "a few gas stations, groceries, no café, garage, or other tourist accommodations."

The bisection of Cuervo by Interstate 40 proved a boon and bane for the old town. It provided a reprieve from the complete abandonment neighboring towns experienced, but it devastated the businesses associated with the era of the old two-lane highway.

The vestiges on the south of the interstate highway, including the shell of a schoolhouse built of cut stone and a similarly constructed church, clearly predate the establishment of Route 66 in 1926. Those that remain on the north side mostly date to the postwar era.

The howling winds of winter and the warm breezes of summer are slowly transforming plastered adobe walls into sand as Montoya fades away.

When You Go

Take exit 321 on Interstate 40 and continue west through the narrow, low tunnel under the highway. This section of the highway ends at exit 291 in Cuervo.

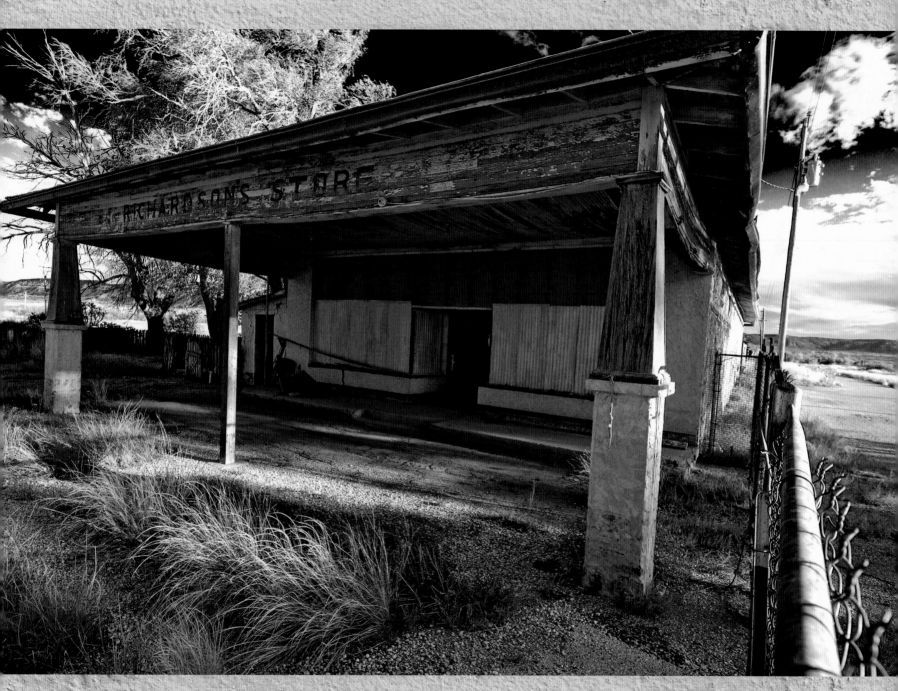

A chainlink fence and boarded windows may protect Richardson's Store in Montoya from vandals, but the winds of change are still taking their toll.

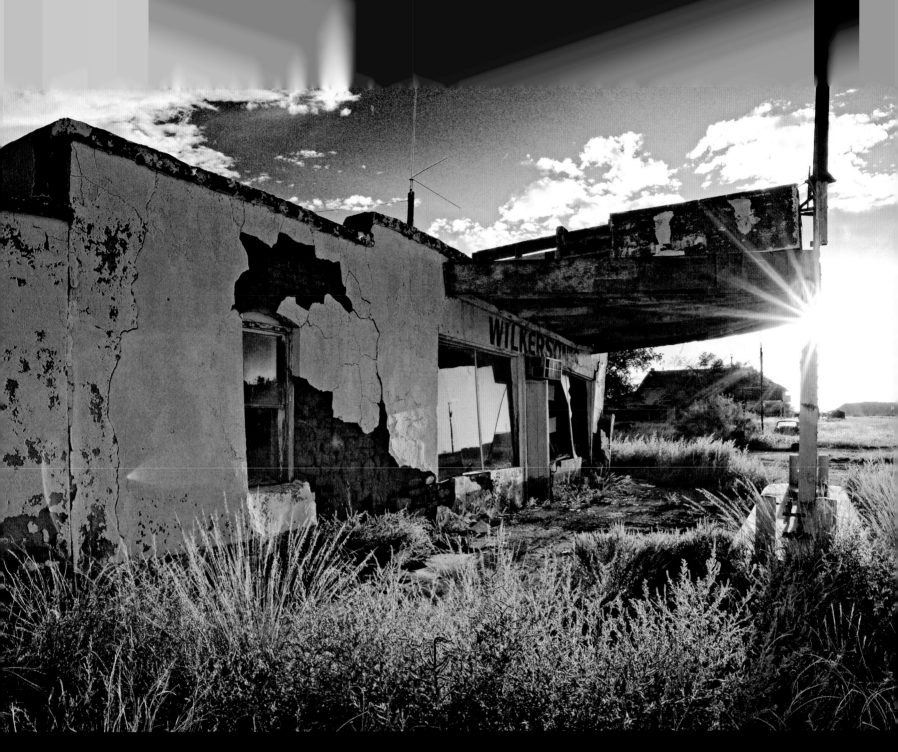

For Newkirk, a ranching and railroad town turned service center, the bypass of Route 66 proved to be the town's obituary.

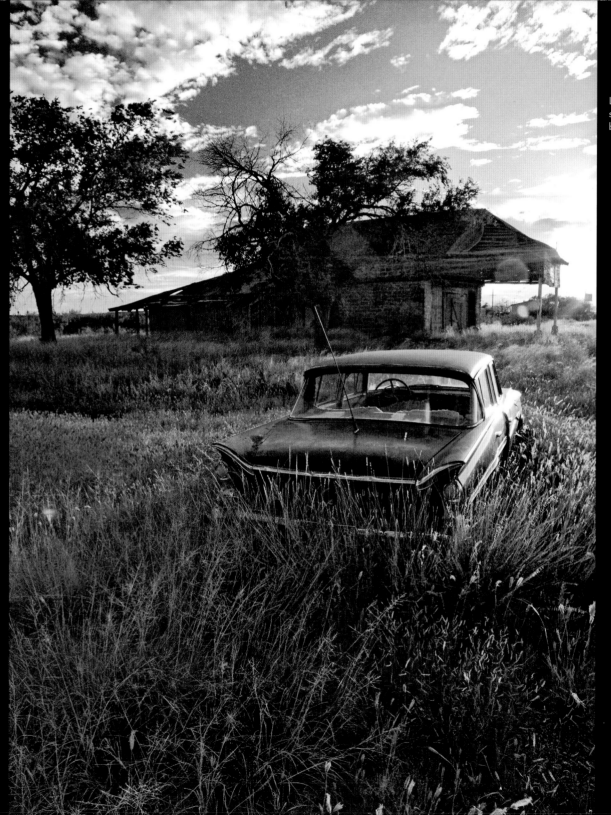

Like a skiff cast adrift on copper seas, a relic from Detroit floats under boundless skies.

GHOSTS OF THE SANTA FE TRAIL

BEFORE 1937, THE ROAD from Santa Rosa to Albuquerque was a 132-mile loop that followed the storied Santa Fe Trail into Santa Fe and then the historic El Camino Real down the steep switchback curves of La Bajada Hill into Albuquerque. Often overlooked even by fans of legendary Route 66, this portion of the highway is, arguably, one of the most scenic—and its ghost towns are counted among the oldest.

Quiet little Dillia (called El Vado de Juan Paiz before 1900) predates Route 66 by almost a century. The old church, an empty garage, and the adobe homes melting back into the soil reflect this long history.

Founded in 1880, Romeroville is accessed by following a rutted dirt road from U.S. Highway 84, the modern incarnation of Route 66 in this portion of New Mexico. The town is the namesake of Don Trinidad Romero, the congressional delegate for the New Mexico Territory and a colorful, larger-than-life character who successfully bridged two cultures.

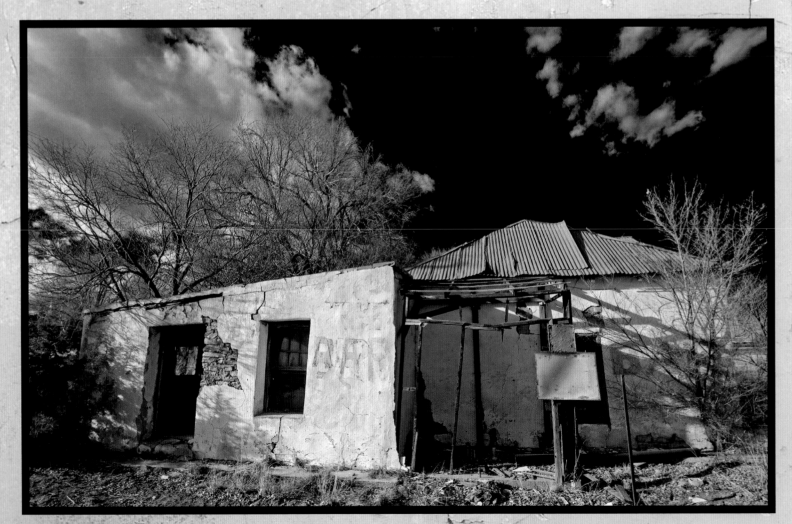

The ruins in El Vado de Juan Paiz, now Dillia, reflect a ranching and farming history that predates Route 66 by almost a century.

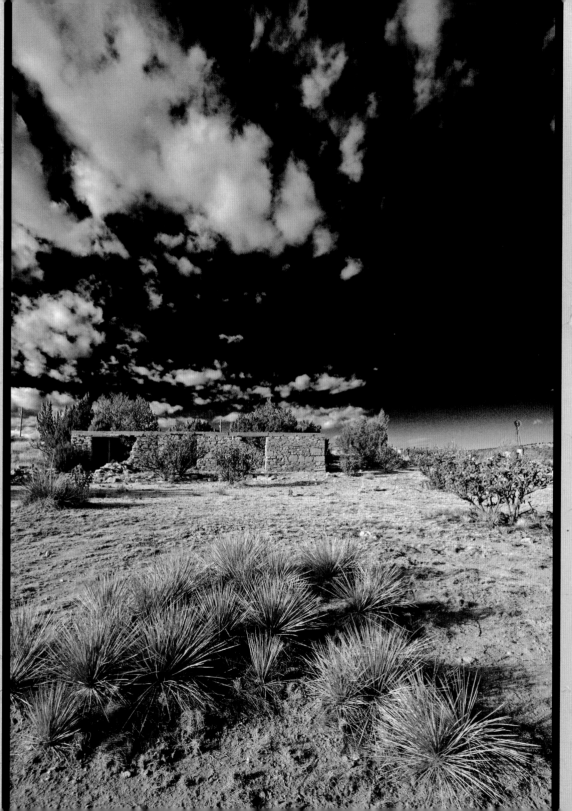

With the speed of a glacier, nature reclaims the land in Dillia, bypassed in the 1937 realignment.

When You Go

Follow Interstate 40 west to exit 256, U.S. Highway 84, and turn north. Continue north through Dillia to Interstate 125. At exit 339, join the frontage road crossing Interstate 25 at exit 319. From this exit, continue on the south frontage road. At exit 307, cross under Interstate 25 and follow Highway 63 north to Pecos, then turn left on Highway 50 to Glorietta.

It stretches the most fertile imagination to picture Romeroville as a place once visited by presidents and dignitaries or as a town worthy of its namesake, Don Trinidad Romero.

In addition to operating a freight company that hauled all manner of goods from Kansas City to Santa Fe, Romero ranched vast land holdings and served as a probate judge as well a member of the territorial House of Representatives. He also served as a U.S. Marshall and operated a number of mercantile stores.

His home in Romeroville was a true showpiece that stood in stark contrast to the adobe and rough-cut lumber houses common on the Western frontier. According to Anna N. Clark, the interior consisted of a "dozen large, lofty, high ceiling rooms paneled in walnut. The downstairs rooms had sliding doors opening into the spacious ballroom. There was a low, wide, curving stairway."

Before its conversion into an asylum and its destruction by fire in the 1920s, the home of Don Romero was a focal point for high society in northeastern New Mexico. The guest list reads like a Who's Who of the late nineteenth century and includes President Ulysses S. Grant, President Rutherford B. Hayes, and General Tecumseh Sherman.

In Tecolote, Route 66 winds through a pleasant old plaza and past the ancient church to dead-end where a bridge over Tecolote Creek once stood. A marker in the plaza memorializes Tecolote as a former stop on the Santa Fe Trail. It was in this plaza that General Stephen Kearny, in August 1846 during the Mexican-American War, announced that he had replaced Governor Manuel Armijo and that the citizens were no longer under the rule of Mexican sovereignty.

The scruffy little town barely warranted a notation in the journal of William Anderson Thornton, a participant in the military expedition to the New Mexico Territory in 1855: "The villages of Vegas and Tecolote made from unburnt clay and in appearances resemble unburnt brick kilns in the States. People poor and dirty. Flocks of sheep, goats, and cattle very numerous.

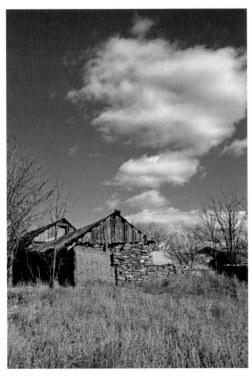

Tecolote's clay buildings still "resemble unburnt kilns," as described by soldier William Anderson Thornton in 1855.

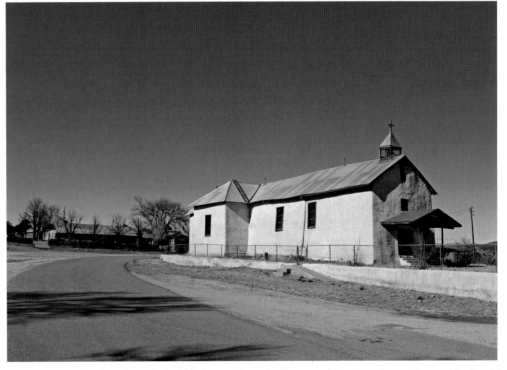

The church in oft-overlooked San Jose predates the christening of Route 66 by a century, and the town's origins can be traced back another fifty years.

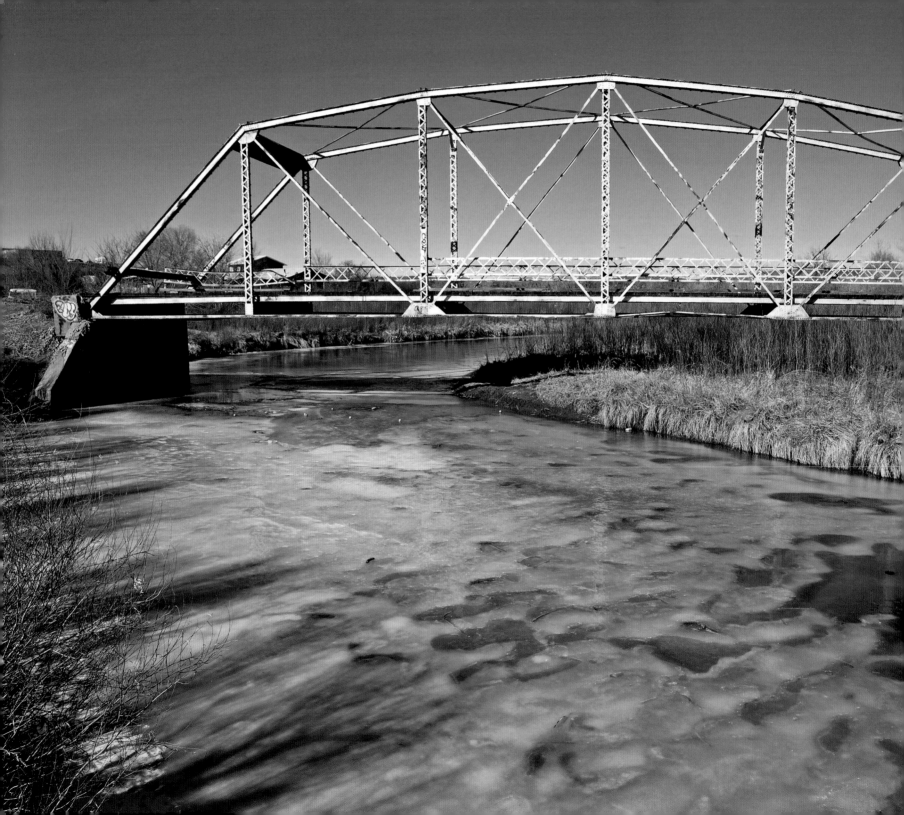

Now closed, the steel truss bridge spanning the Pecos River in San Jose dates to 1921, five years before Route 66 was built through the historic plaza.

NEW MEXICO **109**

GLORIETA PASS—OLD PIGEON RANCH ON SANTA FE TRAIL

MOST HISTORIC AND WONDERFUL OLD INDIAN-SPANISH AMERICAN WELL OVER 388 YRS.OLD

DRINK AGAIN FROM THE FOUNTAIN OF YOUTH

UNDER MANAGEMENT OF THOS. L. GREER, GLORIETA PASS, N. MEX. 2465-29

Route 66, and the traffic that flowed east and west, served as the catalyst for the Pigeon Ranch in Glorieta Pass to be transformed from historic site to tourist attraction. *Joe Sonderman collection*

"The scenery as we advanced towards Tecolote becoming more grand and beautiful. Our camp is located on a beautiful spot overlooking the mud village." The scenery along this portion of Route 66, now largely Interstate 25, rates among the most stunning anywhere along the highway's path.

San Jose, to the west on the banks of the Pecos River, is another unassuming village. Its founding is traced to a land grant issued by Governor Don Fernando Chacon in 1794. A post office, a scattering of homes of indeterminate age, and the plaza church built in 1826, as well as a now-truncated steel arch bridge built in 1921, present an oddly forlorn and timeless feel.

Rowe and Ilfield were never more than wide spots in the road, and both are even less today. To the west is the Old Pigeon Ranch, a historic site that was never really a town, even though for a time it functioned as a small service stop for travelers on the Santa Fe Trail.

Purportedly, ranch owner Alexander Valle, a Frenchman who spoke "pigeon" English, selected the site for his ranch because of its central location on the Santa Fe Trail and the property's well that had been in continuous use for more than 150 years. The ranch took on a new importance in March 1862 when Union and Confederate forces clashed at nearby Glorieta Pass, the highest point on Route 66 before 1937, and the barn served as a field hospital.

In 1924, Thomas Greer transformed the site into a tourist attraction. On one side of the road, signs proclaimed, "Drink Again from the Fountain of Youth—Old Indian-Spanish-American Well Over 388 Years Old." On the north side of the highway, the old adobe barn was plastered with signs proclaiming its association with the historic Civil War battle.

Shortly after the realignment of the highway in 1937, the attraction closed. The barn, now preserved by the National Park Service, and the well are all that remain.

THE TIMELESS LAND

THE LAND WEST OF ALBUQUERQUE seems ancient and the intrusions of man out of context. The exceptions, however, are the towns and roadside remnants that line Route 66 between Albuquerque, an old Spanish presidio transformed into a modern metropolis, and the breathtaking buttes and mesas that straddle the border of Arizona and New Mexico.

These ruins, remnants, and dusty relics seem as much a part of the landscape as the stones themselves. In part, their weathering from centuries of blowing snow and dry desert winds enhances the illusion.

Correo, on the pre-1937 alignment of the highway, had always been a service center. From its 1914 inception as a railroad station, it had met the needs of travelers with a general store and the needs of locals with the only post office for miles. With the realignment of Route 66 and closure of the station, this wide spot in the road quickly became a dusty, empty place.

Paraje was established by a small group of Laguna Indian farmers, but it soon became a favored stop for the new breed of adventurers who called themselves motorists. The town had a population large enough to warrant a post office from 1867 to 1910, but by 1946, Jack Rittenhouse notes that only a small trading post remained.

West of the centuries-old Laguna Pueblo is Budville Trading Company, originally a trading post and Phillips 66 station opened by N. H. "Bud" Rice in 1928.

Cubero, bypassed in 1937, is located just a few miles north of Highway 124, the replacement alignment of Route 66. Its association with Route 66 is a long one, spawning one of the old road's iconic landmarks and forever linking its story to that of the historic highway.

During the teens and early twenties, automobile tourists flocked to the desert southwest to take in the wondrous lands and strange cultures. Old trading posts and new ones capitalized on this new opportunity for profit.

In Cubero, Wallace and Mary Gunn operated one of these trading posts and kept up a thriving business by providing local Indians with goods like flour and coal oil in exchange for pottery, sheep, cattle, and an array of work created by Indian artisans. In turn, these goods were sold to tourists.

Shortly after the realignment of Route 66, the Gunns relocated their business to a new facility on the highway. By the summer of 1937, in partnership with Sidney Gottieb, the new trading post had morphed into Villa de Cubero Trading Post, a complex that included the trading post, a service station, and ten tourist courts.

The facility received a favorable rating by AAA and inclusion in the 1940 *Directory of Motor Courts and Cottages*: "Villa de Cubero, on U.S. 66, 10 cottages with baths, $2 to $3. Public showers. Café. Trailers 50c."

Hollywood discovered the charming village of Cubero and its trading post during this period, and soon the Villa de Cubero was a popular place for celebrities seeking a hidden hideaway or a pleasant stay while filming in the area. The surprising guest list included Gene Tierney, Bruce Cabot, the Von Trapp family, and Sylvia Sidney. Vivian Vance owned a ranch nearby, and Desi and Lucy Arnaz were regulars during the early 1950s. Another brush with fame came with Ernest Hemmingway, who resided here for two weeks, purportedly while working on *The Old Man and the Sea*.

Settlement at San Fidel nearby began with the establishment of a small farm by Baltazar Jaramillo and his family in 1868. In time, the isolated farm became a small community, and in 1919, a post office opened.

Jack Rittenhouse notes that the population in 1946 was listed as 128 and that the town consisted of a café, a garage, a couple of stores, and a curio shop. He also notes that the town had "declined somewhat."

Today, the word *declined* is an apt descriptor for San Fidel. The village consists of a small chapel, an art gallery in an old building, a bar, and a tumbledown garage. Just west of town are the remains of a former Whiting Brothers station.

When You Go

Correo is located south of Interstate 40 at exit 126. The remainder of the towns in this section are on old U.S. 66 on the north side of Interstate 40, accessed at exit 117.

Hidden Gems

An array of vintage Route 66 remnants peppers the old road from San Fidel to the Arizona state line. In the old mining town of Grants, the darkened neon of the Franciscan Lodge and the Lux Theater, and the refurbished sign at the Grants Café, all hint of a time when travelers on the double six were as important to the economy as uranium from area mines.

Prewitt, Thoreau, Iyanbitoall, and Manuelito have long and colorful histories, but Route 66 literally placed these isolated trading posts on the map. Jack Rittenhouse, in his 1946 guidebook, notes that Prewitt was "A small community, including several railroad siding shacks and Prewitt's Trading Post. Gas station here. No tourist accommodations in Prewitt."

Of Thoreau, Rittenhouse says, "Thoreau Trading Post and Beautiful Mountain Trading Post here; gas and garage. Thoreau itself lies off of US 66." Interestingly, this description is quite similar to that given in the 1927 edition of *Hotel, Garage, Service Station, and AAA Directory*.

In Thoreau today, the Red Mountain Market and Deli masks—through a series of additions and an updated façade—a tangible link to the very infancy of Route 66: Johnnies Café. The café dates to the late 1920s and was initially little more than a twenty-by-forty-foot shed with a wood-burning stove for cooking and heating water, a counter with a couple of stools, and four small tables.

An interesting historic footnote is found in Herman's Garage at the junction with Highway 371, the road to Thoreau. Erected in Gallup in 1931, this prefabricated, steel-frame service station was moved to its present location in the mid-1930s.

Today, ruins, faded murals, and other ghostly remnants are the dominant features of this stretch of highway. Against the backdrop of beautiful Western landscapes, these appear as sets in a photographer's paradise.

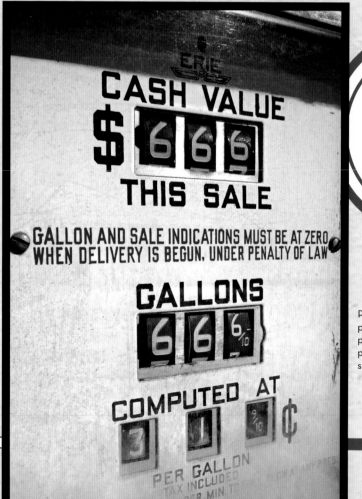

Prices stuck at thirty-one cents per gallon on a pump in Thoreau provide an excellent reference point for when the last car stopped at the station.

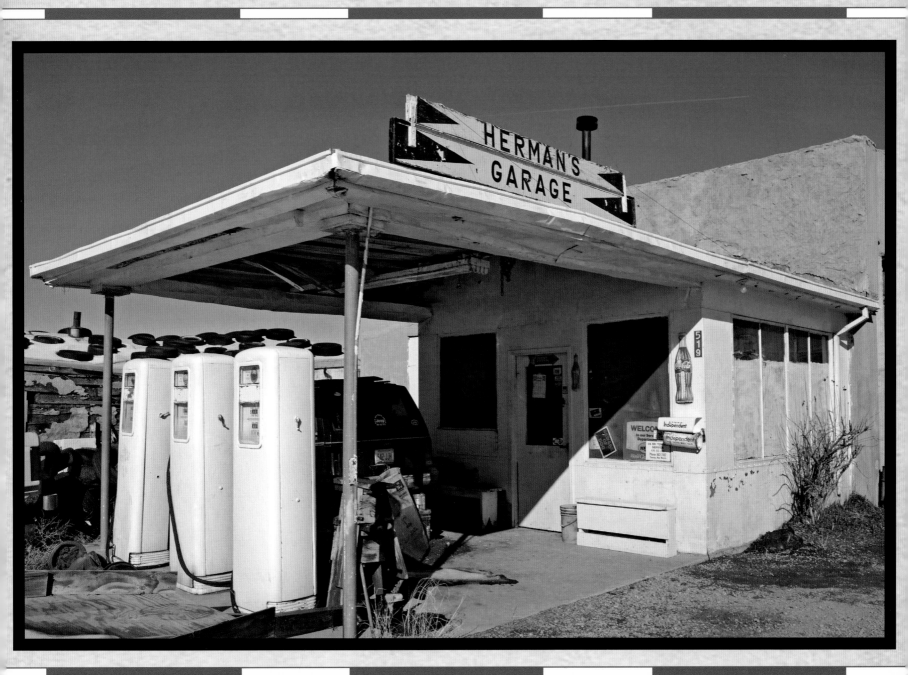

Herman's Garage hints that in quiet Thoreau, the curtain between past and present is a very thin veil.

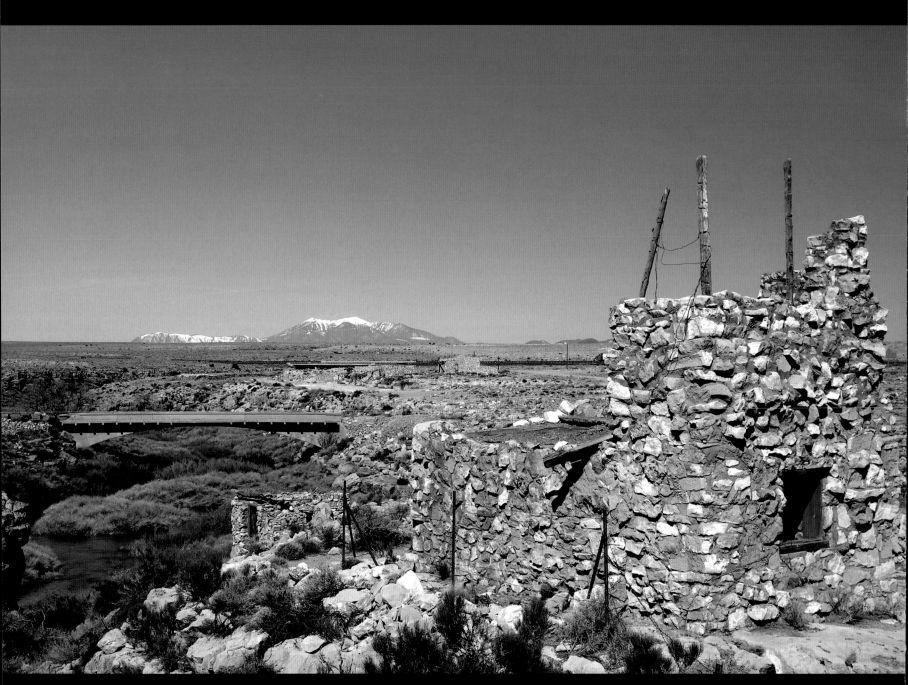

The beautiful Canyon Diablo Bridge gave rise to the quintessential Route 66 tourist stop that was Two Guns.

ARIZONA

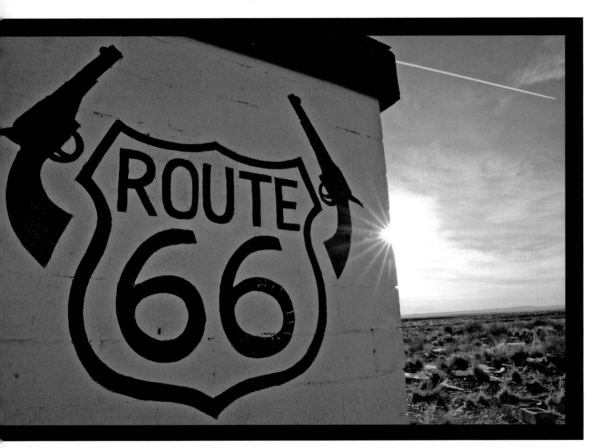

The Two Guns mural may be a re-creation, but it is an apt monument to one of the most enduring legends on Route 66.

THE GHOST TOWNS OF ROUTE 66 in the Grand Canyon State are a diverse lot of mining camps and railroad towns, rough-and-tumble cattle towns and tourism meccas, with two lanes of asphalt linking them all.

With Flagstaff as a median, the ghost towns in the eastern part of the state are largely the remnants of trading posts turned highway service centers. These, as well as the ruins of tourism outposts, such as the isolated Painted Desert Trading Post, are a photographer's paradise because each is framed by truly stunning Western landscapes.

In the western half of the state, you will find the longest uninterrupted stretch of Route 66 in existence. This time capsule section of the highway—peppered with the steepest grades, the sharpest curves, and quintessential Western ghost towns—features tangible remnants of every era of this road's history and its predecessors, the Beale Wagon Road and the National Old Trails Highway. Here you will also find icons of the modern era of resurgent interest.

GHOSTS OF THE PAINTED DESERT

ROUTE 66 FROM THE NEW MEXICO state line to Flagstaff is a broken ribbon of asphalt through some of the most breathtaking landscapes in the Southwest. This is the land of the Painted Desert and the Petrified Forest, of Canyon Diablo and Meteor Crater.

The ghost towns and empty trading posts dot the old roadside as it winds through the colorful sands and through the shadows of looming buttes.

Lupton, located just inside the state line, had a population of thirty-three in 1946 and was the location for the state point of entry inspection station. The post office was established here in 1917, and Jack Rittenhouse notes in 1946 that the town consisted of "gas stations; store; no other facilities."

This "gas station" and "store" were part of the Indian Trail Trading Post established by Max and Amelia Ortega. In 1965, the completion of Interstate 40 to Lupton resulted in the razing of the facility, and today the site is an access road to a rest stop.

Allantown, the next town to the west, never really became a town and, in 1946, consisted solely of Stafford's Café. The café also served as a gas station, grocery store, and gift shop. Rittenhouse notes that, from Allantown, "the trees become more sparse, and you begin to enter a stretch

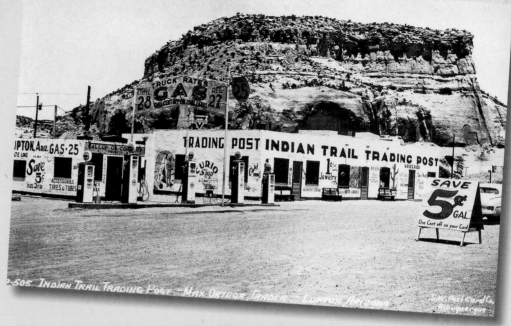

Lupton may never have been much more than a wide spot in the road, but there was a time when the steady hum of traffic past town never quieted. *Joe Sonderman collection*

Early tourists expected the Wild West when they reached the Arizona border, and the proprietors of the trading post in Houck did not disappoint them. *Joe Sonderman collection*

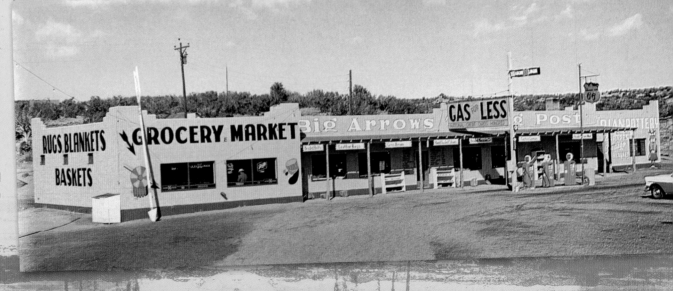

of over 125 miles of almost barren country." This "barren country" is a stark but multi-hued plain dotted with colorful spires of stone and ridges of stone that appear in the red-tinged soil as the bleached bones of the earth itself, where high winds, especially in the months of winter, often result in the closure of Interstate 40.

Houck is the oldest of these forlorn outposts of civilization, dating to the construction of a trading post by James D. Houck in 1877. The first incarnation of modernity was the establishment of Houcks Tank post office in December 1884, three years after the railroad established a siding and section house at the site.

In 1895, an application for the renaming of the post office as "Houcks" was submitted, and it was under this name that it remained open until 1930. The Navajos lounging around the trading post drinking soda pop fascinated Jack Rittenhouse on his 1946 visit.

The Log Cabin Trading Post capitalized on its territorial origins to give travelers on the National Old Trails Highway and Route 66 a taste of the Old West. *Joe Sonderman collection*

When You Go

Lupton is accessed via exit 359 on Interstate 40, Houck at exit 348, and both Sanders and Chambers from exit 339.

Today, all three communities are known for their collection of vintage tourist traps rather than their frontier-era origins. Counted among the most famous of these "trading posts" are Ortega's, Fort Courage, and the Chief Yellowhorse.

Sanders was, and is, the first town of any size in Arizona for travelers headed west on Route 66. Rittenhouse notes it had a population of eighty-eight in 1946, serviced by the Tipton Brothers Trading Post and two gas stations.

Surprisingly, this dusty little oasis houses a number of fascinating Route 66 survivors that are often missed by modern visitors. These include the bridge over the Rio Puerco River, constructed in 1923 east of town, and the classic Valentine Diner in the "business district."

The little diner, relocated from Holbrook and ingenuously mated with a house trailer, is truly one of a kind. Even on Route 66, where ingenuity reigns supreme, this café is unique.

Travel notes from a 1921 tour guide describe Sanders as follows: "On the main A. T. & S. F. R. R. about 20 miles west of New Mexico line. First called Sanders, for C.W. Sanders, office engineer, A.T. & S. F. R. R. Changed to Cheto because of another Sanders station on Santa Fe." This did not keep Art Sanders, owner of the trading post, from claiming he was the town's namesake.

As with Houck, the need for a post office in Sanders was not consistent. The post office opened in 1896 under the name Cheto, then closed a few years later. It reopened in 1932 as Sanders.

Rittenhouse said of Chambers that it "Consists of one small tourist court, 2 gas stations, Riggs café, and a few buildings." And this little desert oasis was not immune to conflicted identity.

Charles Chambers established a trading post on the site in the mid-1870s, but the little station and siding was named after Edward Chambers, vice president of the Santa Fe Railroad, not the trading post owner. It was under Edward Chambers' name that the first post office opened in 1907 with Frank L. Hathorne as postmaster.

In 1926, the approval of a new application made it official: Chambers changed its name to Halloysite, after a mineral mined in the area. The name change was short-lived, though, and in 1930 a new postal application restored the original moniker of Chambers.

Early maps indicate several small towns perched on Route 66 as the original highway climbed into the Technicolor wonderland that is the Painted Desert and Petrified Forest, but in actuality, Navajo, Adamana, and Goodwater never were more than trading posts that offered the most basic of services. Likewise with the "towns" listed between Holbrook and Flagstaff. Of the exceptions, Winona and Winslow were the only ones to warrant a post office.

In his classic Route 66 anthem, Bobby Troup elevated tiny Winona to levels far higher than its importance or size warranted. It never did cast a very large shadow on that historic highway. Established as a siding in 1886 under the name Walnut, the name changed the following year to avoid duplication of another town, and around 1920, the small community was abandoned and the trading post relocated to its present spot along the realigned National Old Trails Highway.

Rittenhouse lists the Winona Trading Post, with its café, gas station, grocery store, and cabins, as occupying the lion's share of Winona. It was here in 1924 that the post office was established.

Two Guns and Canyon Diablo

Two Guns is an iconic Route 66 location with a reputation carefully crafted for tourists during the glory days of the old double six. The original establishment capitalized on the stunning majesty of Canyon Diablo—which was still spanned by a beautiful concrete bridge built for the National Old Trails Highway—and the legend of "Two Guns" Miller.

A colorful character, Miller claimed to be an Apache. Legend has it that he killed a neighbor who shared the canyon, was acquitted when the jury ruled the act self-defense, and then went to jail for defacing the grave after a fit of anger led him to erase the epitaph "Killed by Indian Miller." The Two Guns attraction evolved over the years to include a zoo with desert animals, a variety of manmade "ruins" built into the canyon walls, and Miller's cave.

Ironically, few tourists who stopped to see Two Guns realized that just to the north was a real Western ghost town, called Canyon Diablo, with a very violent history. Canyon Diablo began life in 1881 as a railroad construction camp for the bridging of the chasm. The camp grew into a small collection of bordellos and saloons with a well-deserved reputation for lawlessness. The town became a haven for unruly elements of society. Not surprisingly, there were numerous gunfights and at least two train robberies, plus the staging of an amazing three-week, six-hundred-mile chase of robbery suspects led by Bucky O'Neill, a larger-than-life figure who met his end as a Rough Rider in the Spanish-American War.

A fast-fading mural is among the last vestiges of a tourism gold mine built on the legend of Two Guns Miller.

The extensive ruins and the solid nature of their construction convey the importance of Two Guns to Route 66 travelers west of Winslow.

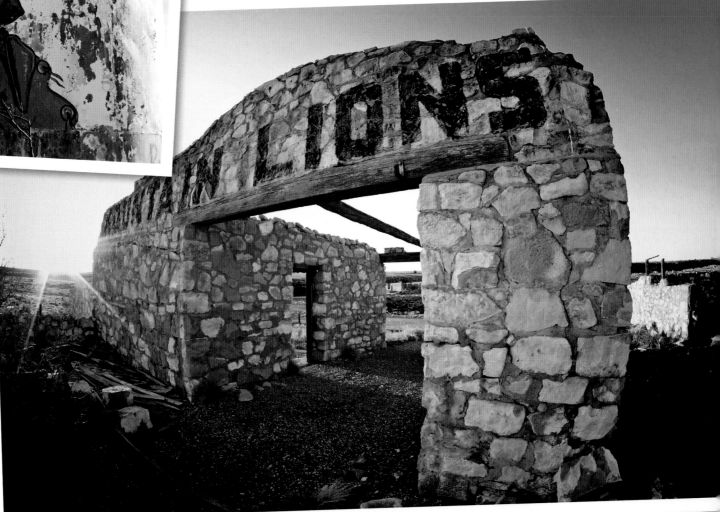

The recently refurbished Frontier Café and Motel neon sign and mural stand in stark contrast to the dusty, worn remnants of Truxton's other roadside survivors.

IN THE FOOTSTEPS OF THE CAMEL CORPS

ON THE ROAD FROM SELIGMAN to Kingman, vestiges of Route 66 blend seamlessly with those of the territorial era and the period of modern rediscovery. Fittingly, one of the ghost towns on this stretch was born to meet the needs of the Route 66 traveler, and another was a frontier-era mining town that survived by morphing into a roadside oasis for the modern traveler.

The road west from Seligman rolls across the wide Aubrey Valley, past the ruins of Hyde Park (promoted by signs that read "Park Your Hide Tonight at Hyde Park"), past Grand Canyon Caverns with its iconic towering green dinosaur, through the center of the Hualapai Indian Reservation at Peach Springs, past the 1927 Osterman Service Station, and into Truxton.

The town of Truxton is a relatively recent phenomenon, dating to 1950. The nearby springs that provided the name for the town, however, have a cultural history that spans centuries. In 1775, Father Garces met with a clan of Hualapai at the springs. In 1851, Captain Lorenzo Sitgreaves camped at these springs during his explorations; likewise with Lieutenant Edward Beale in October 1857.

Lieutenant Beale, famous for his explorations testing the viability of camels for military transport in the desert under orders from Secretary of War Jefferson Davis, named the waters Truxton Springs after his mother, Emily Truxton Beale. The northern Arizona road surveyed by Beale became the path followed by the railroad in the 1880s, then the National Old Trails Highway, and finally Route 66.

Clyde McCune cofounded the town of Truxton. In an interview with Jon Robinson for *Route 66: Lives on the Road*, McCune describes the town's origins:

The Department of the Interior had been talking about building a dam across the Colorado River at Bridge Canyon, and the reasonable way to get to that from Highway 66 was the take off there from Truxton.

The road would have gone up to the reservation and then taken what we call the Buck and Doe Road out to the canyon. That's the reason we set up our business there in 1950.

When You Go

Route 66 is accessed by taking exit 139 on Interstate 40, Crookton Road, just west of Ashfork.

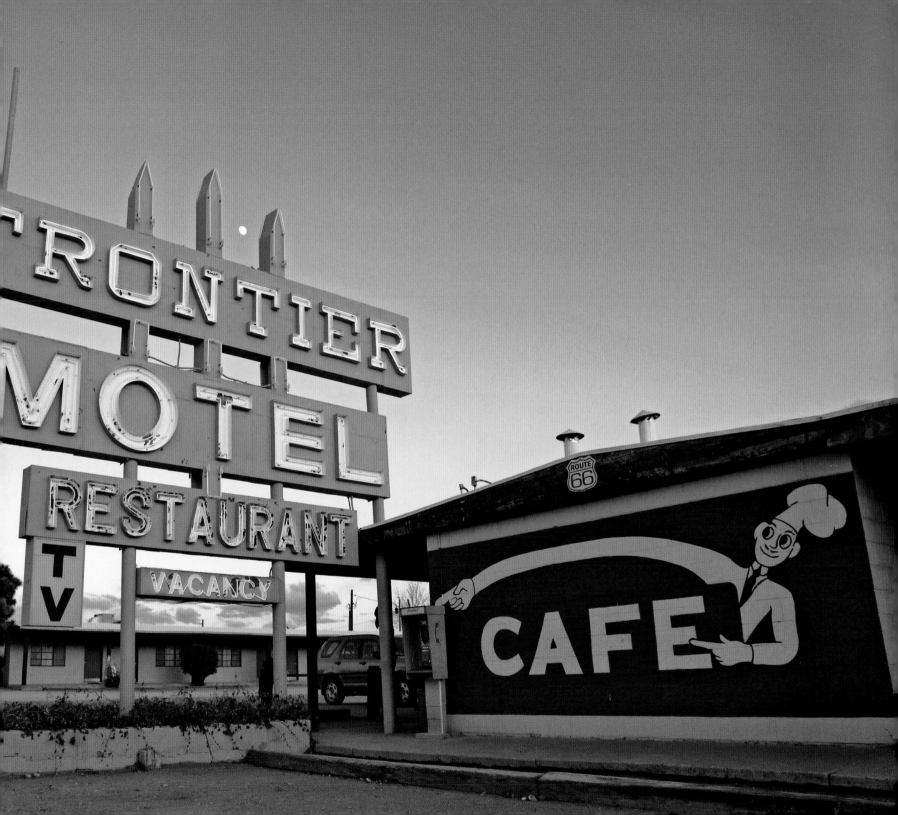

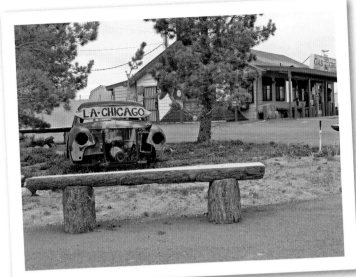

Cowgill's Market in Truxton captures the essence of classic Route 66 with the ruins of a vintage Ford, a colorful mural, and a shaded place to rest out of the desert sun. *Jim Hinckley*

The dam never materialized, but the Truxton Garage opened by McCune and Don Dilts prospered. In fact, it proved so prosperous that Dilts soon opened a service station and restaurant next door.

In rapid succession, other entrepreneurs followed suit. Soon, service stations, motels, restaurants, and garages crowded the shoulder of Route 66 in the wide valley at the head of Crozier Canyon. With the opening of Interstate 40 and the bypass of this section of Route 66 on September 22, 1978, Truxton rapidly began to regress to its pre-1960 origins.

Today, the little town dwarfed by cinematic Western landscapes maintains the slightest of pulses with the Frontier Café and Motel and its refurbished neon, a bar, Cowgill's Market, and a garage/service station that still meets the needs of Route 66 travelers, area ranchers, and the residents of Peach Springs.

Littering the roadside from Truxton to Hackberry are remnants that reflect more than a century of western Arizona history. The Crozier Canyon Ranch dates to the 1870s, and the tourist cabins that were a part of the 7-V Ranch Resort provide a tangible link to the infancy of Route 66 and an alignment bypassed in 1939.

In Valentine, the towering red brick schoolhouse of the Truxton Canyon Indian Agency is shaded by the flanks of looming buttes and mesas. The structure stands in mute testimony to the dark era when Native American children, removed from their families, were kept at boarding schools and taught to be "white." Just down the road, the empty garages, service stations, motels,

The large sign at Cowgill's Market feed barn leaves little doubt that the main street in Truxton is Route 66. *Jim Hinckley*

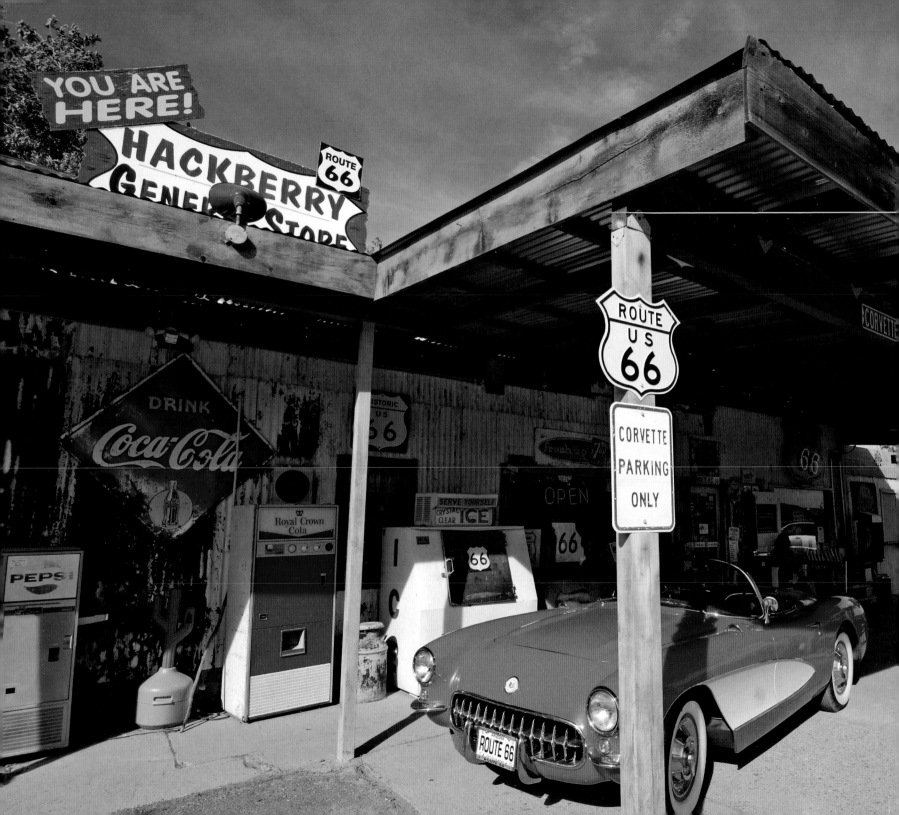

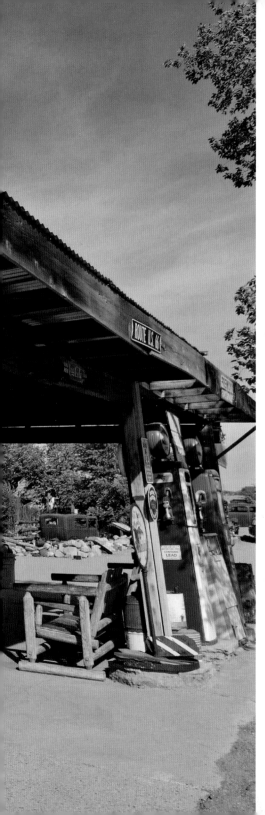

The Hackberry General Store, with its eclectic collection of roadside Americana that serves as the backdrop for a bevy of vintage vehicles, has become a Route 66 icon.

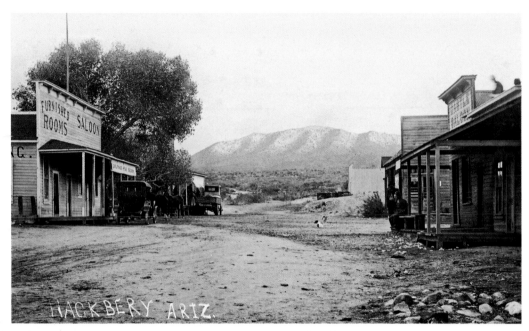

Hackberry, circa 1916, was a town that from its rocky main street to its false-fronted stores reflected its territorial origins. *Mohave Museum of History and Arts*

and post office with their darkened neon and glassless windows appear as a movie set in a post-apocalyptic world.

Against this background of forlorn abandonment framed by breathtaking landscapes is the rustic and colorful Hackberry General Store, a Route 66 time capsule transformed into a cornucopia of roadside Americana circa 1960. The town of Hackberry is located on the south side of the tracks along the original Route 66 alignment, the National Old Trails Highway. The general store is authentic, but it dates to the early 1930s, making it a relatively recent addition to the town of Hackberry.

Near the springs shaded by a large hackberry tree that Lieutenant Beale designated Gardiner Springs on his 1857 expedition, prospectors discovered a rich vein of gold ore in 1871. The rush was on.

By 1874, a five-stamp mill was transforming ore from this and other mines in the surrounding hills into profit, and the town of Hackberry was such a bustling community that the territorial legislature considered designating it the county seat. However, the promising future quickly grew dim, and by 1876, with depletion of the primary ore body and closure of the main mine, the town began a rapid slide into oblivion.

As it turned out, the slide was a very long one. In late 1881, the tracks for the new westbound railroad reached Hackberry, and the springs took on a new importance that again spurred growth of the little town. (Interestingly, signage at the cemetery indicates origins dating to 1884. However, weathered monuments in the graveyard provide stark evidence that the hilltop was used for this purpose much earlier.)

In 1883, the tracks reached the site of Kingman, a town located directly between the mining boom in the Cerbat Mountains and the vast ranching empires in the Hualapai and Sacramento valleys. Hackberry was again eclipsed. The slide resumed, and by 1900, only a few ranching families called Hackberry home.

The next glimmer of hope arrived in the dust of motorists traveling the National Old Trails Highway (Route 66 after 1926) and slightly dimmed with the realignment of the highway to the north side of the tracks in 1936. The bypass of the highway by Interstate 40 in 1978 proved to be the town's swan song.

Today, on the north side of the tracks, the Hackberry General Store and various ruins stand as a monument to that final chapter. On the south side, the old mission-styled two-room schoolhouse, a tiny post office, an old boardinghouse, the towering water tanks that supplied steam-powered trains, and a picturesque cemetery are often-missed memorials to the first chapter.

CHASING LOUIS CHEVROLET

FROM KINGMAN, ROUTE 66 follows two distinctive routes to the Colorado River. The first is, arguably, the most scenic section of Route 66 that remains intact. It follows in the tracks of Louis Chevrolet through the Black Mountains, since this was the path of the 1914 Desert Classic "Cactus Derby" race. The second is the 1952 bypass of this mountainous course, now largely erased by Interstate 40.

On the pre-1952 alignment of the highway, which was also the path of the National Old Trails Highway through the Black Mountains, there are two classic Western mining towns. One is a true ghost with a population of zero. The second is a mere shadow of what it once was, but it is more re-creation than authentic.

Prospectors had wandered these mountains since at least the 1850s and on occasion even found color, but it was the discovery of a major ore body on the west side of Sitgreaves Pass in 1902 that sparked a boom that gave rise to Acme and, a few miles to the west, Oatman.

Within twelve months, the town that rose around Joe Jenerez's discovery was large enough to warrant a post office, but the narrow, rocky canyons severely restricted growth. Three years later, in 1906, the name changed from Acme to Goldroad, but growth remained almost stagnant.

The following year, the primary mine closed after the high-grade ore bodies were exhausted. Only limited mining

From the summit of Sitgreaves Pass, it is easy to see why growth in Goldroad was severely restricted by the canyons and steep slopes of the Black Mountains. *Jim Hinckley*

When You Go

From the Power House Visitor Center and Route 66 Museum in Kingman, continue west on U.S. 66. Take the left curve behind the Mohave Museum of History & Arts. Cross under Interstate 40 just west of Crazy Fred's Truck Stop, and at the four-way stop, turn left onto Oatman Road.

The road through the Black Mountains features the sharpest curves and steepest grades found anywhere on Route 66, and as a result, large RVs or trucks with trailers are not recommended. For these vehicles, it is best to use exit 1 on Interstate 40.

operations—and, after 1912, tourism traffic on the National Old Trails Highway—prevented the town from vanishing.

A boom of sorts in 1937 came with improved extraction methods and new ore discoveries. The mines closed again in 1942, reopened in 1946, and closed permanently in 1948. Spurred by a new Arizona tax law, which held property owners liable for taxes on structures regardless of occupancy, led to the razing of almost the entire town.

An interesting Route 66-related footnote pertains to a garage and service station in Goldroad. The station offered towing service, or a driver, for those heading east over the steep grades and sharp curves (the sharpest and steepest found anywhere on that highway) to the summit of Sitgreaves Pass. Jack Rittenhouse notes, "At last inquiry their charge was $3.50, but may be higher." As perspective, consider that gasoline averaged around twenty cents per gallon.

The sharpest curve found anywhere on Route 66 winds above Goldroad and is seen through the guardrail on that highway's predecessor, the National Old Trails Highway. *Jim Hinckley*

A vintage Goldroad postcard shows just how steep the pre-1952 alignment of Route 66 through the Black Mountains was. *Joe Sonderman collection*

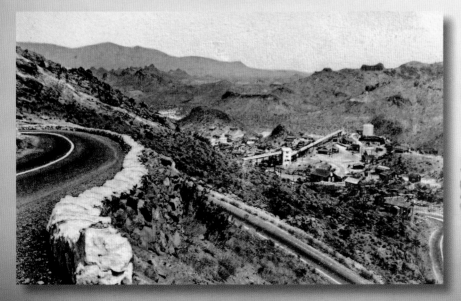

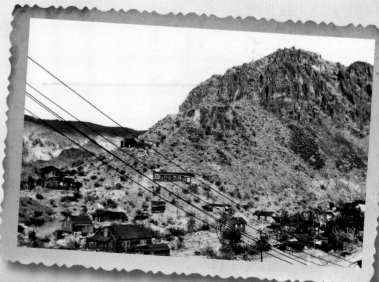

In 1925, the year before the designation of U.S. 66, Goldroad was a mining boomtown about to be transformed by a sea of automotive traffic. *Mohave Museum of History and Arts*

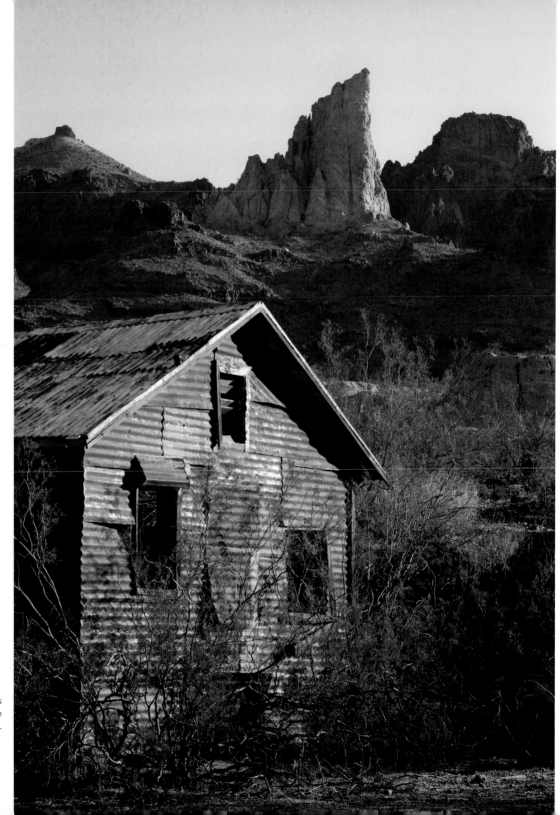

Nestled in its scenic, narrow canyon, the site of Goldroad is dominated today by a new mining operation, mine tailings, concrete slabs, and a fascinating section of old road with stone bridges that dates to 1905 and that served as the first alignment of the National Old Trails Highway.

Oatman, a few miles to the west, was also a mining town. Because the town centered on the massive complex of the Vivian Mining Company, the post office opened in 1903 under the name Vivian. In 1909, it changed to Oatman in reference to the rescue of Olive Oatman—a young girl taken captive several years previously and sold into slavery with the Mohave Indians—near the town site in 1857.

In 1910, the discovery of an even richer deposit led to the establishment of the Tom Reed Mine, and within a few months, it was in sight to eclipse the record of three million

The spire of the Elephant's Tooth dominates this skyline of imposing peaks and cliffs in the Black Mountains above Oatman.

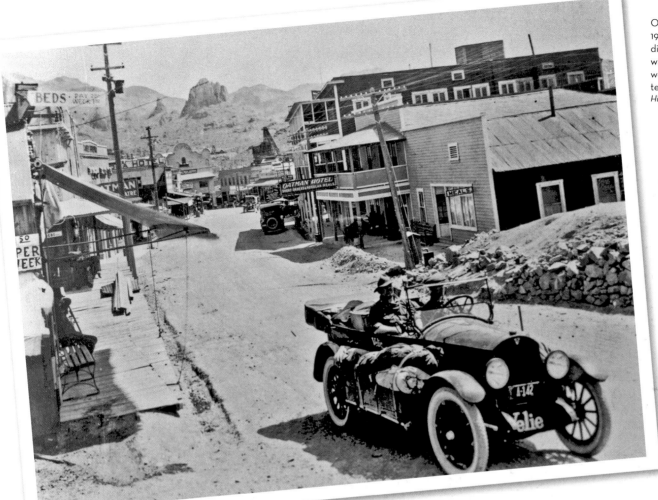

Oatman, established in 1902 in the shadow of the distinctive Elephant's Tooth, was the largest town in western Arizona by the late teens. *Mohave Museum of History and Arts*

dollars in gold extracted from the Vivian Mine. With the establishment of the Oatman Mining District, which included the mines at Goldroad, this became the largest gold-producing district in the territory of Arizona.

Further fueling growth was the National Old Trails Highway, Route 66 after 1926.

Estimates place Oatman's population during the early 1920s as several thousand. The business district included a theater, a lumber company, general stores, garages, service stations, restaurants, saloons, and hotels—including Oatman Hotel, the oldest and largest adobe structure in Mohave County.

The raucous mining town has had a number of brushes with fame. In 1914, Louis Chevrolet, Barney Oldfield, and other drivers roared through town in the last of the great Desert Classic "Cactus Derby" races.

In 1938, after marrying in Kingman, Clark Gable and Carol Lombard spent their first

night as husband and wife at the Oatman Hotel. During the 1950s and 1960s, numerous movies were filmed here including *How the West Was Won*, *Foxfire*, and *Edge of Eternity*.

The slide to obscurity began in the 1930s, escalated with the 1942 closure of the mines, and culminated with the bypass of Route 66 in 1952. Rittenhouse notes that the Oatman of 1946 was "a mining boom town whose day has passed, although a few mines still operate. US 66 passes through the town's one main street. Along one side are boarded up stores, plank sidewalks, old sidewalk awnings."

Oatman today is again a boomtown. This time it is tourism on Route 66, not gold, that keeps the stores open. During such events as the Route 66 Fun Run, held on the first weekend in May, the town becomes a living snapshot from when Route 66 was truly the Main Street of America and the main street of Oatman.

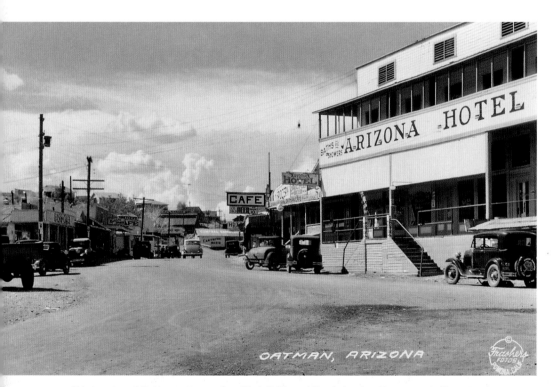

In Oatman, Route 66 is the main street and was the catalyst that transformed the old town into an icon recognized throughout the world.

This is a view of Oatman as it was when Clark Gable and Carole Lombard honeymooned here in 1939. *Joe Sonderman collection*

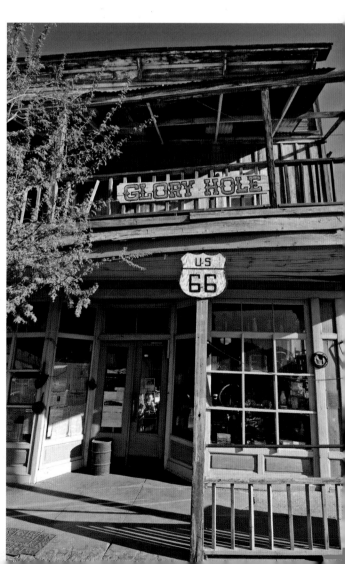

ROUTE 66, THE FORGOTTEN CHAPTER

THE LAST GHOST TOWN on Route 66 in western Arizona is on the post-1952 alignment of Route 66, now Interstate 40. While almost nothing remains to indicate the territorial origins of Yucca, you'll find a wide array of remnants from the Route 66 era.

Ranching, railroading, and providing supplies for remote mines in the surrounding hills formed the foundation of Yucca. Growth proved elusive, but by 1905, the community was large enough to justify the establishment of a post office, and a school soon followed.

Some maps for the National Old Trails Highway dated 1914 indicate that Yucca was on an alternate route for those wishing to bypass the grades and curves of the main road through the Black Mountains. Tying into this alternate route was the primary road from Kingman to Phoenix, a road that crossed the Bill Williams River near Alamo Crossing, a small mill town to the south.

During World War II, the town received an added boost with the establishment of an auxiliary airfield for the massive Kingman Army Airfield training complex. Ford Motor Company transformed this abandoned airfield in 1955 into a test facility, currently operated by Chrysler.

With the realignment of Route 66 in 1952, Yucca briefly boomed. Vestiges from this period include the Honolulu Club (relocated from Oatman), a motel, a garage, café ruins, foundations, and a towering Whiting Brothers sign that looms over a field of weeds and broken concrete.

The recent acquisition of mining claims in the area of the old Boriana Mines south of Yucca by a large mining conglomerate may signal a new boom. This is the largest known deposit of tungsten in the United States.

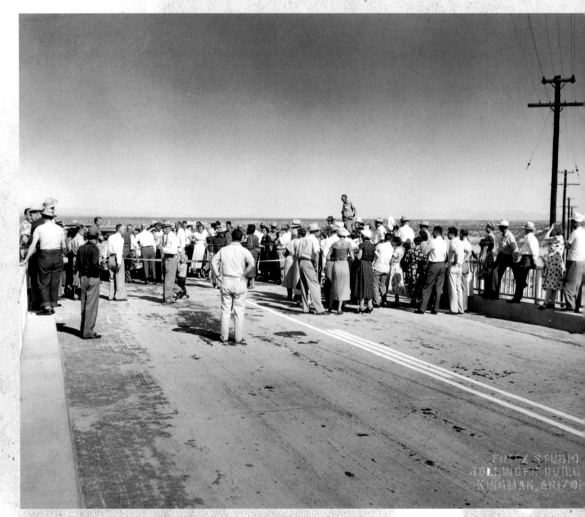

The 1952 opening of the Black Mountains bypass proved the death knell for Oatman and Goldroad, and the catalyst for the rise of Yucca. *Mohave Museum of History and Arts*

Forlorn remnants, empty lots shadowed by towering signs, and empty cafés line old Route 66, now a frontage road for Interstate 40, in Yucca. *Jim Hinckley*

When You Go

Remnants of Yucca's past line the north and south sides of Interstate 40 and are accessed from exit 25.

How long before harsh desert wind and vandals erase this vestige of Yucca's glory days?
Jim Hinckley

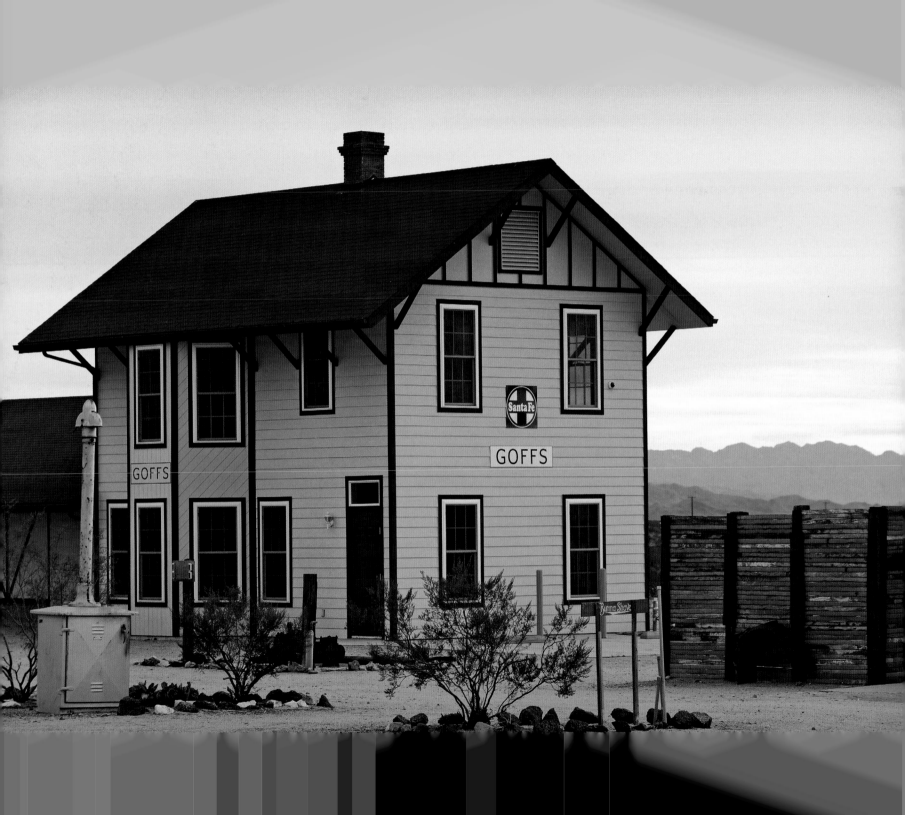

CALIFORNIA

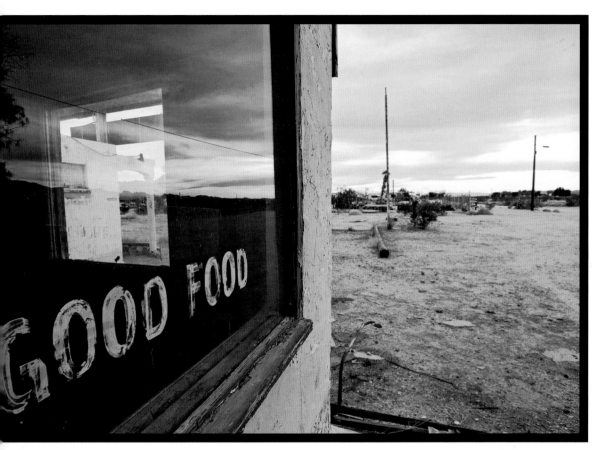

In the café in Essex, tourists no longer seek respite from the blazing sun, nor do truckers warm their hands around a cup of joe.

IN THE GOLDEN STATE, the ghost towns of Route 66 appear as forlorn, weathered islands in a sea of harsh, forbidding desert landscapes. Only a thin line of pockmarked asphalt tethers them tenuously to the modern era and keeps them from vanishing unnoticed beneath the desert sands.

Most were never more than rustic, roughhewn places that offered only the most rudimentary of services, but to travelers on the old double six they were literally lifesaving oases. Others were once teeming, modern communities with bright and prosperous futures.

For all of the towns—whether outposts built upon the needs of the motorist or mining and railroad centers that morphed into roadside boomtowns—Route 66 was their lifeblood. They mirrored the highway then, and they mirror it today with dusty, sunbaked streets and empty cafés, garages, and motels.

GOFFS

Bypassed by realignment in late 1931, Goffs was an early casualty of the societal evolution that led to the demise of Route 66. This bypass proved to be the final blow for the remote community whose foundation was as a transportation hub. In retrospect, Goffs was the Ghost of Christmas Yet To Come for countless towns along Route 66.

The establishment of Goffs exemplifies the old adage that with real estate, three things are crucial: location, location, location. From Needles on the Colorado River or from the depths of the Mojave Desert valleys to the west, the site for Goffs was the top of the hill. For the Southern Pacific Railroad in 1883, this made it an ideal place for a siding, water, and fuel stop. As mining and ranching developed in the surrounding regions and the railroad expanded to meet these needs, Goffs' prominence and importance grew.

The discovery of major silver and gold deposits in Searchlight, Nevada, spawned the 1893 creation of a short line, the Nevada Southern Railway, which linked the mines there with the main line at Goffs. The California Eastern Railroad and eventually the Santa Fe Railroad operated this line until its discontinuance in 1923.

The railroad needed water, which meant that, at regular distances across the dry desert, sidings with wells were established. As a result, early automobile roads and highways closely followed the railroad's path across the harsh desert plains.

This placed Goffs in an enviable position during the teens. Not only was the town the site for an important rail switching yard, it was also a junction for the National Old Trails Highway and the Arrowhead Highway. The latter was the

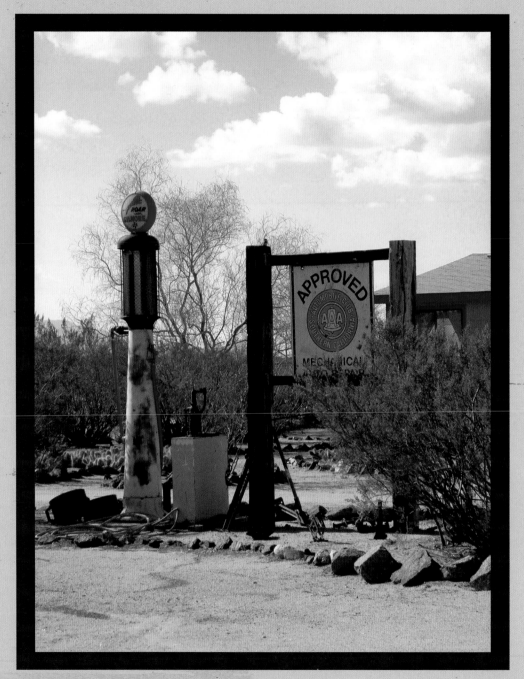

At the Schoolhouse Outdoor Museum Trail in Goffs, the setting may be staged, but the props are authentic.
Jim Hinckley

primary road connecting Los Angeles with Salt Lake City in Utah.

Reflecting the town's prominence as a transportation hub was the mission-style schoolhouse built of lumber and stucco in 1914. In addition to the eight-hundred-square-foot classroom that doubled as an auditorium for community dances and church services, the building featured a library and two covered porches.

The slide into oblivion began in the early 1920s, first with abandonment of the short line to Searchlight and then with consolidation of railroad service in Needles and Barstow. The commissioning of U.S. 66 that followed the path of the National Old Trails Highway across the desert was but a temporary ray of hope for the remote desert town; five years later, realignment to the south along the present path of Interstate 40 left the town high and dry.

When You Go

Follow Interstate 40 west from Needles to exit 133, the junction with U.S. Highway 95, and turn north toward Las Vegas. Just south of the railroad crossing, turn right to go west on Goffs Road. This is the pre-1931 alignment of Route 66.

ARMY CAMP AT GOFFS DESERT TRAINING CENTER CALIFORNIA-ARIZONA MANEUVER AREA

THE U. S. ARMY MAINTAINED A CAMP AT GOFFS 1942-1944. GOFFS WAS AN IMPORTANT RAILHEAD, SUPPLY POINT, HOSPITAL, AND FOR THREE MONTHS IN 1942 HEADQUARTERS OF THE 7TH INFANTRY DIVISION. THAT UNIT WENT ON TO DISTINGUISH ITSELF IN COMBAT IN THE ALEUTIANS AND AT KWAJALEIN, LEYTE, AND OKINAWA. THIS MONUMENT IS DEDICATED TO ALL THE MEN AND WOMEN OF THE U. S. ARMY WHO SERVED HERE WITH A SPECIAL SALUTE TO THOSE WHO LAID DOWN THEIR LIVES FOR THEIR COUNTRY.

PLAQUE DEDICATED OCTOBER 12, 2008 BY THE BILLY HOLCOMB CHAPTER OF THE ANCIENT AND HONORABLE ORDER OF E CLAMPUS VITUS IN COOPERATION WITH THE MOJAVE DESERT HERITAGE & CULTURAL ASSOCIATION

A plaque commemorates forgotten Goffs' role in World War II. *Jim Hinckley*

By 1937, the population no longer warranted a school, and the town quickly slipped toward becoming a footnote in the long history of the Mojave Desert. Fittingly, the old schoolhouse, once the crown jewel of a progressive community, played a key role in the next chapter of the town's history.

During World War II, large swaths of the formidable desert became a stage for the largest war games training center in history as General George S. Patton prepared his troops for the invasion of North Africa. The temporary population of Goffs ebbed and flowed as the army garrisoned soldiers in the area, dismantled abandoned buildings

to use for fuel in wood-burning stoves, and transformed the schoolhouse into a mess hall to feed thousands of troops.

After the war, the town again slipped into a deep slumber, and the old schoolhouse became a private residence, a purpose it served until 1954. After its abandonment, the schoolhouse became a habitat for pack

On most days, the wind through the greasewood, the creaking of the windmill, and an occasional barking dog are the only sounds heard in Goffs.

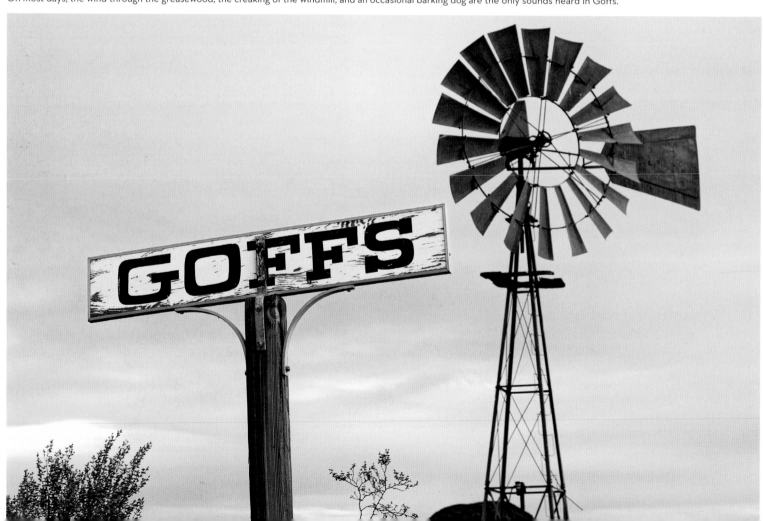

rats and snakes seeking shelter from the blazing sun. Vandals and the harsh desert climate quickly transformed the once stately edifice into ruins that mirrored the town around it.

The schoolhouse's resurrection began in 1982 with the vision of Jim and Bertha Wold, employees of the OX Ranch north of Goffs. After purchasing the property, the Wolds stabilized the old schoolhouse, which was literally on the verge of collapse with most of the east wall gone and the roof sagging by several feet.

The next and most amazing chapter in the history of this forlorn, forgotten little town, surrounded by some of the most inhospitable landscape in America, came with the acquisition of the property by Dennis and Jo Ann Casebier. Their passionate stewardship, leadership, and hard labor have, with the assistance of countless volunteers, transformed the old schoolhouse and the ghost town of Goffs into one of the most astounding and, perhaps, most overlooked treasures on Route 66.

An eclectic collection of souvenirs representing more than a century and a half of life in the Mojave Desert surrounds the schoolhouse-turned-museum. The building also serves as headquarters for the Mojave Desert Heritage & Cultural Association. There is no neon or kitsch—just a small grove of trees, a windmill, and other trappings of a desert oasis to catch the passing motorist's eye.

Those who stop are pleasantly surprised. The old schoolhouse appears as it did in 1914. Inside is a dazzling array of simple exhibits that range from fine art, rare photographs, and arrows to a functioning wood-burning caboose stove that provides heat in the winter and artifacts from World War II.

Throughout the well-maintained grounds, and linked by pleasant little trails, are artifacts ranging from a weatherworn 1921 Buick to an Atlantic & Pacific boxcar more than a century old. The bronze eagle on the flagpole is from General George S. Patton's Indio headquarters. The site contains an operational stamp mill painstakingly moved from an old mine and reassembled on site as well as a collection of bottles with glass turned purple from the desert sun, vintage highway signs, and gas pumps. You'll find telephone poles from the first transcontinental telephone line and an aircraft beacon dating to the 1920s, ore cars and antique railroad crossing gates, and pumps, crushers, and other mining equipment that predate Route 66 by decades.

To say the very least, the schoolhouse and outdoor museum add flesh to the dry, dusty bones of the forgotten outpost of Goffs.

The empty windows of the old general store framing a desert sky present a haunting image in Goffs.

Essex may have begun life around 1883 as a water stop for the railroad, but it was as an oasis for the motorist that it blossomed from a siding into a very busy wide spot in the road. Adding to its prominence in this capacity were efforts to promote automobile travel and the development of good roads in the Mojave Desert by the Automobile Club of Southern California. The organization drilled a roadside well here to create an oasis with signs that proclaimed "Free Water" in the late teens.

GHOSTS OF THE DESERT CAULDRON

By 1930, the dusty little town was a beehive of activity with a "business district" that met the needs of travelers, a new breed of teamsters known as truckers, the desperate Okies, and the hardy few who eked a living out of the unforgiving desert. The commerce included a market, a garage, a post office, and a service station.

The bypass of Goffs in 1931 greatly increased Essex's importance to Route 66 travelers crossing the desert. Additionally, in 1937, the Goffs school closed, the Goffs School District was absorbed into the Needles Unified School District, and a new schoolhouse was built in Essex.

During World War II, traffic slowed to a crawl, the result of wartime rationing of gasoline. Still, the establishment of Camp Essex Army Airfield three miles to the northeast (a small POW camp for the internment of Italian military personnel) and the vast war games that engulfed the Mojave Desert ensured there was no lack of business for tiny Essex.

Rittenhouse notes that Essex had a population of fifty-five in 1946 and businesses that included a gas station, a lunchroom, a small grocery, and a post office.

When You Go

The Mountain Springs Road exit on Interstate 40, exit 115, seventeen miles west of Needles, is the junction with the post-1931 alignment of Route 66; take this exit south to reach Essex, Danby, Cadiz, Summit, Chambless, Amboy, Bagdad, and Ludlow. A secondary option is to continue west on Interstate 40 through Fenner and take exit 107, Goffs Road, then turn south.

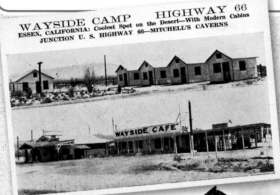

An old postcard captures Essex as a former Route 66 oasis. *Joe Sonderman collection*

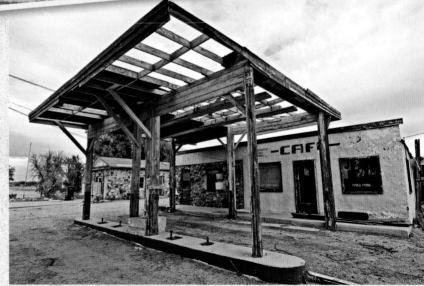

Good food at the café in Essex is as much a distant memory as a shiny new '57 Chevy filing up with high octane at the pump out front.

Essex's brief moment of fame came in 1977 after the bypass of U.S. 66 by Interstate 40. A feature in the *Los Angeles Times* proclaimed that Essex was so remote it was the last community in the continental forty-eight states without television service—after which all thirty-five residents were invited to the *Johnny Carson Show*, and a manufacturer in Pennsylvania donated the necessary translator equipment to move the town into the modern era.

The well remains, even though water is no longer available. The café and garage are closed. Only the post office remains in operation.

Danby, the next town to the west, began life as a water stop for the railroad in the Mojave Desert. These stops, initially named from west to east in alphabetical order, proved important for early motorists.

At some point, Danby morphed into a small oasis on the National Old Trails Highway, Route 66 after 1926. The 1914 edition of the Los Angles/Phoenix route map of the Desert Classic race course indicates that services offered here included repairs, oil, and gas—the same limited services Rittenhouse noted thirty-two years later in his guidebook. Today, a high fence protects the sparse remnants from vandals. The elements are another matter, however, and soon there will be little to mark the site of Danby but ruins.

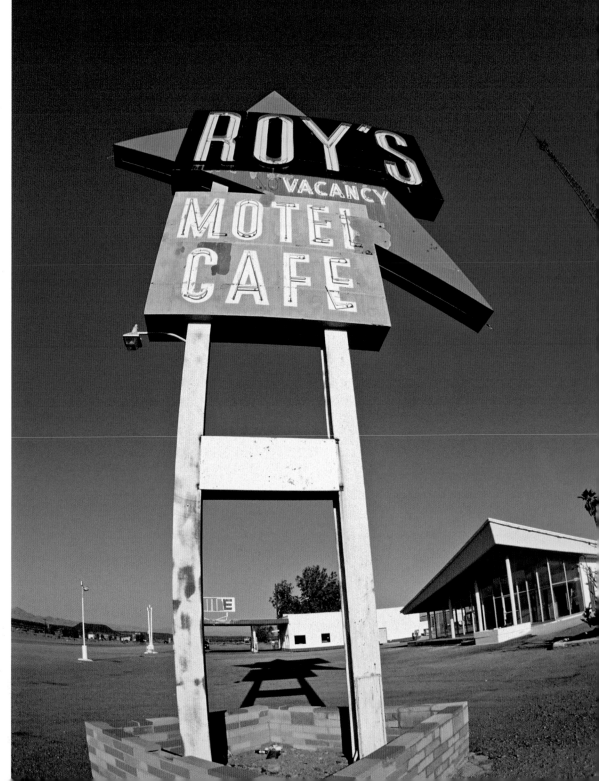

Roy's Motel and Café is one of the most well-known sites along Route 66.

Cadiz has shared origins with Danby. However, its period as a service center for motorists was a short one, for when Route 66 supplanted the National Old Trails Highway, a bypass of three miles left this wide spot in a desert road high and dry.

Nearby on Route 66 are the remains of Summit, occasionally listed as Cadiz Summit. This often results in confusion. Summit was an oasis spawned by Route 66 and the needs of those who drove it. In 1946, Rittenhouse notes that it consisted of "A handful of tourist cabins, a café, and gas station." Today, graffiti covers the ruins of these structures at the top of the pass through the Marble Mountains, and all manner of garbage litters the grounds.

The reason James Albert Chambless chose to relocate from the forested hills of Arkansas to the desolate wilderness of the Mojave Desert is a mystery. What we do know is that the Automobile Club of Southern California noted his proprietorship of a small store at the junction of Cadiz Road and the National Old Trails Highway in 1922 and that, with the 1931 realignment of the highway and its designation as U.S. 66, he relocated his business and reestablished it as Chambless Camp.

Between this point in time and the mid-1930s, Chambless Camp became Chambless, and James Chambless faded into obscurity. During this period, his namesake community grew into a very busy desert oasis that included a grove of trees and a post office, a gas station, motel cabins, a café, and a store.

For Rittenhouse in 1946, Chambless mirrored Danby in that it consisted of a "wide porched gas station, with a café and several tourist cabins." He also noted, "Except for Ludlow, California, there are no 'towns' which merit the definition between Needles and Daggett, California, a stretch of about 150 miles."

The wide porch that once offered travelers the slightest bit of respite from the blistering sun is now gone, victim of a fierce desert storm, but the store built of adobe bricks and the small stone cabins remain. Sequestered behind a towering chainlink fence topped by razor wire, they stand in silent testimony to better times on the old double six and await their resurrection.

Several years ago, Gus Lizalde purchased and fenced the property. His dream to breathe new life into Chambless with its refurbishment as a Route 66 time capsule—and plans for a massive solar-powered generating facility immediately to the west—may once again make the town more than a dusty footnote to the history of the Mojave Desert and Route 66, but at this time the store remains roofless.

The towering Roy's Motel and Café sign erected in 1959 has contributed greatly toward making Amboy one of the most famous ghost towns on Route 66. The sign and its namesake café and gas station have figured prominently in commercials promoting everything from Dodge trucks to Qwest. The sign has also appeared as a backdrop in numerous films, including *Hitcher*, a 1986 thriller starring Rutger Hauer.

By the mid-1980s, the settlement that survived more than a century in one of the most inhospitable places in America had dwindled to less than a shadow of its former self. The bypass of Route 66 by Interstate 40 in the early 1970s, and the subsequent bulldozing of most of the town by the major land owner, Buster Burris, to avoid tax liabilities, hastened its abandonment.

There are indications that salt mining may have taken place near the site of Amboy, as it does today, shortly before the opening salvo of the Civil War. However, it was the establishment of a railroad siding and water stop by the Atlantic & Pacific

Before the rise of Roy's Cafe, with its towering sign, Amboy was a dusty oasis in a sea of desert. *Joe Sonderman collection*

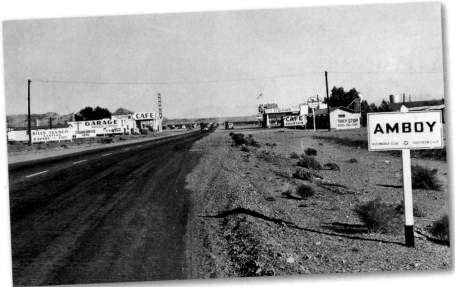

Railroad in 1883 that literally put Amboy on the map.

As such, the little encampment languished until the establishment of the National Old Trails Highway during the teens and the designation of its replacement, U.S. 66. The *Hotel, Garage, Service Station, and AAA Club Directory* of 1927 indicates the population was one hundred and the primary service available was the J. M. Bender Garage.

Notes by Jack Rittenhouse in 1946 clearly indicate the importance of Route 66 in these remote desert communities. "Pop. 264—this desert community consists of two cafés, a garage, and café."

The postwar travel boom and the endless stream of traffic on Route 66 kept the businesses in Amboy busy twenty-four hours a day, seven days a week. They also ensured continued expansion of the miniscule town, and by 1960, the business district included a motel, a second service station that offered gasoline for forty-nine cents per gallon when the national average was somewhere around twenty cents per gallon, and a very busy towing company.

The unofficial mayor of Amboy, Buster Burris, shepherded the small desert community from the infancy of its glory days to its demise. He arrived on the scene in 1938 to assist his father-in-law, Roy Howard, in the management of a motel business. This endeavor soon expanded to include a garage and café, Roy's.

By the early 1950s, Amboy was a boomtown. Three shifts of mechanics worked in the Burris garage, and there was seldom a vacancy at the motel or cabins.

With the completion of Interstate 40 in 1972, Route 66 reverted from a river of gold to an empty, forlorn stretch of dusty asphalt across a desert wilderness. Business in Amboy evaporated quicker than snow in July on the sun-baked pavement. Buster Burris, who eventually owned most of the town, kept the station going for a few more years, but the writing was on the wall.

By the late 1990s, the area population had dwindled to less than fifty. This, however, was not the final chapter.

The resurgent interest in Route 66 led chicken tycoon Albert Okura, founder of Juan Pollo and owner of the original McDonald's in San Bernardino, California, to purchase the entire town in 2005—including the airstrip, Roy's, the church, the schoolhouse, and the remaining houses—from Burris's widow, Bessie. His vision is to transform what remains into a showpiece reflecting the essence of Route 66 circa 1960.

A few miles west of Amboy, Bagdad was even tinier than its neighbor. The 1939 WPA *Guide to California* claimed the population was twenty, and the 1940 census placed it at twenty-five residents. Adding to the mental picture of just how desolate the area was, Rittenhouse says, "Skeletons of abandoned cars are frequent along the roadside." He also records that "Except for a few railroad shacks, this community consists solely of a service station, café, garage, and a few tourist cabins, all operated by one management. At one time, Bagdad was a roaring mining center."

The Amboy School has long been closed. *Jim Hinckley*

There are vague indications that the origins of Bagdad date to as early as 1875 with the establishment of a small camp at the site and mines in the surrounding mountains. However, it is the construction of a siding in 1883 by the Atlantic & Pacific Railroad that serves as Bagdad's agreed-upon date of origin.

The growth of Bagdad—what there was of it, anyway—centered on the railroad, which supplied the needs of remote mines in the area, specifically the Orange Blossom and the War Eagle, as well as shipping ores from a nearby mill. By 1889, the town was large enough to warrant a post office. Two decades later, the remote outpost of civilization consisted of a small depot, a commissary, saloons, a hotel, and even a Harvey House restaurant that catered mostly to railroad employees.

Following the closure of the area's largest mines, a devastating fire erased most of the business district in 1918. The second blow, consolidation of railroad service and repair in Needles and Barstow, followed almost immediately. Only the traffic on the National Old Trails Highway, and later Route 66, prevented complete abandonment.

Today, Bagdad is a historical footnote. Only sand-obscured concrete foundations, a sign designating a railroad siding, a forlorn but surprisingly well-maintained cemetery, and an unofficial railroad record indicating 767 consecutive days between 1912 and 1914 without rain remain to mark its place in history. This is truly a Route 66 ghost town.

Ludlow maintains a faint pulse in the form of a café, service stations, and a motel that serve the occasional Route 66 or Interstate 40 traveler. These businesses, as well as the array of remnants in various stages of decay, hint of better times but offer little clue that—long before the designation of a highway as U.S. 66—this was a town with a promising future.

The tangible links to a long and colorful history in Ludlow are fast succumbing to desert winds, time, and vandals.

Ludlow, as with most Route 66 towns in the Mojave Desert, owes its founding to the railroad and the establishment of sidings at regular intervals during the early 1880s. Moreover, the town named for railroad employee William Ludlow, as with other railroad stops in the desert, owed its initial growth to mining. There the similarities end.

A shortage of dependable wells in Ludlow necessitated the shipping of water by rail from Newberry Springs to the west. By 1900, the limitations on growth were resolved, and Ludlow began to prosper as a supply center. Further fueling growth and the town's prominence in the summer of 1905 was the establishment of the Tonopah & Tidewater Railroad, which linked the main line with the mining boom in the area of Tonopah, Rhyolite, and Beatty in Nevada. Following this line was the establishment of another spur line, the Ludlow & Southern Railroad, which connected the main east–west line of the Santa Fe Railroad with the Buckeye Mining District eight miles to the south.

The boom fueled by the railroad spurs was beginning to ebb when motorists began rolling through town on the National Old Trails Highway. In his 1946 guidebook, Rittenhouse notes, "Although quite small, Ludlow appears to be a real town in comparison to the one establishment places on the way here from Needles."

While most of Ludlow's remnants date to the glory days of Route 66 (roughly 1946 through the 1960s), there are a few notable exceptions. Among these are the 1908 Ludlow Mercantile, severely damaged in a 2006 earthquake, a few old homes, and a haunting desert cemetery.

Gas stations like this once crowded both sides of the highway in Ludlow, but today only one remains open. *Joe Sonderman collection*

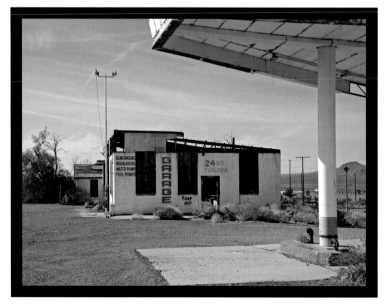

The listing of generator repair as a service offered dates the ruins of a garage along Route 66 in Ludlow. *Jim Hinckley*

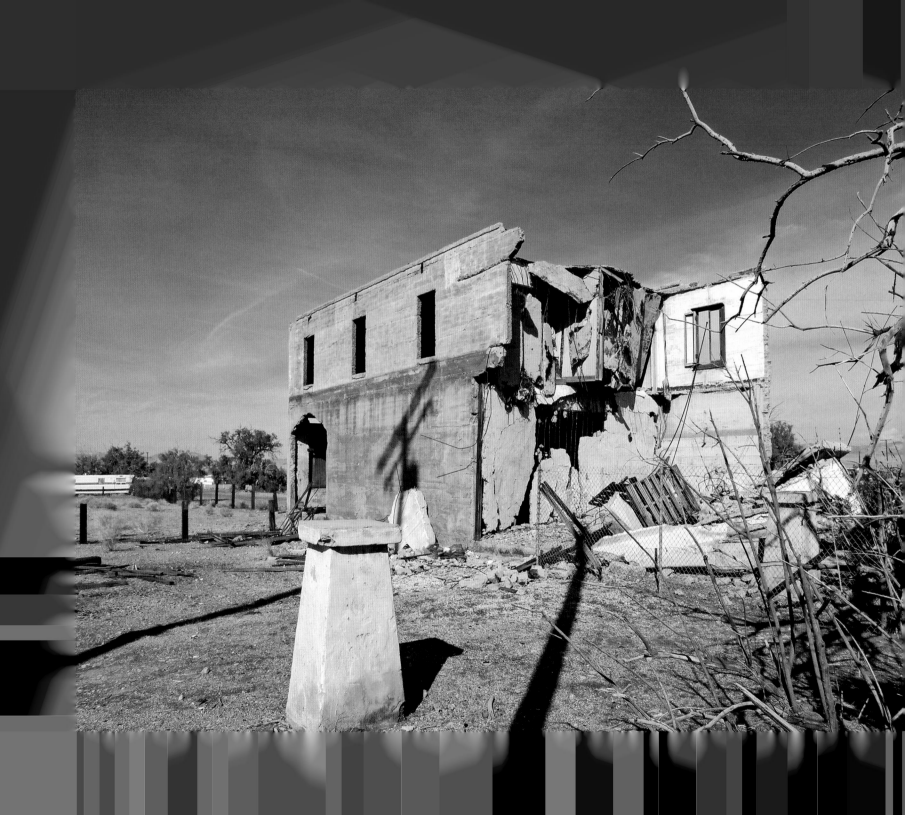

NEWBERRY SPRINGS

AFTER DECADES OF EMULATING LUDLOW in its downward spiral, Newberry Springs (Newberry before 1967) is experiencing a resurgence of sorts. Still, the town remains littered with empty remnants from when it sported five gas stations, four motels, several garages, a barbershop, numerous cafés, souvenir shops, bars, a general store, and a grocery store.

However, even these ghostly vestiges represent modern history here. The springs that gave rise to the town were an important oasis for Native American traders who followed the trade route from the Pacific coast to Hopi and Zuni pueblos in present-day Arizona and New Mexico.

Intrepid Spanish explorer Father Garces followed the trail and stopped at the springs in 1776. In the era of America's westward expansion, the trail became the Mojave Road. Fort Cady was established at the springs to control the vital resource as well as to subjugate the native

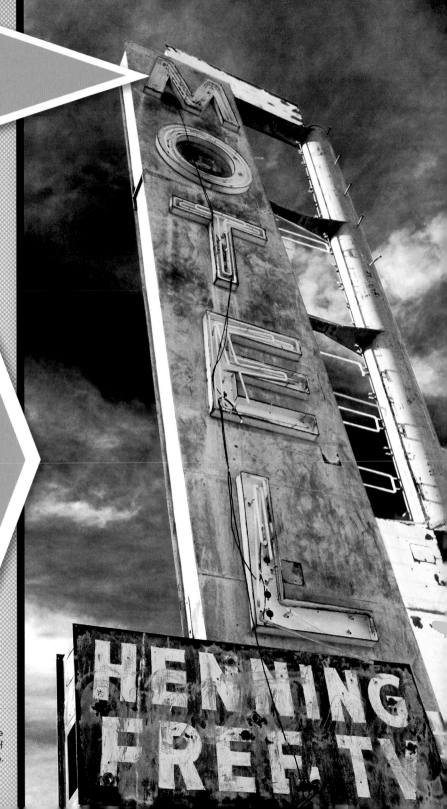

This darkened neon motel sign must have once seemed a welcome lighthouse beacon for those crossing the sea of desert on Route 66.

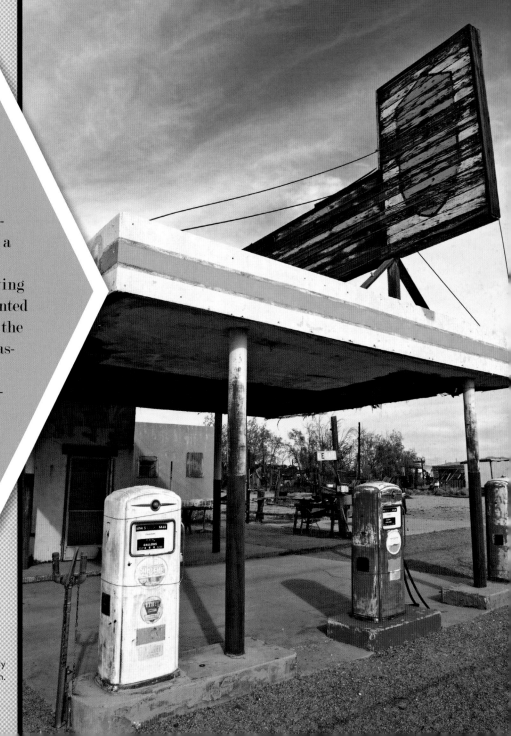

tribes that had turned to raiding along the trail, and farming became a lucrative endeavor.

With completion of the railroad in the early 1880s, the shipping of water enabled the development of several mining centers in the desert, including Ludlow. It also gave farmers access to a wider market for their produce.

With the establishment of Route 66, serving the nearly endless stream of travelers supplanted farming as the financial underpinnings of the springs. Subsequently, the town was devastated by the bypass.

Newberry Springs today stands suspended somewhere between renaissance and ghost town. For fans of the double six, it is a treasure-trove of dusty mementos from better times.

◆

At the long-closed Whiting Brothers station in Newberry Springs, gasoline still sells for forty-nine cents per gallon.

DAGGETT

JUST TO THE EAST OF DAGGETT stands a former agricultural inspection station, now a storage facility, built by the state of California in 1953 to replace one built in 1931, which replaced the original built in 1923. As a historic footnote, director John Ford brought the cast and crew of *Grapes of Wrath* to Daggett's inspection station in 1939 to film the scene where the fictional Joad family is stopped for a second time by inspectors.

In 1946, Rittenhouse found Daggett to be a "tree shaded little old town that was formerly the location of smelters which handled the ore brought down from nearby mountains. Some of the old store buildings remain, but the town is now quiet." Today, the town is even quieter, with the Desert Market being the busiest place in town.

The first settlement of the site dates to the immediate post–Civil War years of the 1860s. The discovery of rich silver and borax deposits in the Calico Mountains six miles north and a dozen years later gave rise to the town known as Calico Junction. It was

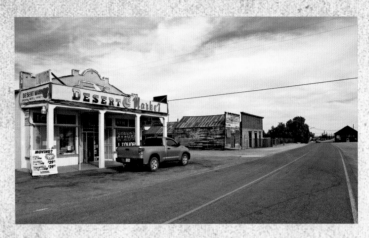

The colorful Desert Market, opened in 1908 as Ryerson's General Store, stands in stark contrast to the faded remnants from Daggett's glory days.

renamed Daggett after the 1882 completion of the Southern Pacific Railroad from Mojave to Daggett, transforming the site from a roughhewn, hardscrabble camp into a boomtown.

Completion of a ten-stamp mill near Elephant Mountain fueled further growth. The large mill required ten- and twenty-mule teams for transport, and freight companies hauled supplies, ore, and water to and from area mines. As a historic note, special Death Valley–Mojave specifications devised to handle the excessively heavy loads gave rise to another industry: the construction and trade of huge wagons. One of the primary builders of these monsters was Seymour Alf. His shop, which served as a garage for motorists on the National Old Trails Highway as well as Route 66, still stands on 1st Street with the ghost sign of Daggett Garage on the wall.

The Daggett-Calico Railroad expedited the shipping of borax and silver ore to the mill, and the line also helped the community survive the collapse of silver prices and the exhaustion of profitable ore bodies during the 1890s. By 1902, the borax mines alone

employed two hundred men, and the business district in Daggett consisted of Alf's Blacksmith Shop, a railroad depot, a drugstore, a lumberyard, the Stone Hotel, three general merchandise stores, two Chinese restaurants, a café, and several saloons.

Just as borax ensured the town's survival after the collapse of silver mining, the National Old Trails Highway, Route 66 after 1926, provided a new revenue stream as borax faded from prominence. Attesting to this was Kelly's Café and Shell Station, the leading national sales outlet for Shell products on several occasions.

With Barstow's prominence as a rail center and as the crossroads for U.S. 66 and U.S. 91, business was slowly siphoned from Daggett. By 1960, it was less than the quiet town noted by Rittenhouse.

Fire and time have claimed a number of historic structures in Daggett, including the old railroad depot. Still, a delightful number of structures survive, including the Desert Market, opened in 1908 as Ryerson's General Store, several now closed cafés and stores, and the circa-1880s Stone Hotel.

When You Go

From Barstow, drive east seven miles on Interstate 40 to exit 7, then turn north.

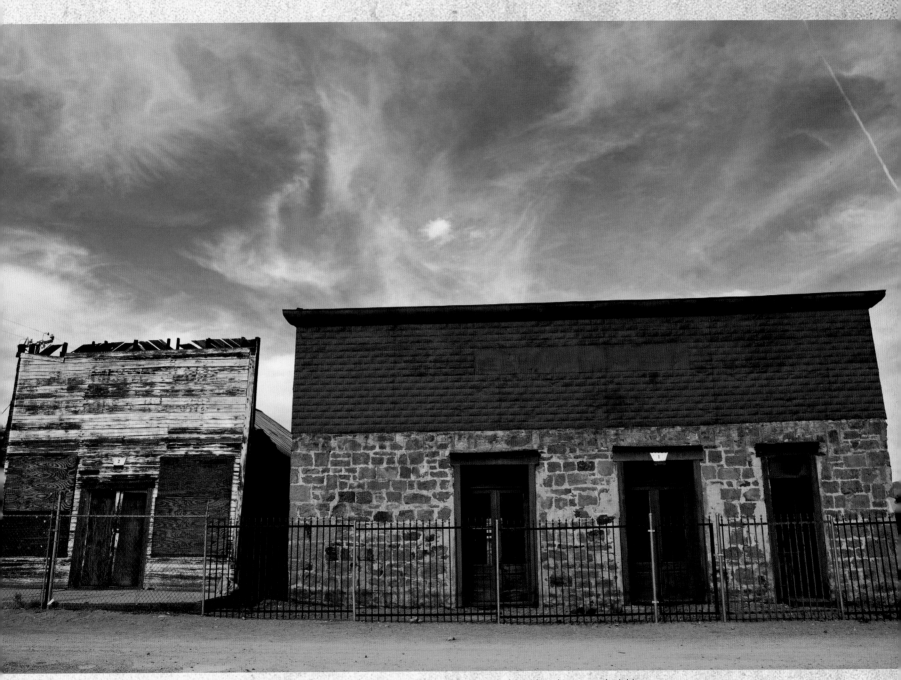

The Stone Hotel, built circa 1875, was originally a two-story structure with a second-floor balcony and a large glass dome over the lobby.

A Lost World

THE VESTIGES OF A LONG and very colorful history along the thirty-mile portion of Route 66 between Barstow and Victorville on the banks of the Mojave River are fast vanishing. In 2007, demolition erased Potapov's service station and auto court, built in 1931 by Spanish-American War veteran Guy Wadsworth. Urban sprawl is rapidly transforming the old town of Helendale—started as a water stop for weary travelers around 1862 and the former site of Exotic World, a burlesque museum—into a suburb of Barstow.

The Do Drop Inn is an empty shell. The Bar Len Drive In Theater is again an empty desert field. Hulaville, once an eclectic roadside attraction, is now but a faded memory preserved in old photos and a diorama at the Route 66 Museum in Victorville.

Still, since this section of road was where the Mojave Trail, the Spanish Trail, and the Mormon Trail converged as they headed for the Cajon Pass, a wide variety of tangible links, many that predate Route 66, keeps the drive interesting.

Counted among these are the row of storefronts from the late nineteenth century in Oro Grande; the Iron Hog Saloon, formerly a dealership for Case farm equipment; and Burden's Store and post office, built in 1926. Other tarnished gems to watch for are the Sagebrush Inn, started as a service station in 1931, and Oro Grande's depot and 1890 schoolhouse.

Anchoring both ends of this drive are two fantastic museums: the Route 66 Mother Road Museum in Barstow and the California Route 66 Museum. The former is housed in the beautifully restored Casa del Desierto Harvey House that originally opened in 1911, and the latter in a former Route 66 roadhouse, the Red Rooster Café.

Even though this faded sign may be more than half a century old, its modernity seems out of place under the desert skies at Oro Grande.